The Art of

OUTDOOR PHOTOGRAPHY

Techniques for the Advanced Amateur and Professional

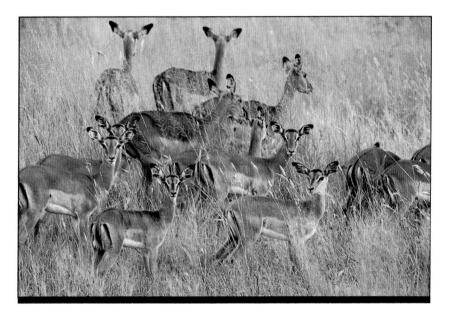

The Professional Approach to
- ◆ Composition, Creativity, and Light
- ◆ Lenses, Film, and Filters
- ◆ Wildlife, Landscape, and Closeup Photography
- ◆ Adventure, Travel, and Underwater Photography

BOYD NORTON

Voyageur Press

Edited by Paul Hintz
Cover designed by Kirsten Ford
Book designed by Lou Gordon
Printed in Hong Kong

First hardcover edition
94 95 96 97 5 4 3 2
First softcover edition
99 00 01 5 4

Library of Congress Cataloging-in-Publication Data
Norton, Boyd.
The art of outdoor photography : techniques for the advanced amateur and professional / Boyd Norton.
 p. cm.
Includes bibliographical references and index.
ISBN 0-89658-159-4
ISBN 0-89658-346-5 (pbk.)
1. Outdoor photography. I. Title.
TR659.5.N67 1993 92-35905
778.7'1—dc20 CIP

Published by Voyageur Press, Inc.
123 North Second Street, P.O. Box 338, Stillwater, MN 55082 U.S.A.
612-430-2210, fax 612-430-2211

Distributed in Canada by Raincoast Books, 8680 Cambie Street, Vancouver, B.C. V6P 6M9

Educators, fundraisers, premium and gift buyers, publicists, and marketing managers:
Looking for creative products and new sales ideas? Voyageur Press books are available at special discounts when purchased in quantities, and special editions can be created to your specifications. For details contact the marketing department. 800-888-9653

To David Brower,
who started it all by publishing those magnificent Sierra Club books in the early 1960s and opened our eyes to the power of an image in creating understanding and love of the natural world. Your encouragement helped guide an errant nuclear physicist along a path of radical career change; otherwise I might still be tending neutrons and gamma rays and other unhealthy things. So, it's your fault. Thanks.

CONTENTS

INTRODUCTION

I think that in one hundred years people will see that photography was the pervasive expressive art form of this era. Charles Traub, photographer, art critic

Photography has become the popular art form of our culture. And outdoor photography is certainly the most prevalent component of the art. Being outdoors and enjoying the natural world goes hand-in-hand with photography, whether it's a day in the park, a two-week vacation to a national park, or a month-long safari in East Africa. For me, capturing the beauty of nature has been a prime motivation behind my photography. I love the challenge of portraying the infinite moods of weather, the mysteries of forests, the elegance of wildlife, the grandeur of sweeping landscapes. And I find it equally challenging to capture the dignity and charm of people and cultures everywhere in my travels.

There are few things in life as exciting as being outdoors, trekking through forest or desert or tundra, absorbing the sights and sounds and smells of places either new or familiar, and being challenged with the awesome task of capturing the essence of a place or subject on film and doing it in such a way as to evoke in others, even in small measure, a hint of the beauty, mystery and drama to be found in our world.

There was a time, not long ago, when photography was a much more difficult medium in which to work. When I was a youngster our family had a Kodak Folding Vest Pocket camera. My father was in charge of all picture taking because the camera was rather sophisticated and involved things like focus, f-stops, and shutter speeds. And loading was a somewhat tricky operation to be undertaken only by those well practiced in such things.

Two or three times a year, on vacations or special occasions, Dad purchased a roll of film (black and white) and carefully loaded it into the camera. The taking of the picture was a somewhat mysterious process to the rest of us, involving certain manipulations we couldn't fathom. I don't think my father fully fathomed them either, for the resulting pictures were occasionally good, but more often not. There were problems with exposure and focus. Anytime those problems were conquered—by luck or design—the picture was deemed good, regardless of content.

Today's electronic revolution has freed us from certain technical chores that too often had hindered and slowed down the photographic process. With modern electronic cameras, we, as photographers, have been liberated to be more creative.

In addition, the high tech has given us fluency that expands photography's expressive capabilities. Take motor drives, for instance. It's now possible to capture a precious slice in time or a vital piece of action that, heretofore, would have depended largely on luck or perfect timing.

But all this fluency and automation won't guarantee great pictures. It is still the person behind the viewfinder that makes photographs exciting and dynamic. The camera, in the final analysis, serves only to complete the picture envisioned in the mind's eye.

We make photographs for various reasons. The primary one is usually to record events or places or people in our lives. Snapshots. Reminders of pleasant experiences, or means to share with others something in our lives—a vacation trip, for example.

For most people the record-making aspect of photography is adequate and satisfying, so long as the pictures are sharp and properly exposed and have believable color rendition.

But for a lot of us photography is a means for capturing the excitement and beauty we see around us. It's a way to express ourselves. It's an art. It's a powerful form of communication. When we arrive at that level of awareness and ambition as photographers, the attributes of the snapshot or "record" picture are no longer adequate and satisfying. Therefore, the casual aim-and-shoot technique of making snapshots needs to be replaced with a more methodical, precise approach to capturing the essence of scene or subject. But how?

The answer to that is what this book is all about. I don't pretend to have any pat formulas for successful photographic expression. In fact, rules and formulas are, too often, the very antithesis of creativity. What I seek to provide here is a blend of information and inspiration in a way that is useful in understanding the mental and mechanical processes necessary in creating strong, dynamic pictures. The rest is up to you. But bear in mind that the only way to learn how to create great pictures is to photograph. Take the camera off that dusty shelf and shoot, shoot, shoot! Record in a journal what you do—which lens, film, and filter; the time of day and quality of light; even the name of the locale or wildflower or why you found the subject intriguing. Then learn by your mistakes as well as your successes.

Enjoy!

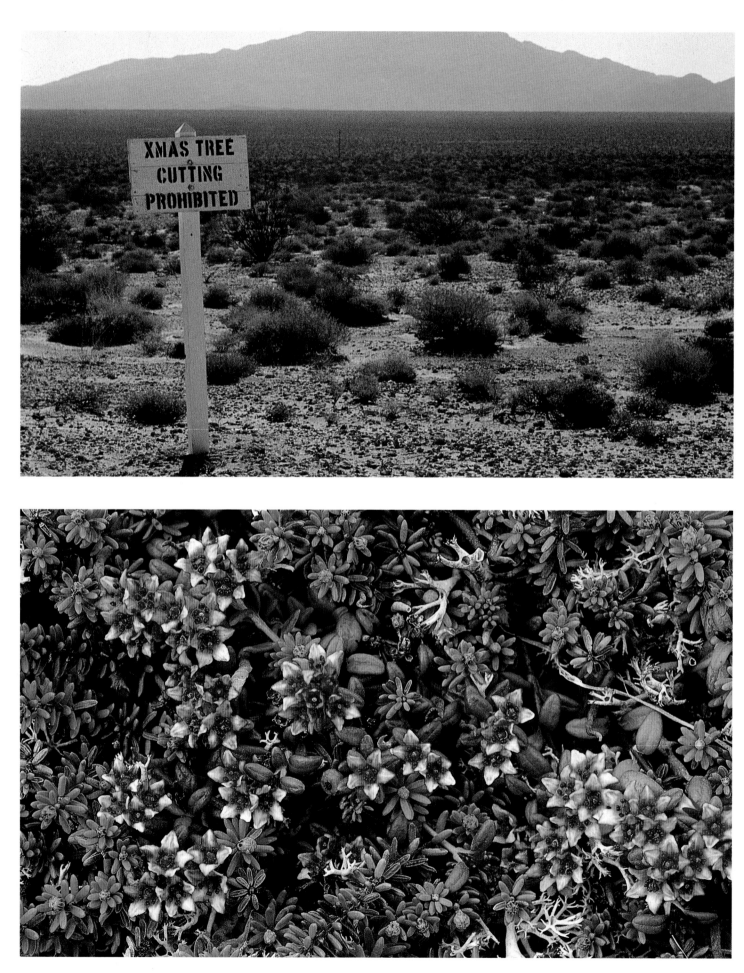

SEEING AND PHOTOGRAPHING

LOOK FOR THE INCONGRUOUS. TOOLING *along on a lonely stretch of highway in the desert north of Las Vegas several years ago, I passed this sign and did a double take. What Christmas trees? I hit the brakes, wheeled around, and came back to make this shot. Too many times we pass up such opportunities—it just never occurs to some people to take a photo like this. The sign was legit—there was a side road leading into the mountains where there really were trees. I like to think that someone procrastinated too long: "Oops, too late; they cut 'em all down." Camera, Nikon F; lens, 105mm Nikkor; film, Kodachrome 64.*

YOU REALLY DO HAVE TO LOOK HARD! *Spend time exploring on your hands and knees; if you do, you'll discover an incredible world in miniature. Anyone who thinks that Alaska's tundra is bleak, barren, and devoid of beauty hasn't learned how to look and see things. These alpine azalea blossoms are about the size of a match head. Camera, Nikon FM-2; lens, 55mm micro-Nikkor; film, Fujichrome Velvia, rated at ISO 40.*

"Where did you go?"
"Out."
"What did you do?"
"Nothin'."
That conversation was more or less typical at my house when I was growing up. We had a farm at the end of our street and I used to spend a lot of time there—not at the farm itself, but in the fields and woods that surrounded the place. Did I really do nothin'? Well, giving that as an answer was easier than trying to explain a day spent exploring the visual wonders of a place. Adults just wouldn't understand.

Nothin'? Hardly. I spent early mornings standing in fields of wind-blown grasses and incredible wildflowers. I climbed gnarled old apple trees covered with shaggy bark and draped with spider webs. I found snakes and insects of all kinds and leaves that rustled underfoot. I spent hours watching ants, or changing patterns of clouds, or bees dancing from flower to flower, or squirrels racing across branches, or . . .

But how do you explain this to adults? In the process of growing up, we lose the sense of visual discovery, becoming jaded, perhaps.

But the beauty and the visual excitement are still there, though as adults we miss a lot of it. Oh sure, sometimes we find time to marvel at a blazing sunset. Or give a passing glance at a field of wildflowers. But what about the infinity of other details, like the way raindrops make circular designs on a pond? Or the patterns created by wind blowing through the grass? Or the texture of a weathered door? Or the prismatic jewels of dewdrops in a spider web, or . . . Well, as I said, the beauty around us is infinite.

FROM EYE TO FILM

One of photography's greatest pleasures is in rediscovering the visual richness of the world around us. I say *rediscover* because it's very much like bringing back those days of childhood when everything was new and exciting and very beautiful.

Photography has been called the art of seeing. Learning to see and appreciate the visual richness of our surroundings is an important first step in becoming a better photographer. But seeing is not enough. We need to learn how to see *photographically.*

Photography is really the art of blending sight, perception, and technical translation. We need to *see* a relevant scene or subject, *comprehend* how best to capture it, *transform* our vision into an image on film.

As in all art, photography involves

11

the careful blending of aesthetics with technical mastery of the medium. The elements of this are *concept* and *execution.*

Concept is seeing the subject, or envisioning it in the mind's eye. Execution is pulling it off—having the precise control over the medium to accomplish exactly what we want on film.

One essential to creating those strong, exciting pictures is learning how to translate, via camera and lens, what we see onto film. This involves thinking beyond the initial excitement of a grand scene or lovely subject, concentrating on these important elements, covered in subsequent chapters:

Lighting. The quantity, quality, and direction.

Perspective Translation by Lens Choice. Telephoto to compress perspective, or wide-angle to expand it.

Composition. Isolating the subject; choosing a center of interest; vertical or horizontal translation; use of line, form, shape, pattern, texture, color.

Depth of Field. Controlling maximum zone of sharpness with small aperture, or creating spatial isolation with large aperture and minimal depth of field.

Capturing Time. Fast shutter speed to freeze action, slow shutter speed to blur and create sense of movement.

Interpretive Rendition. Realism or impressionism.

Film and Filters. Choice of film for best representation, filters to fine tune or alter.

ORDER OUT OF CHAOS

My job as a photographer is to bring order to chaos. While it's true that our world is full of visual richness, it's also true that our world is full of visual chaos. The difficulty in creating strong, dynamic photographs is in dealing with that chaos. Out of an infinite number of elements, I (and you) have to select and arrange a certain number of them into some visual harmony.

Consider the difference between a painter and a photographer. Starting with a blank canvas, the painter constructs an image by adding only those elements needed for visual excitement. But my job as a photographer is to *eliminate*, to strip away many of those chaotic elements that exist in front of me until I arrive at the strongest possible image.

The ways that I can accomplish that are somewhat limited. I can move physically, with my camera, to a different vantage point that eliminates some distracting elements. Or I can isolate things optically, using a telephoto lens, for example, to reach out and selectively frame a portion of the scene in front of me. I can also use the optical properties of lenses to isolate. If I choose a large aperture with a telephoto lens, the depth of field will be shallow enough to keep background and/or foreground sufficiently unsharp and therefore less distracting.

Here's a situation we are often confronted with as photographers. We find ourselves in a beautiful locale—a mountain lake, for example. Our eyes flit from thing to thing, recording instantaneously and continuously a myriad of impressions. Flowers nearby. Sunwashed trees and grasses. Distant mountains and clouds. The blue of lake and sky. The green of leaves. The red and yellow of flowers. Color, texture, patterns, lines, shapes, forms. All of it is recorded in memory, bits and pieces, summed up to convey to us a feeling of natural beauty. But how do we deal with it all photographically?

First, we have to recognize the vast difference between our perceptions and the camera's capabilities. Our perceptions are made up of a number of those impressions—like a huge collection of snapshots or Polaroids. If we piece together all of those images in a single photograph, we have chaos. We need to strip away some of the extraneous and isolate on only a certain number of those elements.

Second, we have to realize that the mind plays tricks. We have a built-in, mental filter, one that allows us to con-

ARCHES NATIONAL PARK IN UTAH IS A *place of intensely colored and elegantly carved sandstone formations. To me the arches themselves are secondary to the magnificent variety of shapes, forms, colors, and textures found here. I was hiking one day in Courthouse Wash when I saw the sensuous shape of the sandstone wall, reinforced by the shape of the cloud. Camera, Nikon FM-2; lens, 180mm; film, Kodachrome 64.*

RAIN. TOO MANY PEOPLE PUT AWAY THEIR *cameras when it starts raining. To me, that's a great time to take out the camera and start shooting. Capture the mood and feeling of a rainy day. Camera, Leica R4; lens, 70–210 zoom; film, Kodachrome 64.*

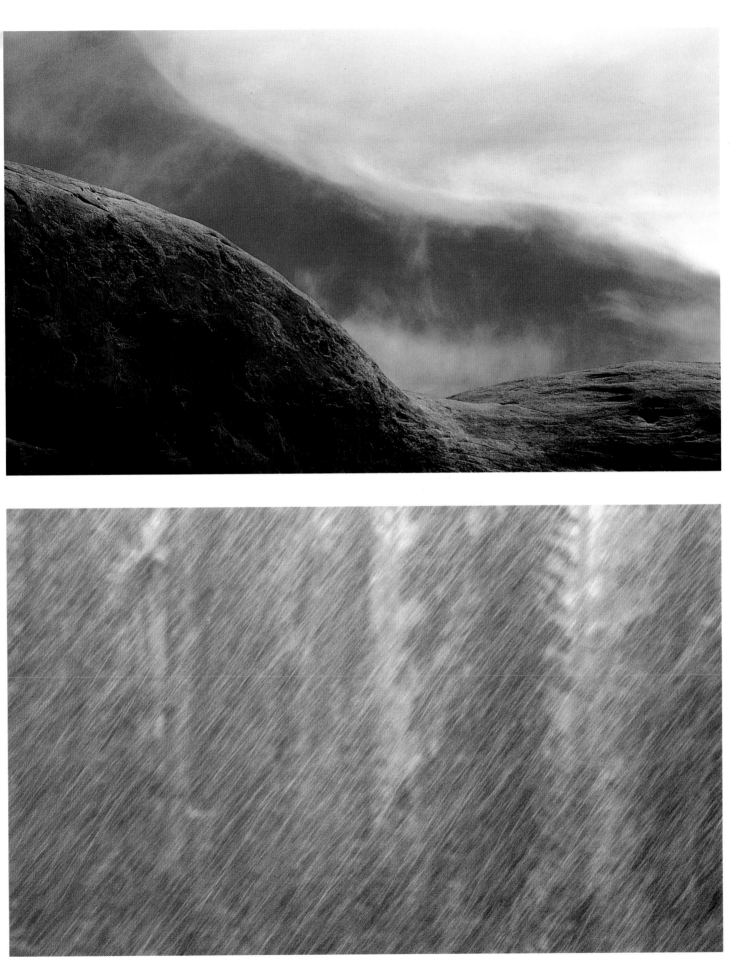

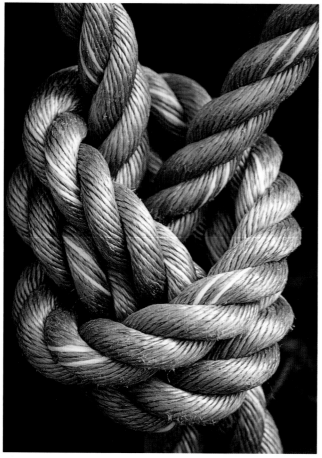

Driving across the flatlands of the high prairie near Laramie, Wyoming, I slammed on the brakes when I saw this scene. I mean, fences are pretty ordinary things, but the dark shadow created by a large storm cloud made this fence stand out boldly. I used a 180mm telephoto lens to isolate a portion of the fenceline. Camera, Leica R4; film, Kodachrome 64.

Find beauty in something as simple as a knotted rope. Something struck me about the design and the implied sense of power in this knot. It was on a large crab pot near Kachemak Bay in Alaska. People were walking by me and taking snapshots of the mountains and glaciers across the bay. Some looked puzzled that I would photograph a piece of rope when there was so much grandeur nearby, but I've taken my share of those magnificent panorama pictures here. Camera, Leica R4; lens, 100mm macro; film, Kodachrome 64.

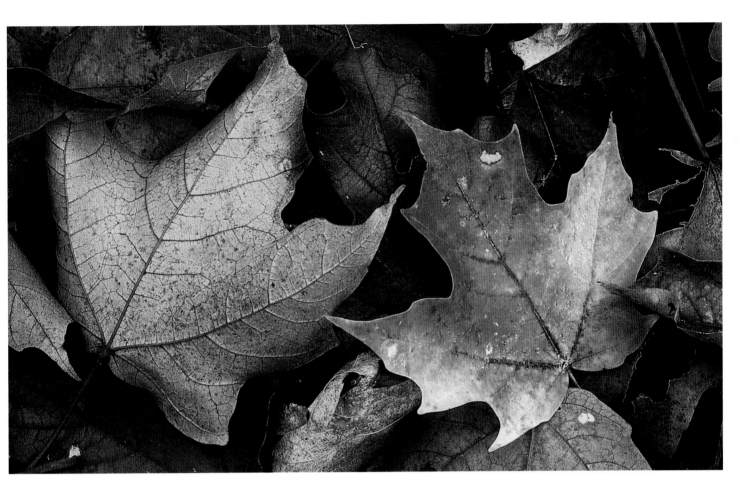

Look down! So many potentially great photographic sub-
jects are those things we often ignore and trample underfoot. When I was a
kid I could find a whole fascinating universe in a few square yards of forest
floor. Well, it's all still there. These fallen leaves were photographed near
the north shore of Lake Superior in Ontario. I used a 105mm lens to isolate
on a tight pattern. Camera was on a tripod and I stopped down to f/11 for
good depth of field to keep everything crisp and sharp as the coldness of the
day. Film, Kodachrome 64.

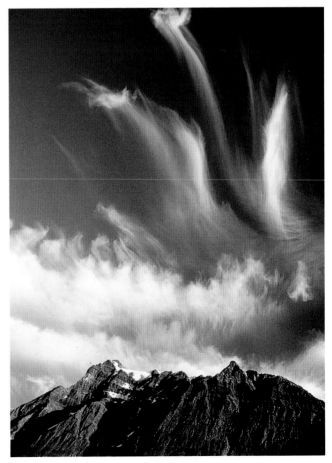

Look up! Sometimes great things happen in the sky. These
wispy, flowery clouds, like brush strokes on a canvas, were in the Cana-
dian Rockies in British Columbia. I was on a magazine assignment and,
frankly, I was concentrating on photographing the people I was with. But
I always scan the skies wherever I am because there are often exciting and
dramatic things going on in the sky. I used a Leica camera and 70–210mm
zoom lens, at about 150mm focal length, to isolate on those clouds. Film,
Kodachrome 64.

centrate on the beauty of a certain element while ignoring some of the visual clutter around us. The trick is to learn how to make the camera selective enough to eliminate that visual clutter also.

Third, we have to look and to see. We have to concentrate. We have to look for—and find—those elements that will give visual excitement to the scene or subject, and to eliminate the rest.

Finally, we have to be analytical. This may sound counterproductive to the creative process because we are dealing with emotions when we deal with aesthetics. But often it is emotion that gets in the way of seeing photographically. We need to look beyond the scene or subject for a moment and analyze how best to capture it on film. What angle of view? What lens? What f-stop (or depth of field choice) and why? What shutter speed (action rendition) and why? What compositional arrangement, i.e., center of interest, lines, shapes, patterns, textures, patterns, or colors, should dominate?

The first two steps should become a part of our awareness and philosophy as photographers. The last two steps are things we must deal with each and every time we create a photograph.

Over the years I've evolved a working pattern that allows me to create the kind of photographs that satisfy me—and the editors that I work with. The key to it all is in allowing enough time to absorb a place. Sometimes I'll just sit for a while to get a feeling for the land and the life around me. Or I may stroll around leisurely, not worrying for the moment about the camera. This is my exploratory phase, where I let my senses soak up a place bit by bit. Even though I'm temporarily ignoring the camera, I am thinking pictures. My mind is exploring picture possibilities in rapid succession and, often just as rapidly, rejecting many of them.

What do I look for? *Simplicity and Elegance.*

Mentally I try to isolate elements that can make a bold pictorial statement, elements such as color or lines or patterns or texture or shapes. If I'm trying for an overall landscape photograph of a place I pay particular attention to the process of isolation, looking for a way to portray the scene with clean simplicity.

Very often this exploratory phase leads to an exciting visual discovery, one that may reveal something unique about the locale I'm in. A certain kind of plant or foliage or rock or some other detail that lends a special character to the place. Or maybe it's something very ordinary, something I've overlooked. For example, on certain Caribbean islands doors and doorways are painted very colorfully. In Siberia, windows in lovely old log buildings are often trimmed with ornate designs and painted with bold colors. Windows and doors—ordinary things—and yet they strongly portray the character of a place.

Light plays an important role in this exploratory process. I'm constantly analyzing the quality of light and how it might affect the overall mood and impact of my pictures. For landscapes and scenics, time of day is a crucial factor in making a picture work successfully. In the middle of the day when it's bright and sunny, I reject most pictures because the light is too harsh and contrasty. However, time can be well spent determining good picture possibilities for early morning or late afternoon lighting, or for a different mood in subdued, overcast lighting or in morning fog.

In a very subtle way the exploratory phase has importance in helping to bring relevancy to pictures. As Kertesz said, seeing isn't enough. You have to feel what you photograph, and the more of a place or subject you can absorb, the more meaningful the pictures. The soul of a place or subject is an elusive entity. The challenge is to capture it on film.

When I've determined the scene or subject I want to capture, I begin the process of selecting the perspective that will

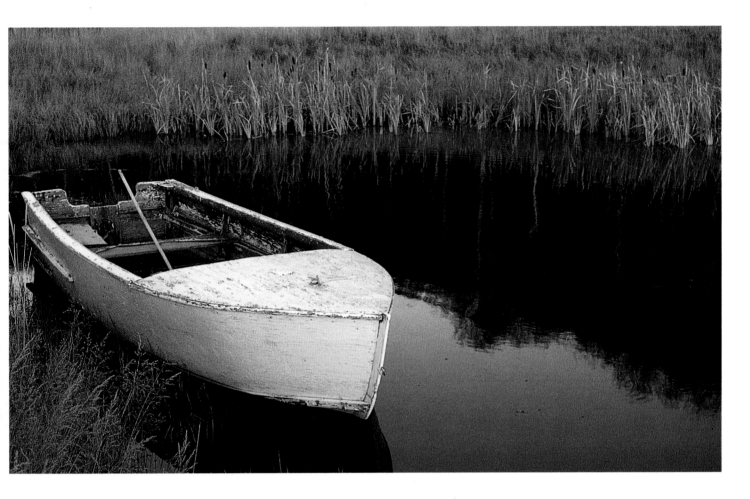

I HAVE A VISUAL LOVE AFFAIR WITH THIS WONDERFUL, WEATHER-
beaten old rowboat at Home Ranch in northern Colorado. I've photo-
graphed it in various seasons, but I've never moved it. I've always ac-
cepted it as a challenge to find ways of photographing it just as it was left
by someone on the shore of the little trout pond. Camera, Leica R4; film,
Kodachrome 64.

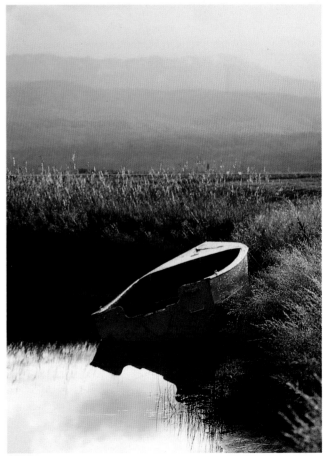

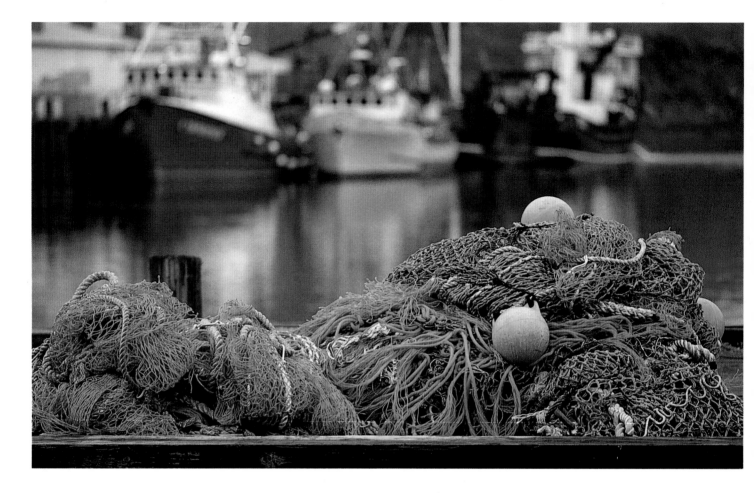

ON A MAGAZINE ASSIGNMENT SEVERAL YEARS AGO I WAS PHOTO-
*graphing the far-flung and remote Aleutian Islands. Some of these islands
have snowcapped peaks and velvet-like green tundra, along with lovely
coastlines. While I was photographing a combination of those elements in
the village of Dutch Harbor, some details on the dock I was standing on
caught my attention. These colorful fish nets represent an important part of
the way of life here. I backed off and used a 180mm telephoto at an f/4
aperture, giving a depth of field shallow enough so that the fishing boats in
the background were apparent, but not sharp. Had they been sharp, they
would have distracted from the primary subject—those wonderful fishing
nets. Camera, Nikon FM-2; lens, 180mm Nikkor; film, Fujichrome 50.*

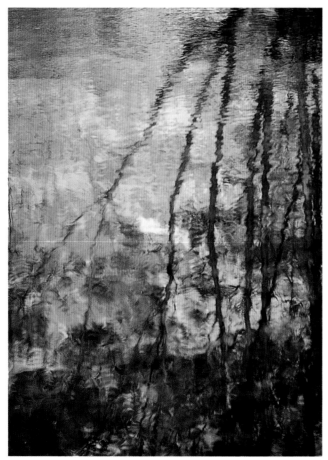

I WAS PHOTOGRAPHING AUTUMN FOLIAGE IN NEW HAMPSHIRE'S
*White Mountains one year. I got the usual backlit closeups of flaming foli-
age and panoramas of blazing hillsides. But as I walked along this stream I
knelt down and discovered this beautiful impressionistic scene created by
the reflection of trees and foliage. Eat your heart out, Monet! It was there
all along; all I had to do was take the time to look and see. Camera, Nikon
FM-2; lens, 105mm; film, Kodachrome 64.*

work best. This involves two important elements: physical locale and lens choice. Both are vital in the construction of a strong picture. Perspective determines the all-important relationship of foreground and background elements. If I choose a wide- or ultra-wide-angle lens, I may need to move physically closer to a foreground element such as a flower or rock or shoreline so that it becomes a dominant feature—a center of interest—in a picture where the expanded perspective portrays great distance between foreground and background. Or I may back off and use a telephoto lens to compress perspective. Or maybe use an intermediate focal length as a compromise between greatly expanded or compressed perspective. Important choices. (And dealt with in more detail in a separate chapter.)

Next comes the tough process of isolating and arranging the picture elements. The viewfinder is a helpful analytical tool in this process. Its importance is too often overlooked. Instead of simply using it as an aiming device, carefully scrutinize your subject with the viewfinder. I concentrate on the image, looking for ways to change, alter, or eliminate elements in the picture. What lines dominate? How do they interact? Is there confusing interaction among the various picture elements? Would this picture make a great magazine cover or print to hang on a wall? If not, why not? How can it be strengthened? What *lens choice* or *physical locale* or *lighting* would make it better? What about depth of field? Do I want to throw certain background and/or foreground elements out of focus? How strongly? Or do I want great depth of field for sharp foreground and background? And how will this affect the picture?

Finally, I deal with the quantity of light—exposure. Running through my mind are questions like: What's the contrast range of this scene? It is too extreme for the film to handle? Where are my middle tones—in the foliage or sky or mountains? How best do I determine ex-posure? Metering off a nearby middle gray (or approximately middle gray) object? Or take an overall average reading? Or use a gray card? (These subjects are also covered in more detail elsewhere in this book.)

Once an exposure is determined, I still have to choose among a number of f-stop and shutter speed combinations. The depth of field may be the overriding factor and a small f-stop, with the accompanying slow shutter speed, may dictate use of a tripod or a faster film. Or maybe shutter speed is my important consideration, that is, I may want to blur the moving water of that waterfall and thus choose something in the range of 1/2-second or 1/4-second shutter speed. Or maybe I want to freeze action with a fast shutter speed.

Whew! Sounds like a lot of work. But that's what it's all about. The final click of the shutter is an anticlimax, the culmination of a process that involves careful seeing and thinking.

If it's done well, the result is a picture that sings.

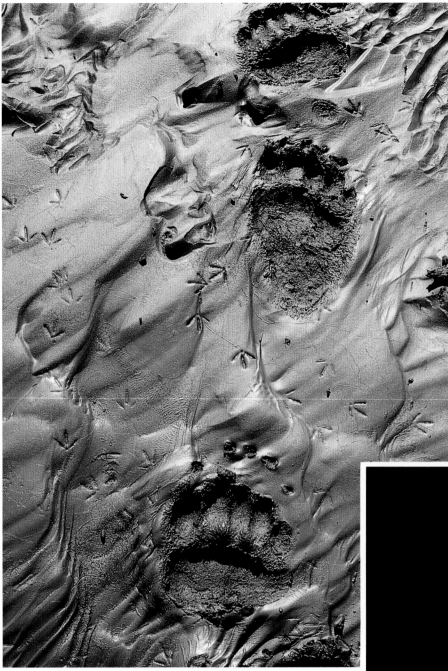

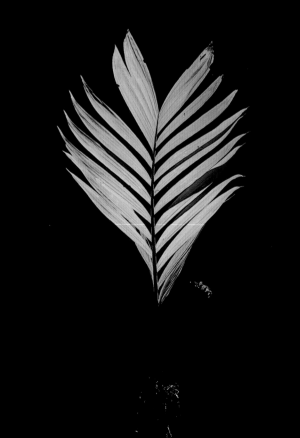

DIRECTIONALITY IS ONE OF THE QUALI-*ties of light to think about. Sidelighting helps bring out texture in this shot of grizzly bear tracks in streamside mud in Alaska's Gates of the Arctic National Park. The sun had just come up over the hills rimming the stream valley, and its low angle brought out the relief and texture. Camera, Nikon F; lens, 55mm micro-Nikor; film, Kodachrome 64.*

BACKLIGHTING BRINGS OUT COLORS IN TRANSLUCENT *objects, and, when combined with a dark background, makes for a dramatic picture. This foliage was shot in the Belize tropical forest when a ray of sunlight coming through the canopy made these leaves glow. Metering this is tough, however; all that black background will cause the meter to overexpose. I used the "Sunny 16 Rule"—the reciprocal of the film speed as shutter speed at f/16. Then I bracketed in one-half f-stop increments to fine-tune exposure. Camera, Leica R5; lens, 70–210mm; film, Ektachrome Plus Professional.*

LIGHT: QUANTITY AND QUALITY

Light is the photographic medium par excellence; it is to the photographer what words are to the writer; color and paint to the painter; wood, metal, stone, or clay to the sculptor.
Andreas Feininger

The essence of photography is light. The very word *photography* is derived from two ancient Greek words: *photos*, meaning "light" and *graphos*, or "write." Literally, then, photography means writing with light. To become good writers of light we must understand two attributes of light: quantity and quality.

Quantity of light has to do with exposure. More specifically, it deals with the intensity of illumination and the proper exposure of the film.

However, there's much more to mastering light than just proper exposure. Quality of light is extremely important in the overall mood and impact of a photograph. The element of quality has to do with direction of light, that is, front, back, or side light, and with certain intangibles like mood or warmth or coolness, and with the softness or the harshness of light.

By achieving absolute mastery of the quantity of light and by having good knowledge of the attributes of the quality of light, we can write with light very fluently.

QUANTITY OF LIGHT

We have two means for controlling the amount of light reaching the film: adjusting the lens aperture (f-stop) and adjusting the shutter speed. The combination of the two gives us a wide range of light control. We can use very slow shutter speeds, coupled with large apertures, to capture subjects in dim light, or, in brighter light, we can use fast shutter speeds, together with small apertures, to render sharply something moving.

The moment we press the camera's shutter button, a sequence of events takes place in a fraction of a second that controls light reaching film. The diaphragm of the lens closes down to the preselected aperture, the camera's reflex mirror flips upward to open the path to the film plane, the shutter curtains, with a preselected open slit, travel across the film plane at a predetermined speed, exposing the film to a predicted quantity of light. And then everything returns to normal—the lens diaphragm reopens, the mirror drops back to viewing position, the shutter is recocked, and the film is advanced. All in less time than it takes to blink. But in those crucial milliseconds, an exposure is made and an image is formed. The question is: Did the proper amount of light reach the film? Was it too much? Or too little? Even more basic: How do we determine the proper quantity of light to make the perfect exposure?

Nowadays most, if not all, of the task of determining proper exposure and set-

ting the camera correctly is taken over by the internal electronic system of the camera. The built-in light-metering systems are swift and accurate, allowing us more freedom to concentrate on picture content. However, that does not mean that we can ignore exposure considerations and let the camera do it all. There are times and situations when even the best metering systems can be fooled, and by understanding the basics of exposure determination, you can be prepared to compensate.

First, it's necessary to understand that all metering systems are based on the reflectance of an 18 percent gray card. Why? Because an average outdoor scene or subject can made up of many reflective elements, ranging in brightness from white or near-white to black or near-black. If it were possible to make very precise spot measurements of the reflectance of a great many of these elements, you could average them all and come up with an approximate exposure determination. It's also possible to arrive at a good approximation of exposure by using a single gray card with a reflectance of 18 percent—often referred to as "middle gray." This simply means that most objects in an average scene have a reflectance not greatly different from that of 18 percent gray. Keep in mind that this has nothing to do with the *color* of these objects, only the *amount* of light reflected from them.

Light meters work very nicely, so long as most scenes and subjects fall within this range of reflectivity of around 18 percent. But problems arise when a subject is very much lighter than, or very much darker than, middle gray. In the case of something very light or white, like the whitewashed wall of a building (illustrated on page 26), the meter reads the reflectance and suggests an exposure based on 18 percent gray. If the exposure is made, the white or light object will appear too dark in the final picture. Actually, it will appear to be approximately 18 percent gray. The meter wasn't wrong (it was doing the job it was designed to do), but it was fooled by the above-average reflectance of the subject and tried to render it as 18 percent gray.

Similarly, my mountain gorilla friend, Mrithi, was much darker than 18 percent gray. In trying to make the gorilla 18 percent gray, the meter suggested an exposure that made Mrithi too light.

How do you deal with such situations? There are a couple of effective ways. First, think of the simple rule: Add light to white and dark to black. In the case of the white wall, it's necessary to open up the lens—use a larger aperture—to add more light than what the meter suggests. This means adjusting the exposure by manually overriding the meter reading. How much? This is tough to answer precisely; time and experience will guide you, but in general for a subject like my white wall, at least one full f-stop opened up from the meter reading. Actually, the best exposure for this example was nearly one and one-half f-stops opened up. For the mountain gorilla, it wasn't necessary to compensate quite so much—stopping down about one f-stop was sufficient (illustrated on page 24).

A more accurate way of determining proper exposure for these extremes would be to take a meter reading off some nearby objects that are closer to middle gray. Foliage or grass are good approximations. But be sure that these are in the same lighting as your primary subject, and not shaded or highlighted excessively. Of course, ideally you could place an 18 percent gray card in the scene and meter from that, but in some situations it's too dangerous (I don't think Mrithi would have stood for it!), the subject is too distant, or some other obstacle stands in your way.

I'm often asked by photographers if it wouldn't be better to use a separate light meter—a spot meter or incident light meter, for instance. My answer is no. I mean, it's okay if you want to bur-

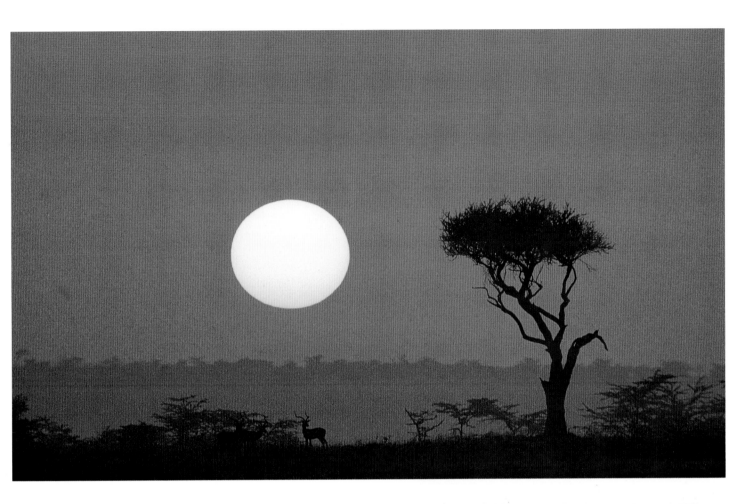

QUALITY OF LIGHT IS AN ELUSIVE ENTITY TO DEFINE. GENERALLY IT *is determined by the harshness or softness of the light source, and this quality determines the effective mood of a picture. Time of day and atmospheric conditions dictate the quality and therefore the mood of the picture. It's a matter of planning, making sure to be there at the right time when the light is right. Or being patient enough to wait for it to change.*

I'm always up before dawn when I'm on safari in Africa because this land has such a special quality of light at dawn and dusk. Here in the Masai Mara Game Reserve in Kenya the sun came up through mist and cloud, silhouetting these impala and the gnarled old acacia tree. No filter was used—this is exactly the color of dawn that morning. For exposure, I metered off the sky well to the right of the rising sun. By doing so, I gave that portion of sky a middle tone or middle gray rendering. Metering this scene with the sun in the picture would have given a reading that would have made the picture too dark. To emphasize the sun and make it appear large in the picture, I used a 560mm lens. Film, Kodachrome 200.

NO METER CAN MEASURE QUALITY OF LIGHT. YOU JUST KNOW IT *and feel it. Most often that soft, warm glow of sunlight at dawn or dusk has magical qualities. The sun had just come over the horizon when I made this shot of the curved beach at Babushka Bay in Pribaikalsky National Park in Siberia's marvelous Lake Baikal. Camera, Leica R6; lens, Leica 70–210mm zoom; film, Fujichrome Velvia.*

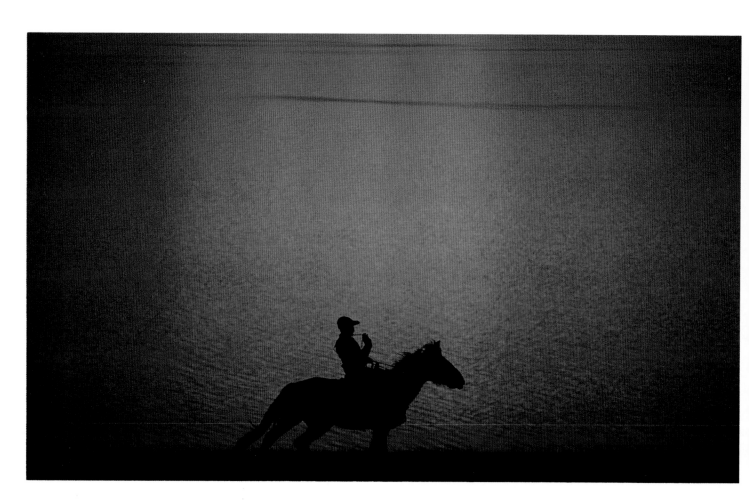

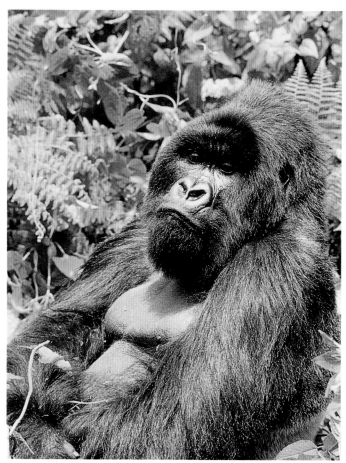

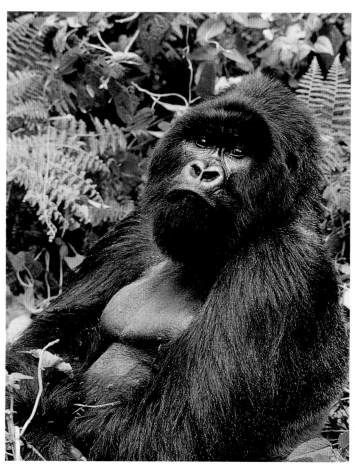

SHOOT, AND THEN ANALYZE THE results! *You'll gain more experience—particularly in understanding the metering system. This will benefit you later in making split-second decisions. The Nikon 8008s has matrix metering, which compensates for backlighting. Sometimes you may not want that, as in this case when I was on remote Olkhon Island in the middle of Lake Baikal in Siberia. It was at sunset when this Buryat sheepherder galloped out of nowhere. The matrix metering, had I used it, would have opened the lens too much, aiming for detail in the figure. I wanted a silhouette, not detail, so I quickly switched to manual and exposed for the light on the water. I got two shots before he galloped off. Camera, Nikon 8008s; lens, Nikon 35–135mm; film, Fujichrome 100.*

LIGHT-METERING SYSTEMS CAN CREATE *problems when the subject is very dark, as in the case of my friend, the silverback mountain gorilla Mrithi in Rwanda. When I tried to determine exposure by using Mrithi's dark fur, the metering system called for an exposure to make it 18 percent gray—which, as you can see, is too light (far left). Instead, I metered from the nearby foliage as an approximation to middle gray, and Mrithi appears properly exposed (left). Incidentally, Mrithi was brutally shot and killed in early 1992 by rebel terrorists who invaded northern Rwanda from bordering Uganda. With fewer than 320 mountain gorillas left in the wild, this was especially tragic. Camera, Leica R5; lens, Leica 70–210mm; film, Kodachrome 200.*

den yourself with additional things to carry around. But there is absolutely nothing wrong with metering systems built into modern cameras. *No matter what kind of light metering you use, internal camera meter or hand held, it is absolutely essential that you understand the information the meter is giving you.* Hand-held spot or incident meters can be fooled just as easily and require an understanding of how to adjust for those extremes of subject reflectance.

Learn how to use and understand your camera's metering system. The best way to do that is practice. Until you become very proficient at it, keep field notes. Not for everything, but just those lighting situations you're unsure of. Eventually, it should become a part of your normal working practice to evaluate a scene or subject in terms of how close it is to middle gray rendition. If the subject is very much lighter or darker than middle gray, you should then look at nearby objects from which to take a meter reading—objects that are close to middle gray.

Also, you must understand how your light meter is functioning. Is it giving an average over the whole viewing screen? Or is it center weighted, as many meters are nowadays, giving 75 percent or so emphasis to the light measured in a central circle. Some cameras have the capability of switching to a spot metering mode, whereby all the light being measured is contained in a central circle in the viewfinder. If so, you must be sure to place that spot on a middle-toned object for a correct reading.

Incidentally, and related to this, I recommend that you calibrate each new camera body you buy. Don't assume that the metering system is absolutely accurate. Run a test roll through the camera, first using the normal ISO film speed, then varying the speed in half-stop increments up and down. For example, using Kodachrome 64, shoot a picture or two of a test subject first with the film speed set at 64, then a couple more with

the ISO set at 80 (one-half f-stop faster) and then 40 (one-half f-stop slower). Keep notes, of course, and use the same test subject for all shots. Compare the results. You may decide that the exposure is better with the ISO set at 80. Or maybe it's fine set at 64. But it's a good idea to make this test, because I've noted variations in camera bodies made by the same manufacturer; by calibrating them, and marking them with this calibration information, I'm able to avoid any surprises in exposures when I'm shooting with two or more camera bodies on an assignment.

As I said earlier, you need to think *light*. In this case, *quantity* of light. There's another little trick that's useful when confronted with tricky lighting—the "Sunny 16 Rule." A good approximation to proper exposure, in bright sunlight, is to use f/16 for aperture and the reciprocal of the film's ISO as the shutter speed. In other words, for ISO 64 film, use 1/60 of a second shutter speed at f/16 for correct exposure. For ISO 100, 1/125 of a second at f/16, and so on. Keep in mind that this works only in bright sunlight, and between midmorning and midafternoon.

Contrast is a real killer of pictures shot on transparency film and it ain't so great for negative films either. As I discuss in the chapter on film and filters, slide or transparency film has inherently narrow latitude—meaning that it can't handle extremes of lighting in the same picture. Here's a typical situation: bright sunlight streaming down through foliage in a forest. Objects are either lit brightly by sunlight or are in deep shade, with a range of lighting well beyond the latitude of the film. If one exposes for the shadow detail, sunlit areas are totally washed out. If one exposes for the sunny spots, the shadows become inky black with no detail. Trying to compromise by averaging the extremes results only in partially washed-out areas and partially blocked-up shadows. You can't seem to win.

So how do you deal with exposure in such an extreme situation? My recom-

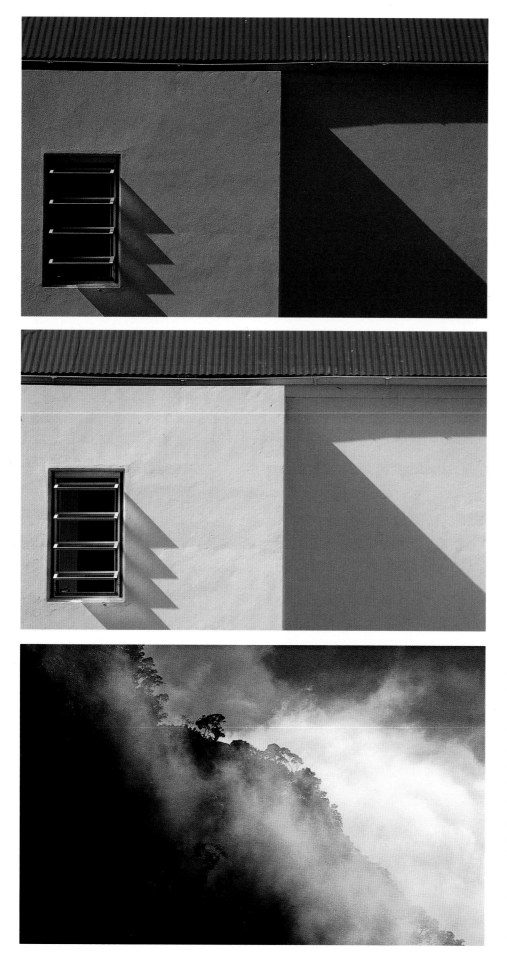

HERE'S ONE OF THOSE SITUATIONS *where we need to be aware of the information given us by the camera's light-metering system. When I aimed my camera at this white-walled building in the Virgin Islands, my meter indicated that the top picture was the correct exposure. Remember, however, the meter is basing its exposure on an 18 percent gray (also called middle gray) and, indeed, that's the result I got. When I used the f-stop that the meter said was correct, I got a gray building. But in order to render the walls truly white, I had to open up the lens one and one-half f-stops from the indicated exposure.*

The important thing to keep in mind here is that whenever the picture in the viewfinder is dominated by something very much lighter or darker than a middle or 18 percent gray, you will need to override the meter's reading for a correct rendition. How do you do this? When possible, I try to find something nearby in the same lighting as the subject to take a meter reading from. Foliage or grass or tree bark or even a piece of clothing—all are good approximations of middle gray. If there's nothing nearby or if speed is essential, meter off the subject and open up one f-stop (if the subject is white) or stop down one f-stop (if the subject is very dark) as a first approximation for the correct exposure. Then bracket exposures for good measure.

ANOTHER TRICKY SITUATION—CLOUDS *and mist and fog. The meter sees that whiteness and tries to make it 18 percent gray. For this shot, in the rain forest of Mount Kinabalu National Park in Borneo, I made a preliminary meter reading off the trees without including much of the mist. But I also recognized that exposing for the forest greenery would cause the mist to be washed out. So I chose a compromise exposure between the forest and mist as a starting point. Perhaps more than any other case, this one called for careful bracketing—in one-third f-stops—because of the ephemeral quality of mist and light. Camera, Leica R6; lens, 70–210mm set at 210mm; film, Kodachrome 64.*

26

mendation is this: Sit down, open the camera bag, take out a cool can of beer (What? You don't carry beer as an accessory?), open it, sit there and sip your beer while enjoying the ambience of the place, and wait. Wait for what? Wait for a cloud, of course. With luck, a big, fat cloud will come along to create some overcast and reduce the contrast, and you should be able to make a good forest photograph. Otherwise, forget it.

No, actually, you shouldn't forget it entirely. Sometimes contrast can be used to advantage. In the chapter on composition I talk about how vital it is to strive for simplicity and isolation of subjects to eliminate visual clutter. Here, we can use high contrast and turn the narrowness of film latitude to our advantage. Let's suppose you'd like to photograph a flower, but the background is cluttered. If the lighting is such, you might be able to compose the flower in a ray of sunlight against a background of deep shadow in the forest, thus effectively isolating the subject from cluttering background. Proper exposure for the flower (you might want to consider the Sunny 16 Rule if you have trouble metering it) will render those shadows deep black and unobtrusive. Keep this in mind next time you're confronted with high contrast sunlight in a forest and you don't have a handy cloud (or can of beer) to reduce the contrast of the scene.

Keep in mind that there is no single, absolutely precise exposure for a given scene or subject. A normal picture can be made up of a myriad of reflective surfaces and the best exposure is a compromise. For various reasons, one may wish to render scene or subject slightly lighter or slightly darker. More importantly, however, in certain tricky lighting situations—for example, backlit subjects, or colorful sunrises or sunsets—it is wise procedure to bracket exposures, that is, make two or more pictures by varying the determined exposure setting. This may seem wasteful, and some purists may ar-

gue that *they* can determine proper exposure with such accuracy as to negate the need to bracket. To which I say bull. They may come up with a perfectly acceptable exposure, and so can I, but I find that very often in those tricky lighting situations, something a little lighter or darker may make for a more successful picture. Bracketing exposures should never be a substitute for careful technique, but rather used at times for *fine tuning* exposure.

Many of today's sophisticated cameras have built-in electronic features that can evaluate tricky lighting situations that would fool ordinary meters. For example, Nikon's matrix metering system divides the viewing screen into a number of parts or matrix elements, and the light striking each element is evaluated by a mini computer chip. If you shoot a portrait of a person with strong backlighting, the matrix system is able to judge that bright background light and adjust the exposure so that the person is properly exposed. An ordinary metering system would be fooled by all the bright backlight and cause the picture to be underexposed—that is, the subject would be rendered too dark. There are limits to the extremes of backlighting such systems can handle, so you need to run tests of your own and determine what the limits are.

In fact, that's good advice for using any of the new fully electronic cameras. Learn all the features on them thoroughly so you don't have to waste time trying to figure it all out when in the field. Practice!

In case you haven't figured it out by now, I'm not a real fan of these fancy all-electronic cameras. I feel that, too often, reliance on all this automation may take away certain creative controls that we, as photographers, should exercise. For example, most electronic cameras have a program mode. You set the mode selector to P (I think it should be D, for Dummy) and the camera will automati-

cally select the shutter speed and f-stop. You just point and shoot. However, I think that you should have complete mastery of the medium. It doesn't mean you have to give up all automation, just that you should constantly be thinking of *why* a certain f-stop might be used (depth of field) or *why* a shutter speed might be chosen (creative blur or stopping action).

I'll concede that automated cameras can be a good learning tool, but only if you graduate from the P (or D) mode to something with more exacting control. For example, I often use my cameras in the Aperture Priority Mode, meaning that I select the aperture I want and the camera selects the appropriate shutter speed for correct exposure. But I always monitor that shutter speed selection as well, to be certain that it's right for what I want.

There are occasional situations when the lighting is so dim as to be out of the range of accurate measurement by your light meter. Under these circumstances exposure must be determined by rough guidelines and experience. The table gives some approximate exposures for various nighttime lighting situations. For most of these you'll need a tripod or at least a monopod. Keep in mind that many night or low light scenes (e.g., stage shows) are illuminated by tungsten lights that have a warmer (more red or yellow) color balance than daylight. Regular day-light-balanced films may render the scene too red or yellow, so you may want to use a *tungsten-balanced* color film, such as Kodak Ektachrome 160 or Fujichrome 160. Use the exposure guideline for ISO 200 film and open up one-half f-stop.

Lightning photography is always fascinating and challenging. Because it's a fleeting phenomenon, it's unlikely that you'll capture a lightning strike during the daytime and, even in gloomy, stormy weather, there's too much light to allow long exposures—which would increase your odds of capturing a lightning bolt on film. However, it's not that difficult if

you wait until after dark. Set the camera on a tripod, choose a moderate focal length lens—50mm, or even a wide-angle (35mm, 28mm)—to cover more sky area and increase the odds of getting a flash in the picture area. For aperture, use about f/5.6 for ISO 64–100 speed film or f/8 for ISO 200. Use a locking cable release to hold the shutter open, then hold a black card over the front of the lens, remove it for several seconds at a time and hope for a lightning strike. To record more than one flash on the same frame, cover the lens again and wait for sufficient time to uncover it. It's a guessing game, but usually a successful one if you have patience. Of course, all of this assumes that the storm is some distance away. If you're in the *middle* of a raging thunderstorm, you may not want to stand next to a metal tripod—or you're likely to be the first person to photograph a lightning bolt *end-on* as it hits you, the camera, and the tripod.

In summary, for mastering control over quantity of light, you should have complete understanding of what your camera's metering system is measuring, how it is measuring, and any tricky lighting situations that might affect it. And this can only come from practice, practice, PRACTICE.

QUALITY OF LIGHT

There is no meter that can measure the *quality* of light. It is something we must learn to look for, determine, and utilize. One of the attributes of light we need to concern ourselves with is directional properties. It used to be a slavish rule for amateur photographers to take pictures with the light coming over the shoulder. In other words, the subject should always be illuminated by front-lighting. This made a certain amount of sense when using simple, non-adjustable cameras because it ensured uniform, proper exposure of the subject. However, as a photographic artist you need to think about the directional qualities of light and

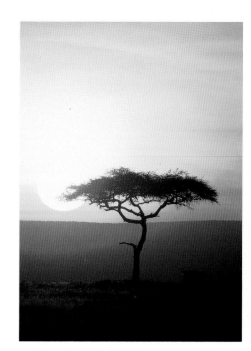

SUNRISES AND SUNSETS CAN BE ES-*pecially tricky for determining proper exposure. If you use a long telephoto lens to make the sun more dramatic in the picture, the intensity of that thermonuclear ball will cause the meter to pick an exposure that is likely too dark—that is, the sky will be almost black and the sun a medium bright spot in the final picture. I usually meter off the sky or clouds well to the right or left of the sun, using that as my basic exposure, then recompose with the sun in the picture. And bracket in one-half f-stop increments to fine-tune the exposure to your liking. This shot of wildebeest in Kenya's Masai Mara Game Reserve was done in just that way. Camera, Leica R5; lens, Leica 560mm; film, Fujichrome Velvia.*

THE BEST WAY TO LEARN TO FLUENTLY *handle tricky lighting situations is to practice and record what actions you took (f-stop, shutter speed), what equipment you used, and what the conditions were—soon after you've shot the photo or photos. Use a diary such as PhotoJournal, published by Voyageur Press, which also contains an 18 percent gray card and vital on-the-go tips.*

Nighttime/Low-Light Photography

Don't quit shooting when the sun goes down. Because most light-metering systems aren't sensitive enough to give accurate exposures in low light, the table below gives some approximate exposures for various nighttime/low-light situations. For most of these, a tripod may be necessary. Also, many night scenes are illuminated by tungsten lights, which have a warmer color balance than daylight does. Regular daylight films may render the scene too red or too yellow, so you may want to use a tungsten-balanced color film: Kodak Ektachrome 160 or Fuji's Fujichrome 160 (use the exposure guidelines for ISO 200 and open up one-half f-stop). Remember, these are only rough guidelines to be used as a starting point. Bracket your exposures!

Subject Film Speed:	ISO 64	ISO 200	ISO 400
Interior of homes (average)	1/4 at f/2.8	1/15 at f/2	1/30 at f/2
Interior of homes (bright)	1/15 at f/2	1/30 at f/2	1/30 at f/2.8
Candlelit subject	1/4 at f/2	1/8 at f/2	1/15 at f/2
Christmas lights and trees (indoors)	1/2 at f/2.8	1/4 at f/2.8	1/4 at f/4
Christmas lights and trees (outdoors, with snow)	1/30 at f/2	1/30 at 2.8	1/60 at f/2.8
Street scenes (brightly lit)	1/30 at f/2	1/30 at f/2.8	1/60 at f/2.8
Store windows	1/30 at f/2.8	1/30 at f/4	1/60 at f/4
Buildings, monuments, and fountains (floodlight lit)	1/2 at f/2.8	1/4 at f/2.8	1/8 at f/2.8
Skyline (ten minutes after sunset)	1/30 at f/4	1/60 at f/4	1/60 at f/5.6
Skyline (right after sunset)	1/60 at f/4	1/60 at f/5.6	1/60 at f/8
Traffic (moving, with light patterns)	20 sec at f/16	10 sec at f/16	10 sec at f/22
Fairs and amusement parks	1/15 at f/2	1/30 at f/2	1/30 at f/2.8
Campfires	1/30 at f/2.8	1/30 at f/4	1/60 at f/4
Subjects lit by campfires	1/8 at f/2	1/15 at f/2	1/30 at f/2
Football games (floodlight lit)	1/30 at f/2.8	1/60 at f/2.8	1/125 at f/2.8
Moonlit landscapes (moon not in picture)	4 min at f/2.8	2 min at f/2.8	1 min at f/2.8
Moonlit snowscapes (moon not in picture)	2 min at f/2.8	1 min at f/2.8	30 sec at f/2.8
Circuses and stageshows (floodlight lit)	1/30 at f/2	1/60 at f/2	1/60 at f/2.8
Circuses and stageshows (spotlight lit)	1/60 at f/2.8	1/60 at f/4	1/60 at f/5.6
Museums and art galleries (well lit)	1/8 at f/2	1/15 at f/2	1/30 at f/2
Fireworks (shutter open, on B*)	f/8	f/16	f/22
Moon (telephoto closeup)	1/125 at f/8	1/250 at f/8	1/500 at f/8
Lightning (shutter open, on B*)	f/5.6	f/8	f/11

Note: For fireworks and lightning, set shutter on B and hold it open with a locking cable release. To capture several bursts of lightning strikes, leave the shutter open and block the camera lens between events.

use them for creative effect. Let's look at some of these qualities.

Frontlighting. It's often referred to as flat lighting, because three-dimensional objects tend to lose their form when illuminated with frontlighting. Texture, too, is lost. It can also be very harsh, as in the case of on-the-camera flash or direct sunlight. Shadows, which often give a sense of perspective or dimension, are minimized or eliminated with frontlighting. So it becomes a challenge to use frontlighting to create drama and dimension to pictures. But not impossible. The most dramatic use of frontlighting occurs when a main subject is lighter or darker than surroundings or background. Contrast between colors or contrast between reflective qualities keeps the picture from becoming flat and uninteresting with frontlighting.

Sidelighting. This is the kind of light that gives dimension to things. Shapes are given form, textures crackle when sidelighting is used effectively. Shadows are most prominent with sidelighting and help to give a sense of perspective and dimension to landscapes. One of the pitfalls of sidelighting is contrast, especially with very harsh lighting. One side of an object may be very brightly lit, while the opposite side is in deep shadow. Unless you want the drama of such stark contrast, be cautious.

Backlighting. This is the trickiest attribute of light to utilize. But it can also be the most dramatic. Two problems: exposure determination, and lens flare. Since you're aiming the camera at the light source, the meter can be tricked into giving the wrong exposure. In fact, what is the right exposure? Because of the dramatic nature of the light in a backlit scene, there actually may be several "correct" exposures, depending upon the degree of contrast and the emphasis you wish to give between subject and background.

Backlighting also dramatizes the translucency of things, like flowers and foliage. For brilliant autumn foliage shots, try moving around the tree so that sunlight is shining through the leaves toward you. The color becomes much more intense with backlighting.

The same applies to flowers. Use backlighting to bring out the intense colors or delicate variations in whites.

When we talk about quality of light we also deal with such attributes as harshness or softness. Bright, direct sunlight is very harsh, with the strong tendency to wash out color and negate subtle differences in hue and tone. It's also the most contrasty of natural light, straining the limits of what most color films can handle.

Overcast light has a lovely, soft quality to it that enhances the rendition of many subjects. I find that overcast light is perfect for many scenes and subjects where I want to portray subtle hues and tones, as in forest scenes or flower shots. It's also very flattering light for portraits of people. Open shade is somewhat similar in its quality, that is, it's soft, diffused lighting, but there's another attribute concerning open shade that you need to consider—it often has a cooler quality. In the shade of a bright sunny day, the clear blue sky above adds a strong element of blue. This may require use of a warming filter such as an 81A or skylight, or the use of a warm-toned film (see discussion of this in the chapter on films and filters). In open shade at higher elevations, like my domain in Colorado, there's a distinct blue component in the light that often requires a warming filter.

There are also times when light has a warm quality to it. Very early morning and late afternoon sunlight is very warm and this warmth is flattering for many subjects and scenes. In landscape photography midday light is deadly—harsh and contrasty. However, in early morning, with long shadows and the warmth of the dawn sun, landscapes take on an intensity of color and a dimension that can't be equaled at midday. Late afternoon light is similar, though in many places it tends to be softer in quality, even though it has warmth. The reason is dust in the air, picked up by daytime breezes, and even a bit of moisture from evaporative heating during midday. Both contribute to diffuse the sunlight a little. I notice the difference between dawn light and late afternoon light most in places like Africa and in our Southwest. The air is crisper in the morning, perhaps because nights are cool and settle the dust. At dusk the air is not so crisp, and the quality of light is often softer. The two effects can render landscape shots of the same scene different in subtle ways.

CREATIVE USE OF LENSES

The difference in "seeing" between the eye and the lens should make it obvious that a photographer who merely points his camera at an appealing subject and expects to get an appealing picture in return, may be headed for a disappointment.
Andreas Feininger

Lenses form images.

On the one hand, a lens can be thought of as a precise optical construction of glass elements of differing indexes of refraction, polished to various curvatures, and designed to correct for spherical and chromatic aberrations, coma and astigmatism, minimal flare, and optimized for low distortion, all to form an image of highest resolving power. That's my physicist side talking.

My artistic side says: Looked at another way, lenses magically transform the real world of three dimensions into two dimensions on film.

Because a photograph is a two-dimensional compression of the three-dimensional world, we need to give careful thought to the properties of lenses and how they form that image. This is important because of the spatial relationships formed in that two-dimensional image.

For example, in the real world our stereoscopic vision makes depth apparent to us when we view a nearby object and one that is farther away. But a photograph, lacking a three-dimensional view, renders the two objects in the same plane. We need to give thought to how those objects appear on film so that we create a sense of depth in the picture. We can do this by emphasizing their relative sizes (the foreground object being larger than

the distant one) or by overlapping their two-dimensional forms, making it apparent that one is in front of the other.

Before the advent of zoom lenses, photographic lenses were generally lumped into three broad, focal length categories: normal, wide-angle, and telephoto. Obviously, we still use these terms even though zoom lenses often encompass focal lengths from wide-angle to telephoto, all in one convenient optical unit.

A so-called normal lens, in 35mm film format, is one with a focal length of about 45mm to 55mm, with 50mm more or less being the standard. Technically, this focal length was chosen because it was close to the diagonal measure of the 35mm frame—about 43mm. Unfortunately, the term "normal" lens has also been used to suggest that it is a "normal" sense of perspective created by this lens, that is, close to the "normal" way we view things. I don't believe it. A lens of 80mm to 100mm is closer in perspective rendition to the way I see things.

Wide-angle lenses, as the term implies, have a wider angle of view than normal lenses. The focal lengths are shorter than 50mm—35mm, 28mm, 24mm, and, in the realm of ultra-wide-angle, 20mm, 18mm, 15mm, all with increasingly wider angles of view. (Don't confuse these shorter focal lengths with

20mm

50mm

105mm

200mm

400mm

CHANGING PERSPECTIVE WITH CHANGING FOCAL LENGTH. In
*the first sequence here, changes in lens focal length were made with
the camera in a fixed position; from 20mm ultra-wide-angle through
400mm telephoto, you can see the change in the size of the primary
subject.*

20mm

50mm

105mm

200mm

FOR THE SECOND SEQUENCE, I CHANGED BOTH THE CAMERA *position* and *the lens focal length. Each change was made in such a way as to keep the primary subject the same size in the picture. Note the dramatic differences in perspective: With the 20mm, we see a lot of foreground detail and background is diminished; with the 400mm, relationship of foreground and background is greatly compressed and the mountains in the background seem very close.*

400mm

fish-eye lenses. Fish-eyes have a curvilinear perspective, rendering straight lines as curves; the ultra-wide-angle lenses are rectilinear and render straight lines as straight.) Unfortunately, the very term "wide-angle" has often been associated with the idea that the wider angle of view will allow cramming more things into a given picture. This is *not* the most effective way of using wide-angles and ultra-wides—more on this when we deal with perspective.

And, of course, telephotos have a focal length significantly greater than that of a "normal" lens. We all know that telephotos deliver a magnified image, and most often we associate telephoto lenses with wildlife and sports photography.

As I said, these very terms have too often suggested certain ways that we use different focal lengths—normal lens for normal perspective, wide-angles to pack more into a picture, long telephotos exclusively for wildlife. These routine notions stand in the way of good creative expression.

From a creative standpoint, the most important properties of lenses that we need to know and understand are perspective relationships produced by different focal lengths, and depth of field control.

When we approach the task of photographing a scene or subject, we need to think of focal length and especially *the relative perspective renditions of different focal lengths and how that will affect our rendition*. The choice of a particular focal length will also dictate how we position ourselves with respect to the scene or subject. We may want to move in closely to a primary subject and use a wide- or ultra-wide-angle lens to increase the sense of perspective and show dramatically the relationship of foreground to distant objects. Or we could back off significantly and use a telephoto lens to compress the perspective, that is, make it appear that background elements loom large against our foreground object. Using a so-called normal lens of 50mm focal length

achieves a compromise between these extremes, but because this is done so often, scenics and landscape photographs made with this lens tend to lack drama and to look pretty much alike. (Unless, of course, there's something else to add drama to the picture, like moody lighting or an unusual subject.)

Let's look in detail at some lens characteristics, in particular those lenses representing somewhat the extremes of focal length, starting with the short focal lengths.

USING WIDE- AND ULTRA-WIDE-ANGLE LENSES

As a group, wide-angle, and especially ultra-wide-angle lenses, may be the most misunderstood, most misused, and, too often, the most disappointing of lenses for beginning photographers.

Take scenics, for example. We're all awed by great panoramic vistas. Whether it's the Grand Canyon or the Grand Tetons, we want to capture that *grandness*. There's a tendency to think that, in order to capture the great scale and scope of it all, we need to use a wide- or an ultra-wide-angle lens.

It's inevitable that the results are disappointing. Instead of capturing the grandeur and greatness, these short focal lengths diminish everything in size. Rather than picturing towering mountains, the majestic peaks appear as little bumps way back there in the far distance. The picture is often further weakened because too much has been included. There's a confusing clutter of elements, with no strong center of interest. And if the picture was made at normal eye level, even foreground foliage and flowers may lack detail because they appear so far away.

After a number of such disappointments, many photographers tend to shy away from using wide- and ultra-wide lenses. But, instead of relegating that 20mm, 18mm, or 15mm lens to the camera bag, learn to use it for its two most

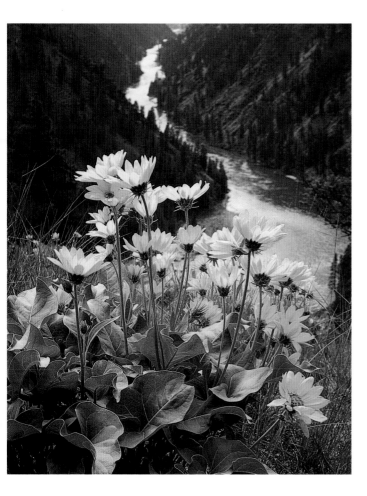

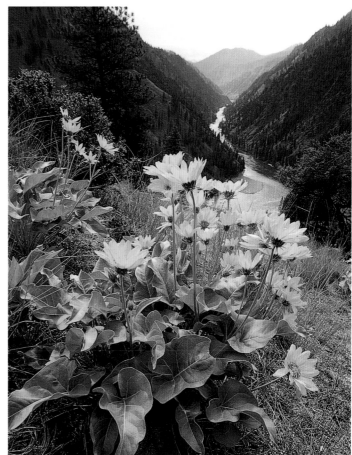

THIS IS ANOTHER EXAMPLE OF HOW PERSPECTIVE CAN CHANGE *the impact of a picture. In the first picture (above), I used a 50mm lens stopped down to f/22 for maximum depth of field. It shows these arnica in bloom and relates them to the locale, in this case Idaho's Salmon River. In the second picture (above right), I switched to a 20mm ultra-wide, and, to keep the flowers the same relative size in the picture, moved in closer. Here I could relate flowers, river, and river gorge, without losing the impact of the lovely flowers as a center of interest. The third picture (right), also taken with the 20mm, has less impact because, instead of moving in closer, I stayed at the same position I had been in for the first picture.*

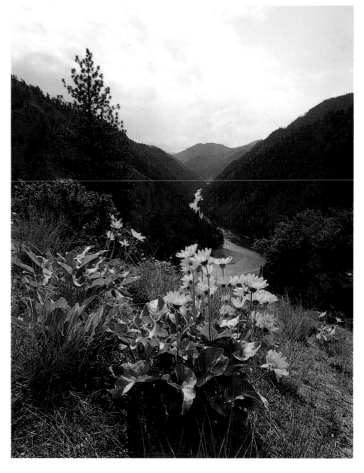

important characteristics: exaggerated perspective, and great depth of field.

Let's examine the first: exaggerated or increased sense of perspective. To utilize this characteristic best, you need to choose an angle that places a foreground subject close to the lens. Most often this is best done at a low angle, close to the ground. Used in this way, the foreground subject can be made to loom large in the picture, while the middle and background elements remain apparent and sharp in the picture. The overall effect is a heightened sense of distance between foreground and background.

The second characteristic, great depth of field, works hand-in-hand with the first to enhance the impact of pictures. A typical 20mm lens, when stopped down to f/22, has a depth of field ranging from about fourteen inches to infinity. And a 15mm lens, stopped down to the same f/22 aperture, has a depth of field from ten inches to infinity! Keep in mind that these figures are measured from the film plane. And since a 15mm lens may be four or five inches long, that depth of field figure means that something only five inches in front of the lens will be sharp, *along with everything else to infinity.*

By the way, let's dispel the common notion that ultra-wide-angle lenses *distort* things. They don't. This usually implies optical distortion, but, in fact, these modern rectilinear wide-angle lenses display very little optical distortion. What's thought of as distortion is really perspective exaggeration. It becomes especially apparent when you use an ultra-wide and tilt it upwards or downwards. Straight, parallel lines will appear to converge strongly. Actually, this can be used for dramatic effect in some pictures. For example, lying on your back in a grove of trees and pointing the camera upward with a wide- or ultra-wide-angle lens creates an interesting effect of strong, converging lines of tree trunks. If you try this, take note of the fact that it really isn't much of an exaggerated perspective. As

you lie there looking up, you'll see that these lines really do converge. But somehow, when seen with the eye, the effect seems to have less impact than when we view it in a photograph.

Another interesting characteristic of wide-angle lenses is the fact that you can hand-hold them at surprisingly slow shutter speeds. The wider the angle, the slower the shutter speed. You'd never dream of hand-holding a 50mm or a telephoto at a 1/4-second shutter speed. But with practice and a bit of bracing, you can hand-hold a 20mm at that speed. For example, in shooting interiors in dim light, I can use such slow shutter speeds by bracing the camera against a doorframe or wall. And lying down, with elbows braced on the ground, provides a stable position for such slow speeds.

I particularly like using ultra-wides—20mm and 15mm—for their dramatic possibilities. They really open up a whole new world of photographic seeing. Since many ultra-wides focus down to less than one foot, you can even use them for close-ups. Crawling around on a forest floor gives a whole new perspective. For example, you not only can get a close shot of a mushroom, you actually can see underneath it—giving something of a snake's eye view of the world.

Speaking of snakes, I once did an assignment on snakes for *Audubon* magazine, during which I used ultra-wide-angle lenses frequently. By using a 20mm or a 15mm at ground level, I could capture an unusual perspective of these fascinating creatures—a look at the snake and, at the same time, a glimpse of a snake's-eye view of the world.

I even used the 15mm to make closeups of North America's deadliest snake, the eastern diamondback rattlesnake. No, I did *not* have my eye behind the viewfinder for those close encounters (I may be crazy, but I'm not *dumb!*). Instead, the camera and motor drive were mounted on a small, lightweight tripod, the legs of which were collapsed to form

I LOVE USING ULTRA-WIDES TO ESTABlish visual relationships. In this case, I could relate these alpine flowers to their environment—an alpine lake above timberline in Wyoming's Snowy Range. Here I used a 15mm, stopped down to f/22, which gave me a depth of field ranging from nine inches to infinity. Camera, Nikon F3; lens, 15mm Nikkor; film, Fujichrome 50.

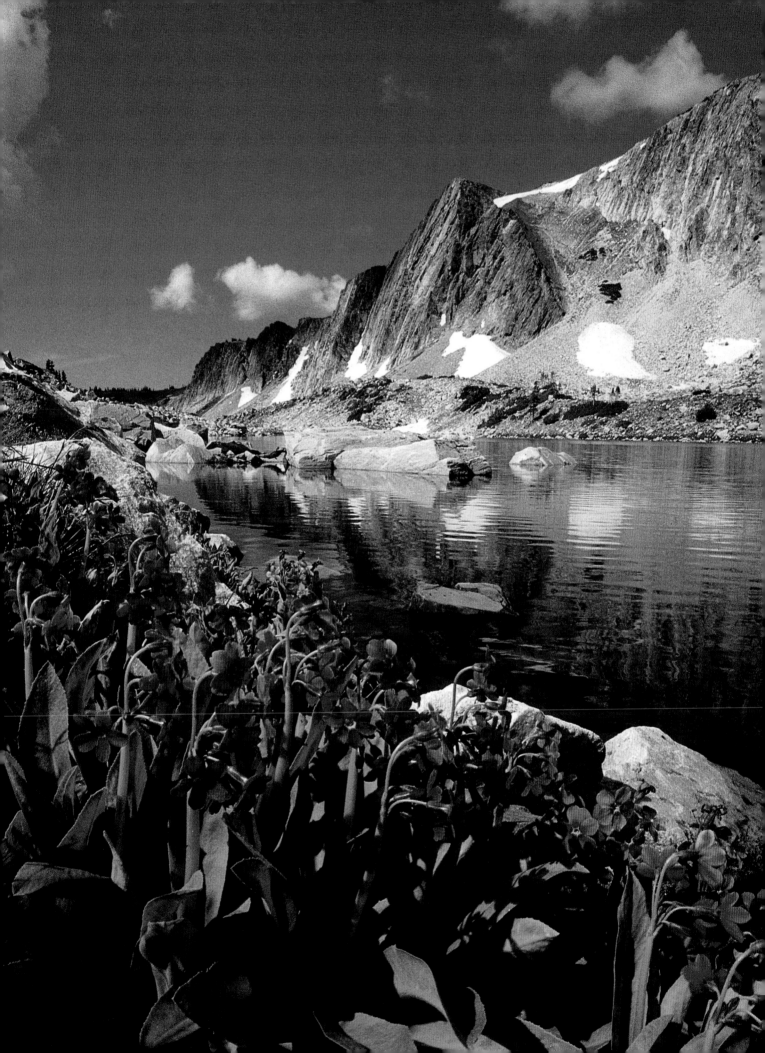

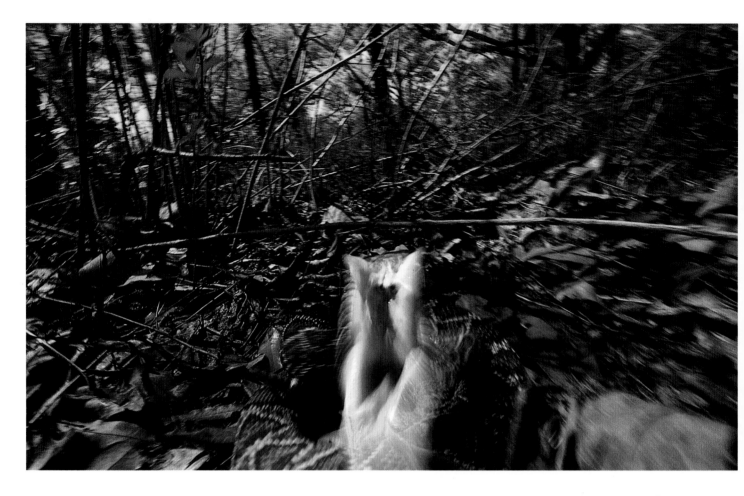

TALK ABOUT PUMPING ADRENALIN! WHILE ON ASSIGNMENT FOR Audubon *magazine I used a 15mm to photograph an eastern diamondback rattlesnake (deadliest of North America's venomous snakes) as it struck at my lens. I did not have my eye behind the viewfinder; I held the camera using a small tabletop tripod as a handle, tripping the shutter with a cable release. Ever try to wipe snake venom off your lens? It's not as easy as you think. Camera, Nikon FM-2; lens, 15mm Nikkor; film, Kodachrome 64.*

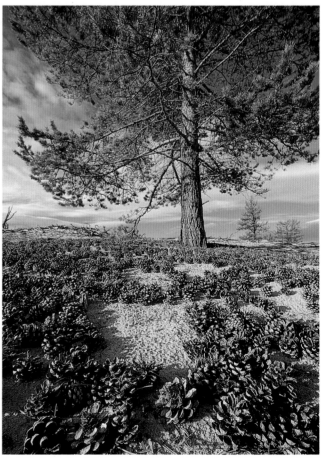

AT LAKE BAIKAL IN SIBERIA, WHILE EXPLORING OLKHON ISLAND *(reputed burial place of Gengis Khan), I found an area where sand dunes were encroaching on some forest. I used a 15mm, stopped down to f/22 for maximum depth of field, to show the pine cones, sand, and tree in stark relation to each other. Camera, Nikon 8008s; lens 15mm Nikkor; film, Fujichrome Velvia.*

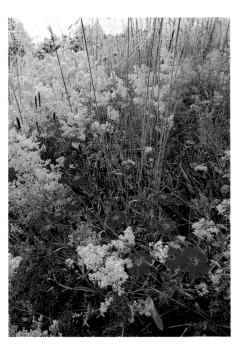

USE AN ULTRA-WIDE FOR CLOSEUPS? *Sure, why not. Most ultra-wide-angle lenses focus fairly closely—under one foot or less. I wanted to capture the tangled riot of color of these wildflowers and grasses growing in Zabaikalsky National Park on the shore of Lake Baikal in Siberia. So I used a 20mm at a low angle, stopping down to f/22 for sufficient depth of field. Camera, Nikon 8008s; lens, 20mm Nikkor; film, Fujichrome Velvia.*

a convenient handle. By presetting focus and using a small aperture for great depth of field (to compensate for any slight focusing errors), I could edge the lens toward the snake and trip the shutter with a cable release. Of course, I don't recommend this procedure unless you're experienced at dealing with poisonous snakes.

USING TELEPHOTO LENSES

I think all photographers are awed the first time they use a long telephoto lens or zoom out a tele-zoom, like a 100–300mm, to its longest focal length. It's like an embodiment of the famous AT&T commercial—"reach out and touch someone." You can optically reach out and touch not only some*one*, but some*things* as well.

But let's get back to perspective for a moment. Moving in close to a subject is *not* the same thing as using a telephoto lens, even though the subject is kept the same size in the picture. Telephotos create a strong sense of compressed perspective, that is, the separation of elements in a picture is diminished with telephotos; the longer the focal length, the more dramatic the effect.

Though people normally think of telephotos as useful for wildlife photography, they can be used for much more than that. In fact, medium telephotos are most useful for landscape and scenic photography. Mountain scenes are rendered more dramatically with a longer focal length than with a normal or wide-angle. But be aware that atmospheric conditions may present problems. When shooting over a long distance using a telephoto, haze and dust diminish contrast and sharpness. And on a hot summer's day, shimmering heat waves will cause unsharp images.

Telephotos need to be used with care, particularly when it comes to hand-holding. Every little movement becomes magnified when using teles; the longer the lens, the greater the effect. So, faster shutter speeds are called for in order to mini-

mize image blur from such movement.

As a rule of thumb, choose the reciprocal of the lens focal length for the *slowest* shutter speed at which to hand-hold a particular lens. For example, for a 200mm focal length, use 1/250 of second; for a 500mm, 1/500 of a second. *However,* you still need to brace the camera and lens carefully. If there's not a handy tree to brace against, I sometimes hunker down, Bushman style, with elbows braced on knees. Or, if standing, I hold my arms close to my body, with elbows pressed against ribs, to hold the camera as steady as possible. In fact, I do this for most shooting, regardless of focal length, when not using a tripod.

Even with these steadying methods, there comes a time—or focal length—when you really should use a tripod. I rarely try to hand-hold a telephoto lens longer than 200mm. It's just too risky in terms of image quality. The only exception is on our photo-safaris in Africa when we can use a beanbag on an open roof hatch. This provides an exceptionally stable platform for even the longest telephoto lenses.

Experimentation is a vital aid in learning to use lenses creatively, particularly those that are outside the familiar, medium focal length ranges. Try giving yourself a self-assignment: Shoot a whole roll of film using the widest-angle lens you own—the wider the better. Then examine carefully the photographs made. Disappointing? Ask yourself why. Was it because you were too timid with the scene or subject? Too far away from a primary subject?

Repeat the assignment with long telephoto lenses. Try using these extreme focal lengths in non-traditional ways—for closeups, for example. I mentioned, already, using ultra-wide-angle lenses for closeup work. Telephotos, too, can be used for such purposes. Because the minimum focusing distance on most teles doesn't allow very close focusing, you often need to use an extension tube (dis-

cussed in the chapter on closeups) in order to move in close. Just remember that it takes longer extension tubes for reasonable focusing distances with telephotos than with medium focal lengths. This can open up a whole new world of creative possibilities by using the relatively shallow depth of field and compressed perspective of telephoto lenses. More about this closeup technique in the chapter on closeups.

CREATIVE USE OF DEPTH OF FIELD

When I'm preparing to take a photograph, one of the most important questions I ask myself is, What f-stop should I choose—and why? It's an important consideration because I must know what depth of field I want. I can't overemphasize the importance of this. It's one of the vital creative judgments to be made in creating a good photograph.

Depth of field is defined as that zone of acceptable sharpness that extends on either side of (that is, in front or in back of) the point of focus. Depth of field (DOF) is a function of lens aperture, lens focal length, and point of focus: For any given lens, DOF is increased by stopping down to smaller apertures; a longer focal length lens has inherently narrower depth of field than a shorter focal length lens has; and the depth of field shrinks when the point of focus is very close to the lens.

There are two ways to ascertain depth of field: using a depth of field scale on the lens; or using a depth of field preview button on the camera. Unfortunately, nowadays some camera manufacturers are leaving off depth of field scales from lenses, particularly on zoom and autofocus lenses. And some cameras no longer have depth of field preview buttons. The latter is especially important, and if you are at all serious about photography, you would be well advised to *not* buy any camera without this feature.

At first glance, it would seem that maximum depth of field would be desirable for every picture. Wrong! For creative effect, it is often important to limit the depth of field. This can prevent background—or foreground—elements from distracting from the center of interest in a picture. Remember, we are compressing the real world of three dimensions onto two dimensions on film. And depth of field control is one of the ways of dealing with that third dimension. There may be times when we want great sharpness from foreground to background. But there may be an equal number of times when the foreground and/or background should remain out of focus and unobtrusive.

It's also important to know that a depth of field zone is *not* like a no-parking zone that has clearly defined boundaries. When we say that the depth of field zone is one where things are acceptably sharp, you should realize that objects just outside the boundaries of that zone are not *totally* unsharp, that is, so unsharp as to be unobtrusive. So you can have problems, pictorially, when objects in the foreground and outside the DOF zone are readily apparent, unsharp, and very distracting. *Keep in mind that in most compositions, objects in the foreground that are readily apparent and unsharp are very distracting.* They demand to be sharp. You should know before the picture is taken whether or not they are in or out of the depth of field zone.

Depth of field scales are most useful on lenses of moderate- to wide-angle focal lengths. On telephoto lenses, particularly long focal lengths, it becomes increasingly difficult to interpolate distances on the scales. Thus, using the depth of field preview button is important for these lenses.

Using the depth of field preview button takes some getting used to. When it's used, the lens stops down to the chosen aperture—which means that the viewfinder can get very dark. I find it helpful to shield the viewfinder and my eye with my hand to cut down on stray light, allowing me to see better the dim image.

Also, leave your eye at the view-finder long enough for it to adjust to the dimness.

One of the reasons that I might choose to use a telephoto lens for a certain subject is to limit the depth of field for spatial isolation of the subject from its foreground and background. The effect can be very dramatic, depending on the focal length of the lens and the aperture chosen. In the illustrations here, the juniper tree was photographed with a 180mm medium telephoto, first at an aperture of f/5.6, then at f/2.8. In the photograph made at the larger aperture, the background is less busy in the picture and the tree stands out more boldly against that background, almost with a 3-D effect.

EXPLORE THE USE OF LENSES

The best way I know of to become completely familiar with all focal lengths of lenses is to give yourself some self-assignments. Explore the perspective-compressing potential of telephotos for scenic shots. And familiarize yourself with the perspective expanding capabilities of wide- and ultra-wide-angle lenses.

Devote one or more rolls of film to the exclusive use of a particular lens and explore its potential. Make portraits of family members using the longest telephoto and the widest-angle lens you own. Shoot closeups with telephotos and wide-angles. And keep some notes during these self-assignments so that you can check on such things as depth of field control at various apertures.

The basic idea is to feel comfortable using any lens, no matter what focal length, and have a good sense for what that lens can do for you creatively in any shooting situation. To me, it's very exciting and creatively challenging to explore any photographic subject with different lenses.

CREATIVE CONTROL OF DEPTH OF FIELD (DOF). IN THE FIRST shot (above left), I chose an aperture of f/5.6 on my 180mm lens. The juniper tree in Canyonlands National Park blends in too well with the background because there's just enough depth of field to make those distant sandstone cliffs too sharp and too distracting to the main subject. For the second shot (above right), I opened my lens to maximum aperture, f/2.8. Notice how the tree now stands out boldly against the soft background—almost a three-dimensional effect. If you're uncertain about the DOF and its effect on your picture, use the depth of field stop down button on the camera. Camera, Nikon FM-2; lens, 180mm Nikkor; film, Kodachrome 64.

TELEPHOTOS FOR LANDSCAPE SHOTS? IF IT WORKS, WHY NOT? I like to think of telephotos as a means to reach out and touch something, a way of isolating a subject, in this case a gnarled dead tree in sand dunes along the shore of Siberia's Lake Baikal. Camera, Leica R5; lens, Leica 70mm–210mm at 210mm; film, Fujichrome Velvia.

COMPOSITION

AVOID VISUAL CHAOS! OKAY, IT'S A *beautiful place, but this first picture doesn't do justice to it. Your role, as a photographer, is to bring order to chaos. How? ISOLATE. In the first picture, made with a 35–135mm zoom at 35mm, there's no strong center of interest; lots of conflicting elements compete for your attention. But there are numerous possibilities in this lovely glen in Tennessee's Great Smoky Mountains. Move in closer, physically or optically. In the second picture I used a 180mm telephoto to isolate on a portion of the stream in the background, creating a tight composition that conveys the beauty of the stream and the greenery of mosses and forest. A 1/2-second shutter speed created the blurred movement of the water. The camera was, of course, on a tripod. Camera, Nikon FM-2; lenses, 35–135mm zoom Nikkor and 180mm Nikkor; film (first picture) Kodachrome 64 and (second) Fujichrome 50.*

In addition to photo workshops, college lectures, and one-day photography seminars, I'm sometimes asked to give programs to local camera clubs. One such experience, several years ago, stands out in my mind. The evening began with usual club business—treasurer's report, club outing announcements, and so on. Then came the monthly slide contest, judged by the more "expert" photographers of the club. Among the pictures, there was the usual mix of clichés: not very exciting sunsets, old wagon wheels with flowers poking through wooden spokes, landscapes with old barns that lacked freshness, flower closeups taken in the worst possible lighting. But there were a few very imaginative pictures as well.

What interested me most, however, were the judges' critiques. The dull clichés drew praise. The more creative work was scorned. (A rather nice shot of a bird in flight, taken with a slow shutter speed to create an impressionistic blur, was criticized for not being sharp!) Pictures were pronounced good if they fit some kind of formula, and bad if they fell outside the parameters of the magic formula. The capper, however, was the critique of a lovely shot of a mountain goat. It was a clean and simple portrait, full body, with the animal standing on a rocky boulder and a background of pure blue sky. Moreover, there was a soft quality of light, with the goat bathed in warm, early

morning sunshine. There were enough elements in the picture to convey a sense of place—high alpine tundra—but it was framed tight enough to create a strong portrait of a lovely animal in nice lighting. I liked it. The judges didn't think it was so good. Why, I asked. Because, they said, the body should be in three-quarter view and the head is turned the wrong way! But why, I persisted. Well, everyone knows that a three-quarter view with head-turned-to-the-side is the preferred composition for wildlife shots. And, oh yes, there aren't any catchlights in the eyes.

I was astonished, although I had run into this attitude before. Among too many photographers, there seems to be the idea that certain "rules" of composition are chiseled into stone tablets and woe be unto those who break the rules. This kind of thinking stifles creativity.

AVOID THE PITFALLS OF "RULES"

The subject of photographic composition is one of the toughest to teach because, too often, there is that tendency to rely on certain so-called "rules." I remember years ago coming across a book on photography and in the chapter on landscape photography there was a statement that said, in effect, that all scenic shots should be framed with foliage or branches. The reason, it was explained,

was that such framing around the edge of the picture kept the eye from wandering off the picture. I remember thinking at the time about the absurdity of this statement. If the picture content is dull or boring, no amount of foliage will keep *my* eye from wandering off the page.

There are other such examples. The insistence, for example, that a primary subject or center of interest should always reside one-third in and one-third up from the edge of the frame. Or that such subjects should *never* be placed in the exact center of the picture or that horizon lines should *never* divide a picture equally in half. Sometimes these "rules" work, but more often than not there's a tendency to blindly follow such precepts. And doing so stifles experimentation that can lead to the creation of truly unique and exciting photographs.

Great photographs are created, not by following some recipe, but by a careful process of thinking and planning.

EYES AND CAMERAS SEE DIFFERENTLY

Earlier, I discussed the fact that our world is visually chaotic and that we, as photographers, must select and arrange elements in our viewfinders that capture the visual excitement of a scene or subject, while at the same time excluding elements that contribute to visual clutter.

It's not easy. The camera and the eye do not necessarily register images in the same way.

When we look at a scene, our eyes continually scan, flitting from nearby objects to distant elements, and back again. Moreover, although the eye has a lens not unlike that of a camera, when we look at some particular object in a complex scene, we have a psychological "cone of concentration." This cone is like a selective focus, allowing us to concentrate on a single element of a scene, while our peripheral vision still gives a complete view of the scene. The mind then pro-

cesses this selective image, along with the peripheral information, and we effectively filter out, mentally, some of that chaos.

The camera, on the other hand, does not process information. It only records it. And sometimes with brutal frankness, with all the visual clutter we can pack into a picture. Thus, any viewer of our picture finds it difficult to sort out the visual clutter and appreciate the beauty of the scene or subject as we experienced it.

The point here is, we must keep the picture from becoming too complex. To do that, we must force the camera to be selective about what it records. And this is done by a conscious and deliberate process involving some discrete steps.

See. This isn't necessarily as easy as it sounds. There's more to seeing than looking. Begin concentrating on the things before you. See how light strikes objects. See color. See quality and direction of light. See contrast ranges. See texture. See patterns. See lines. See forms and shapes. See details such as leaves or rocks or patterns in grass or the clarity of water in a mountain stream. It becomes especially important to look for—and see—the things that give a special quality and distinctiveness to a place. The strength of a photograph is directly related to how well—and how carefully—you see things around you.

Feel. This one is tougher to define. It has to do with the emotion generated by a place or subject. As I wrote in chapter one, sometimes you just need to sit, put the camera away, and *absorb* the land and life around you. Listen to the wind and the birds. Smell the flowers and the pines. Feel the rough texture of the granite you sit on. If the subject is an animal, watch its movements and behavior. If a person, listen to the words, understand the feelings, and watch, also, movements and interactions with surroundings or other people.

Use this input from your eyes, ears, fingers, and nose to guide your emotions

SHOULD THE FORMAT BE VERTICAL OR HORIZONTAL? WHICH YOU
*choose depends on your subject and your intent in the picture. Trees shot as
horizontals are most often effective as repeating-pattern shots, that is, a
strong pattern of vertical lines spread across the picture horizontally. Com-
posed as a vertical, the format helps to isolate on just a few elements and to
emphasize the tallness of the subjects. The locale was South Water Cay on
Belize's Barrier Reef. Camera, Leica R5; lens, Leica 70–210mm; film,
Fujichrome Velvia.*

LINES. RECEDING LINES GIVE A SENSE OF *depth to a picture, as illustrated here with these lines of ripples in sand dunes on the island of Lamu off Kenya's Indian Ocean coast. To give even more emphasis to these lines, I shot at a low angle with a 21mm ultra-wide-angle lens. Late afternoon sunset gave strong sidelighting, emphasizing the ripple. Camera, Leica R5; lens, Leica 21mm; film, Fujichrome 50.*

in capturing the essence of the place or subject on film. True, you can't photograph the smell of flowers, the sound of birds, or the feelings of a person, but emotions generated by this sensory input can subtly guide you in finding important attributes of the scene or subject.

Think. Maybe this is the most important step in the process. Strong composition begins in the mind, not the camera. Before you begin blazing away with the camera, think about how to utilize that sensory input and couple it with the realities (and limitations) of the camera, the lens, the film, the lighting, the physical dimensions, the mood. Is the lighting the best? Is it too contrasty and beyond the range of the film? Would soft, overcast light work better? Or a different time of day? What about angle of view? High angle? Low angle? Lens choice: use a wide- or ultra-wide-angle with great depth of field and expanded perspective? Or maybe a telephoto to compress perspective and reduce depth of field? And shutter speed. Is it adequately fast to allow hand-holding, or is it necessary to use a tripod? Or what about a slow shutter speed for deliberate blur?

Isolate. Now we get down to the nitty-gritty of composition. Get rid of those extraneous, chaotic elements in the picture. Simplify. If necessary, move in closer to the subject (unless it's a grizzly bear or a rhino). Or use a telephoto lens to optically isolate things. In scenics it's not necessary to include every tree, rock, flower, and mountain in the picture. Isolate on only those elements that convey a strong sense of the place. Emphasize the strong lines or shapes or patterns or textures or colors of things—but not all of them at the same time!

Be bold and decisive! Think you need to frame the scene with foliage or branches? Ask yourself why. What does it contribute, other than visual garbage, to the picture? Keep it clean and uncluttered.

Examine your subject through the viewfinder very carefully before you take the picture. Is what you see in there the best you can do to isolate the elements of a picture. Or can you make it stronger by isolating even more? Would that viewfinder image make a good magazine cover? Would you hang that picture on your wall? If not, why not?

Organize. Having isolated carefully, you now need to organize or arrange those elements in the strongest possible way. Traditionally, this part of the process is what we've normally thought of as "composition." Where should you place the center of interest or subject in the frame? In the center? If so, why? It may be too boring or static an arrangement. On the other hand, it may also convey a sense of peacefulness about a place or scene. Or put the subject near the edge of the frame? Or one-third in and one-third up (or down) from the edges of the frame. Again, why?

And what about the horizon line? Should it divide the picture evenly in half? Or would the picture be more dramatic and dynamic if the horizon line is higher or lower in the frame?

And finally, what about the picture orientation itself? In most film formats, you have a choice of creating a vertical or a horizontal picture. Which is best for the subject? Vertical orientation tends to emphasize vertical lines or the tallness or height of things. Horizontal orientation can give emphasis to sweeping panoramas or the movement of subjects. But again, be careful. These are not chiseled in stone. In fact, this leads to another step in the process:

Experiment. Look for new ways to portray familiar subjects. Don't always photograph the same kinds of scenes or subjects in the same ways. Try different lenses or compositions or angles of view. Experiment with different orientation of scenes. Do you shoot landscapes mostly as horizontals? Try some as verticals, paying special attention to the impact created by that orientation. And what about action shots? More often than not we shoot ac-

tion as horizontals—partly because that's the quickest and easiest way to hold a camera, and partly because we need to give room for the action in the picture if it's moving past us parallel to the film plane.

THE ELEMENTS OF COMPOSITION

The elements that go into each picture are basically the same: shapes, forms, lines, texture, and color, plus the composite element of patterns. These are the components of design, and we seek harmonious use of them in our pictures. There's also the element of subjective response that has to do with emotional reaction to a scene or subject, and less with reaction to any of the other elements. For example, a photograph of an event or of a person or even an animal may have discordant elements in the picture, creating a "bad" composition, yet we react to the picture emotionally, based on feelings of empathy, fear, abhorrence, humor, or remembrance. Many news photos fall into this category, capturing some element of drama in life. While we may strive for impact using the strength of simple design, many striking photographs—certain landscapes, for example—are complex, even bordering on discordancy, yet they appeal to us by reason of emotional response. So maybe we should add another element, mood.

Let's analyze each of these elements individually.

Shapes. As a part of growing from infancy to adulthood we acquire a visual database of things in our world, allowing us to instantly recognize things by shape alone—trees, cars, airplanes, a violin, a hammer, a camera . . . ad infinitum. As photographers and artists, we deal with shapes in our photographs. Shapes are two-dimensional, the outlines of familiar things. How do we use shapes in our photographs? Sometimes we can use recognizable shapes to establish a sense of place—the distinctive skyline of New York, for example, or the Grand Tetons. More often than not we need to ask how we *misuse* shapes. For example, if we photograph the silhouette of a familiar object—an airplane or a bird—and don't pay attention to the orientation, the resultant shape may end up a meaningless blob.

We can use shapes as strong visual design elements, emphasizing the familiar aspect of a particular object's shape. Also, we can create unusual renditions by playing on the visual similarity of the shapes of two widely different subjects, as in the case of my shot of a curved sandstone cliff resembling the sensuous curves of a female body (page 9).

Forms. Shapes become forms when we use light to sculpt them into three-dimensional objects. While the image of a form on film remains two-dimensional, we create the illusion of three dimensions with careful use of lighting. It's often easy to overlook the importance of portraying forms when we're busy arranging a composition in the viewfinder. Later, in viewing our effort, the picture appears flat and lifeless—and puzzling. What had been a dramatic *form* is merely a meaningless shape because we didn't pay enough attention to the lighting.

Often, when photographing a particular object, we need to decide whether it is the form or the shape that is a key design element in our picture (leaving aside, for the moment, other elements such as texture and color). A flower, for example, may be photographed at such an angle as to emphasize the beauty of its shape, either as a silhouette or a translucent backlit object, or at another angle that emphasizes its three-dimensional form.

Lines. When I scrutinize through my viewfinder, perhaps more than anything else I look closely at lines and how they interact, because lines can have a strong impact on pictorial composition and on the feeling you wish to create in a picture.

SHAPE AND FORM. EVEN IN SILHOUETTE WE RECOGNIZE CERTAIN *things, such as this big cat—a leopard resting on a rock in Samburu National Reserve in Kenya. It has shape, but no form. Regardless, the picture has drama because of its simplicity—no distracting elements, just a recognizable shape and the color of a burning sun. By using varying kinds of light we give form to things; they begin to appear to us as three-dimensional objects even in the two-dimensional format of film. In soft lighting, subtle shading and highlighting give form to this same leopard, now in a tree. Camera, Leica R5; lens, 560mm Leica; film, Kodachrome 64 (above) and 200 (right).*

Bold vertical lines, for instance, convey a sense of tallness or height. They can also connote a sense of stability and perhaps strength, as might be associated with the lines of a building.

Horizontal lines also convey stability as well as a sense of breadth or expansiveness. And horizontal lines can, in subtle ways, reinforce a feeling of peacefulness—probably because we associate horizontal lines with horizon lines and good, solid earth.

Diagonal lines represent instability, movement, something dynamic. The more oblique we make diagonals in a picture, that is, the farther from vertical or horizontal, the stronger the sense of movement or instability.

Curved lines can connote something sensuous, or peaceful, or graceful. Smooth, gentle curves have more of a feeling of sensuality and gracefulness, while tight curves and re-curves become a bit sinister, as in the coiled body of a snake.

Finally, zigzag or jagged lines have a feeling of busyness, tension, sometimes chaos. The same is true of crisscrossing lines, especially lots of them in a random pattern—there's a feeling of something chaotic. That's fine, if it's your intent to create a chaotic feeling in your picture for effect. But sometimes that feeling creeps in by accident because we haven't paid enough attention to the lines in our picture.

In using lines as design elements, we need to think about the orientation of our picture format as well. Using vertical orientation helps emphasize vertical lines, giving a strong sense of the tallness and stateliness of trees, for example. But shooting a horizontal picture of strong vertical lines de-emphasizes those feelings. The tall trees appear stunted, less impressive.

The subtle effect of lines is something we need to be constantly aware of. For example, in trying to capture the feeling of action and movement, diagonal lines can play a strong role, as illustrated by my shots of racing yachts made on assignment at the Rolex Regatta one year in the Virgin Islands. (Frankly, as a spectator sport, yacht racing is pretty boring—about as exciting as watching grass grow, someone once said.) The challenge here was to convey *action*. But most often when the boats were under sail, even moving at a pretty good clip, the pictures had lots of horizontal lines—hulls, booms, and horizon—and lots of verticals—masts and lines—but almost no diagonal lines that could convey a sense of movement. So I stationed myself at one of the marker buoys on the course where the boats had to make sharp turns and heel over strongly as they came around. Notice that in the picture where the mast, sail, and deck, and even the people, are all in strong diagonal positions, there's a much greater sense of action than in the other picture where everything is vertical or horizontal or nearly so.

Texture. Texture relates to us the *feeling* of a surface. We can tell texture by touching, but to convey it photographically requires special attention. The test of how successful you are in capturing texture in a photograph is when a viewer *feels* mentally what that surface is like, without benefit of actually touching it.

Lighting plays a key role in conveying textural qualities. Sidelighting, in particular, helps to impart a sense of texture by bringing out surface relief and contrast.

Thus, if the primary element of your composition is the textural quality of something, you should pay very careful attention to the lighting and use light to heighten the texture.

Color. We react to color in very emotional ways. Even our vocabulary sometimes reflects ways that certain colors affect us—"seeing red" as an indication of anger, having "the blues" to denote sadness. Often the impact of color is very subtle, but it can have strong impact on the success of a particular picture. Let's

SHAPE AND FORM. THE FLAT LIGHTING *on these alkili hills in Death Valley makes for a lifeless picture; we can see that the hills have shape, but the three-dimensional form is not apparent. Waiting for a different angle of the sun, we can use that lighting to sculpt form into those hills by creating a feeling of three dimensions with light and shadow. Camera, Nikon F3; lenses, 105mm and 180mm Nikkor); film, Kodachrome 64.*

OPPOSITE: YOU DON'T THINK THAT LINES *can be that important? Which of these two pictures conveys a stronger feeling of action and movement? The first is a static picture. Even though the boat is moving there's nothing here to emphasize action: The lines of the sails and booms are straight vertical or horizontal. Also, the picture feels somewhat chaotic—too many conflicting lines. But the second picture conveys a sense of action. Why? Strong diagonal lines. I waited until the boat heeled over as it came around, and the diagonal line of the sail plus other, more subtle diagonals in the picture create a visually dynamic situation. Shot during an assignment several years ago at the Rolex Regatta in Saint Thomas, U.S. Virgin Islands. Camera, Nikon FM-2; lens, 105mm Nikkor; film, Kodachrome 64.*

TEXTURE IS ANOTHER OF THOSE COM-*positional elements we need to seek and use. Here, strong sidelighting brought out the texture of the bark of a ponderosa pine in Idaho's Salmon River country. Camera, Nikon F3; lens, 55mm Micro-Nikkor; film, Kodachrome 64.*

look at the spectrum of light and color and see what psychological implications there may be in photographic compositions.

Blue is always associated with coolness or coldness. And, as mentioned above, there's a psychological hint of sadness. To me, blue also seems a quiet color—perhaps because, in those predawn moments before a sunrise, things are tinged with blue and usually very, very still. Blue whispers. Blue is tranquil. Distant objects often appear blue, and thus blue is often referred to as a receding color.

There are times when I use a subtle blue filter to enhance the sense or feeling of coolness, quietness, tranquility. A CC05B or CC10B is just right for subtle effect (see the chapter on film and filters for discussion of CC filters).

Green is very close to blue in its feeling. There's still a strong sense of coolness—as in the cool green of evergreens. But green can range in hue from bluish to yellow-green, which becomes less somber, more active psychologically. Also, we strongly associate green with natural things, earthy things, giving a subtle sense of stability and also tranquility.

Yellow and orange move us into the realm of warmer colors. We associate these colors with sunlight (remember those crayon drawings you made in grade school, the sun always a big yellow blob?). So the main impact is a feeling of warmth, perhaps joy and action.

Red shouts. If blue is quiet, red screams. If there's a red object in your composition, and it's *not* intended to be your center of interest, you've screwed up because it will draw attention from any other subject that's not red in color. Red is hot. Red is excitement. Red is tricky.

There are no neat formulas to guide you in using color in your photographs. A lot of what we do in arranging compositions with strong colors is guided by our own instincts and reactions. Just be aware that wild mixtures of intense colors have

a chaotic, kaleidoscopic effect that can be counterproductive if, say, you were hoping to create a feeling of tranquility in the shot.

Patterns. With both natural and human-made objects, patterns can be strong compositional elements. These can range from ripple patterns in wind-blown sand dunes to straight, repeating patterns of a fence or buildings in a city. The key element is the visual rhythm created by such designs and the appeal or sense of order created by the patterns. The major compositional consideration here is how much of a pattern to include in the picture. Include too little and you lose that sense of visual harmony. But if you include too much, you dilute the impact of the strong graphic design. Use your own instinct and, if in doubt, experiment with different compositions utilizing patterns.

Mood. This is one of those intangibles that are hard to define in precise ways. You know it when you've got it, but the process of seeking out a particular mood for a picture takes some careful thought and planning. Some of it has to do with lighting. High-key lighting, in which things are bright and light in color, creates a mood of lightheartedness, an upbeat feeling. Low-key lighting, in which things are dark and colors muted, creates something somber, forbidding.

In the outdoor world we can take advantage of weather and time of day to create certain moods. And these can be enhanced by controlling our exposures. For example, dark storm clouds gathering over a landscape have a ominous sense of foreboding. That can be enhanced further by underexposing slightly to create a darker scene. But that ominous feeling is lost, or at least diminished, if you overexpose the scene.

CRITIQUE YOUR WORK

Think, for a moment, about photographs that have really excited you, really caught your attention and made you say, "Wow! I wish I had made that pic-

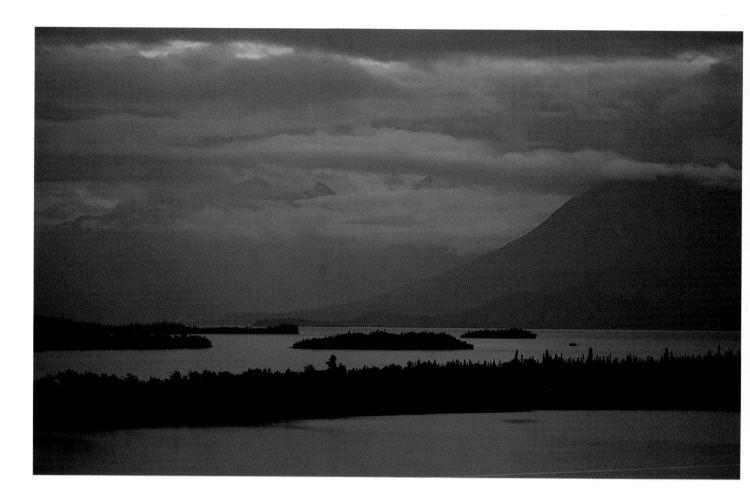

As we move into the warmer end of the spectrum, things get a little livelier. Yellow is one of the warm colors, and even on an overcast day, a yellow subject radiates warmth. Against one of the cooler colors, yellow stands out. These yellow mushrooms grow in an almost rain forest–like setting in the Bikin River Valley of far eastern Siberia. Camera, Leica R6; lens, Leica 21mm; film, Fujichrome Velvia.

COLOR. BLUE IS COLD, FRIGID. BUT I *also think of blue as being quiet, subdued. Blue whispers. If I want to emphasize either of those qualities, I sometimes use a blue filter, as in this case at Lake Clark National Park in Alaska. I used a CC30B filter to enhance the blueness of this scene at dusk, making it cool and quiet. Camera, Nikon F3; lens, 180mm Nikkor; film, Kodachrome 64.*

GREEN, TOO, IS QUIET AND COOL, *though depending on the hue, green begins to be a little more lively than blue. But this shot of alder leaves at Kachemak Bay, Alaska, still has a feeling of coolness and silence. Camera, Nikon FM-2; lens, 105mm Nikkor; film, Kodachrome 64.*

ture." Chances are, those photos probably were clean, simple, direct, and emphasized only a few of the elements just discussed. The more elements we add to a picture, the more visual confusion is created. Simplicity and elegance is the goal.

ZERO IN! Make some element the central subject or center of interest—a line or a form or a color or a pattern. Don't dilute the impact by including too much.

Once again, use self-assignments to sharpen your compositional skills. Deal with a single color in a whole roll of film. Or devote one or more rolls to other compositional elements—patterns or textures, for example.

One of the major problems we all have is in self-critiquing our pictures. In my photography workshops, the critiquing sessions are the most valuable part of the whole workshop. But this is done as a group process, with lots of individual insights. Besides, it's always easier to critique someone else's work.

When it comes to our own pictures, there is often too much emotional energy tied up in creating those photos. It's not easy to be objective about your own work.

So, what to do? One thing that works for me is to let my pictures age a little (easy enough, because I'm often traveling to the far corners of the world on various projects and by the time I return, previous pictures have aged pretty well). Move on to some other picture-taking efforts and come back to earlier photos in a few months' time when emotional involvement with those pictures has diminished. Then play the role of picture editor: Would this one make a good magazine cover? Or a lead photo for a story?

Here's something that helps—sometimes—in judging your own work: Reverse the picture. Put the slide in the projector or on the light table so that it's reversed from left to right. We often remember a place or a particular shot as having a certain orientation and it re-

mains familiar to us in just that way in our memory. By reversing the picture, the familiar becomes a little unfamiliar. Now judge the composition—the arrangement of elements, the mood, etc.

Sometimes we come across those pictures that are vaguely disturbing. They just don't quite make it. And it's hard to put your finger on just why. Most often, I find that in those situations the picture is weakened by cramming too much into it. The composition could have been strengthened by eliminating some elements. TIGHTEN IT UP. If you project your slides, use a couple of pieces of cardboard held in front of the projector beam to crop pictures. If you use a light box, a couple of three-by-five file cards work well as croppers. For some of those problem pictures, try cropping to eliminate certain elements. Very often you'll discover a sensational picture within a mediocre one. Next time do the cropping in the camera!

Practice! You'll never improve the quality of pictures if the camera sits on a shelf for months gathering dust. You can learn as much from your mistakes as your successes—if you spend the time to analyze your pictures once they've been processed.

Finally, study the work of others. In the early 1960s Dave Brower, then executive director of the Sierra Club, launched an exciting new book publishing program featuring the work of Ansel Adams, Eliot Porter, Phil Hyde, and others. I learned a great deal about photography and composition from these Exhibit Format books. (A few of them are still in print.) I spent hours going through each one, savoring pictures and analyzing them—the kind of lighting, the compositional elements. You can do the same. Anytime you see a picture that really grabs you, take a moment to analyze it. What makes it such an exciting image? When you are able to answer that question effectively, you can begin to apply that knowledge to your own work.

HOT STUFF, RED. HANDLE IT CAREFULLY. RED WORKS WELL AS *visual counterpoint, drawing attention to something in an otherwise subtle picture: a red star on a doorway in the village of Listvyanka near Lake Baikal in Siberia. Or you can use it to overwhelm, as in my shot of a DeHavilland Otter bush plane in Alaska. Siberia: Camera, Nikon FM-2; lens, 105mm Nikkor; film, Kodachrome 64; Alaska: Camera, Leica R5; lens, 70–210mm Leica; film, Kodachrome 64.*

PATTERNS. IN USING PATTERNS IN COMPOSITIONS, THE KEY IS TO *create a strong visual rhythm. But you need to be careful: If you make the arrangement too tight, you may lose that rhythm; include too much, and you lose it again because the repeated pattern is diluted. Use your gut instinct and even then, experiment with different arrangements. This is a common plant called beachweed that grows along the coastline of Alaska. Camera, Leica R5; lens, 100mm Leica macro; film, Kodachrome 64.*

VERTICAL VERSUS HORIZONTAL. OFTEN WHEN I COMPOSE A *scenic photograph as a vertical, I think of it as a window—I restrict left-to-right observation and force the viewer to look into the picture from foreground to background. Placing the horizon line high in the compositional arrangement forces such a visual confrontation with the foreground. If you do that, make certain that there's something visually exciting there. This shot in Tanzania's Serengeti National Park illustrates the point: low angle, high horizon line. Camera, Leica R4sp; lens, Leica 21mm; film, Kodachrome 64.*

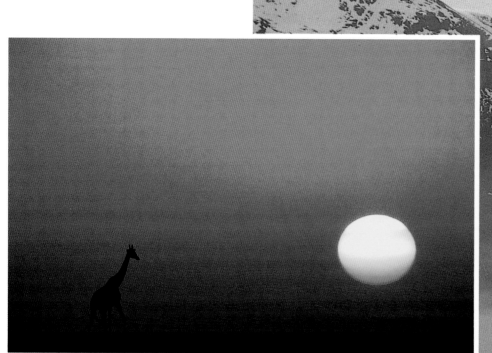

PLACE THE HORIZON LINE VERY LOW IN *the picture to create a feeling of open spaces. Kenya's Masai Mara Game Reserve is part of the vast Serengeti Plains that extend into Tanzania. It seems to go on forever—free, open, wild, vast, spacious. So I put the horizon line low in this picture to capture that feeling as the giraffe wandered off into the sunset. Camera, Leica R5; lens, Leica 560mm; film, Kodachrome 64.*

MOOD. THIS IS TOUGH TO DEFINE. YOU *know it when you see it, that special quality of a scene when the lighting is just right, like before or after a storm, or a misting, foggy morning. It's the kind of situation that really makes you remember a place, as in this shot on a misty morning at Lake Oldenvann in Norway's fjord country. Camera, Leica R6; lens, Leica 70–210mm; film, Fujichrome Velvia.*

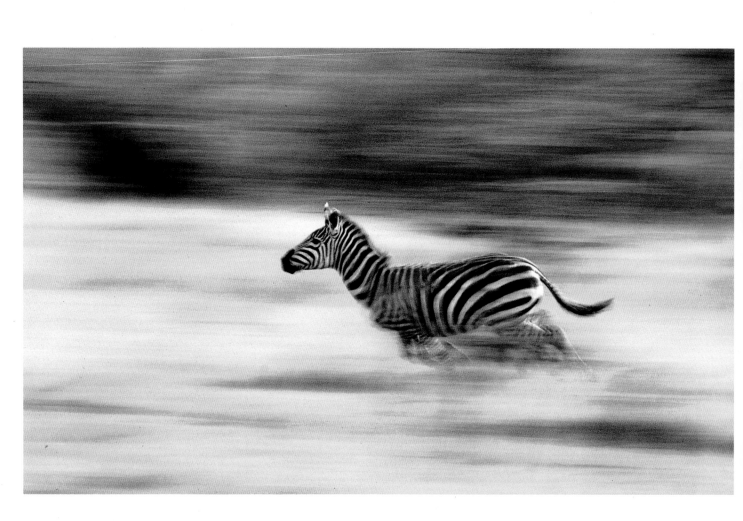

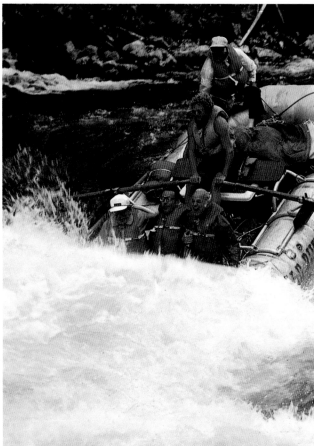

THIS TECHNIQUE IS CALLED A BLUR-PAN. IT WORKS BEST WITH A *telephoto, 300mm or 400mm. I find that for that focal length range, a 1/15-second shutter speed gives just the right effect (you might try experimenting with this a bit). The idea is to pan with the movement of the subject, kind of like following action with a video or motion picture camera, and shooting when you've timed the movement of the lens with the subject. This creates a blurred background while the subject, or part of it, remains relatively sharp. A motor drive is vital, and shoot lots, because you never quite know what you've captured on film. My running zebra in Kenya's Masai Mara Game Reserve was photographed in this way. Camera, Leica R5; lens, Leica 400mm; film, Kodachrome 64.*

CAPTURING TIME. MOST OFTEN WE THINK OF THE CAMERA'S *ability to freeze a moment in time. With a fast enough shutter speed, we can capture all the excitement of action, as in this case of running a rapid called Velvet Falls on the Middle Fork of the Salmon River in Idaho. Using a 1/250 of a second shutter speed froze the peak of action. Camera, Nikon F3; lens, 105mm Nikkor; film, Kodachrome 64.*

CAPTURING TIME

The camera is a time machine. A photograph is a slice in time. In certain aspects of photography, *how* we capture that instant of time determines the drama and impact of the photograph.

Obviously we have a number of choices for shutter speeds. With automatic cameras, the choice is often made for us in the program mode, where a preselected speed is used in conjunction with a preselected aperture. I guess one of the reasons that I'm not particularly fond of automatic cameras is that I like to make such decisions myself. I admit that for many subjects and circumstances it's convenient and fast to have the aperture and shutter speed selected for you, allowing more time to concentrate on picture content—particularly with action shots. But there are times when we should go through the process of selecting shutter speed manually—because it forces the questions: What shutter speed should I use, and Why?

To illustrate, let's say we find a lovely scene with running water, a fast-moving brook with small waterfalls. How can we best capture the feeling of flowing water? One obvious answer is to use a slow shutter speed, allowing the water to become a dreamy blur in the picture. But how slow? This is an area where experimentation is crucial in gaining some knowledge about such situations, because the effect will vary with the speed of the wa-

ter. As a starting point, you might use 1/8 of a second (with the camera firmly mounted on a tripod, of course). Then try bracketing shutter speeds (keeping some notes to guide you later when comparing pictures)—1/4, 1/2, 1 second, perhaps even longer (and, of course, choosing the appropriate f-stop for correct exposure).

Of course, such choices will depend on the lighting. In bright sunlight with a medium speed film of ISO 50 or 64, the slowest shutter speed, with the lens stopped down to its smallest aperture of f/22 (assuming the lens's smallest is f/22; some stop down to only f/16), is 1/30 of a second. You can't expect much of a blurring effect at that speed. So you may have to wait for lower light conditions—overcast, for example, because even switching to a slower film doesn't allow allow very slow shutter speeds; at f/22 with ISO 25 film, the shutter speed would be 1/15 of a second.

Another choice for sunlight conditions would be to use a neutral density filter, that is, one that absorbs a certain amount of light but doesn't change the color rendition of a scene. These filters are designated as ND 0.3, ND 0.6, ND 0.9, etc. A 0.3 ND holds back one f-stop of light, a 0.6 ND holds back two f-stops, a 0.9 ND holds back three f-stops. If you don't have access to an ND filter, a polarizing filter makes somewhat of a sub-

stitute. Most polarizers soak up about one and one-half f-stops of light.

What about using faster shutter speeds for subjects such as moving water? This depends upon the effect you wish to create, and again some experimentation is called for. I find that very fast shutter speeds—like 1/250, or 1/500—that "freeze" the motion of falling water create a rather unpleasant effect. This is because we view moving water as a blur, rather than an action-stopping impression recorded in the mind. An exception would be when photographing surf and breakers. A shutter speed of 1/125 of a second or shorter "freezes" the curl of a wave or the spray of surf crashing against rocks. It doesn't seem unnatural to capture such action because, as we watch waves crashing against rocks, there is a moment when spray and water drops seem suspended.

Other kinds of water—rain and snow—can be effectively captured by choosing a shutter speed that gives a feeling of movement. Experiment a bit with this, for it will depend on how fast the rain or snow is falling, wind velocity, etc. Start with 1/30 of a second shutter speed for a good winter's snowfall or a summer thundershower. For snow, have a dark background so the streaks of falling flakes stand out. Use the same for rain, or, if

possible, some backlighting. Vary shutter speeds—sometimes 1/15 of a second works best, sometimes 1/8.

One of the unique aspects of photography is its ability to capture, via long exposure, events or scenes that are not readily apparent to us because they take place over a long period of time. Such time exposures reveal to us an unusual viewpoint of our world.

One example is capturing star trails, that is, the tracks left by the light of stars as our planet revolves, using a long exposure. It's simple. Choose a clear, moonless night and a locale free of any ambient light that might impinge on the picture being made. A wide-angle lens works well, giving a view of a large area of sky. Keep in mind that such tracks will be curves of varying radii and if you aim the camera at the north star, the tracks will be circular, with the north star at the center. With camera mounted on a tripod, lock the shutter open with a locking cable release. For film, try an ISO speed of 100 and use an aperture of f/4. The longer the exposure time, the longer the resultant streaks of star tracks. If you leave the shutter open for three or four hours, you'll record a whole set of circles made by the stars. It's also helpful to include some stationary elements in the picture in silhouette—trees, or hills, or mountains.

IN NORTHERN KENYA THE SAMBURU people perform a traditional dance that involves spectacular leaps upward. I chose three different ways of portraying this: First, using a 1/250-second shutter speed, I froze one of the dancers near the peak of his jump; second, with a 1/60-second shutter speed I allowed the motion of the jumpers to become a blur, holding the camera steady to record the surroundings sharply; and third, I used a 1/15-second shutter speed and moved the camera up and down with the jumping dancers, creating an overall blur and impressionistic rendition of the dance. Camera, Leica R6; lens, Leica 70–210mm; film, Kodachrome 64.

Minimum Shutter Speed to Stop Subject Movement			
	Shutter Speed for Direction Indicated		
Subject (30 Feet from Camera)	↓	↘	→
Person or animal walking (1-2 mph)	1/30	1/60	1/125
Bicyclist, person jogging (6-15 mph)	1/125	1/250	1/500
Person running, animal trotting (15-25 mph)	1/250	1/500	1/1000
Galloping horse (>25mph)	1/250	1/500	1/1000
Speeding car (70 mph at 50 feet)	1/500	1/1000	1/2000

For a camera/subject distance of 60 feet, use a slower shutter speed by a factor of two; that is, instead of 1/250, 1/125 will suffice. If the camera/subject distance is 15 feet, use a faster shutter speed by a factor of two; that is, instead of 1/250, use 1/500 to stop the action.

The color rendition may be strange to you, with the sky appearing as magenta or blue-green or yellow-red, depending upon the film you choose. This has to do with color shift from reciprocity failure, explained in chapter seven.

At the other extreme is the camera's ability to stop action and render something moving very fast as though frozen in time. The success of this depends on the direction and speed of the subject and the appropriate shutter speed needed to "stop" the movement. The accompanying chart gives some guidelines; use the recommended shutter speeds as starting points. If film speed allows, and there's some doubt about direction or velocity, use faster shutter speeds. As you practice with this, keep notes. Some modern electronic cameras are capable of extremely fast shutter speeds—up to 1/8000 of a second. The limiting factor here may be in having enough light and a fast enough film to allow such shutter speeds. For example, using an ISO 200 speed film on a bright, sunny day, will allow a top shutter speed of 1/8000 of a second at f/2.8. That large an aperture means a shallow depth of field, particularly if you're using a medium or long telephoto lens. Thus focusing becomes critical—compounded by the difficulty of focusing on something that's moving rapidly, such speeds prob-

ably make a good case for using autofocusing lenses.

The technical accomplishment of stopping action is not that difficult. It's *how* you render the moving subject that is all-important in creating dramatic pictures. Trying to compose a strong picture while the subject is moving is difficult. Moreover, at the moment you take the picture you may not be certain of what you've captured. The best advice here is: Shoot lots. When I photographed the incredible jumps made by Samburu dancers of central Kenya, I made a number of exposures, trying to capture the peak of their jumps. But I couldn't be certain about what I had. In addition, I also used some slow shutter speeds to create a blur effect, imparting a sense of motion. For this I panned the camera up and down as the dancers jumped, keeping some of them relatively sharp against a blurred background. When, and if, you're confronted with such opportunities, experiment with these techniques. And shoot lots.

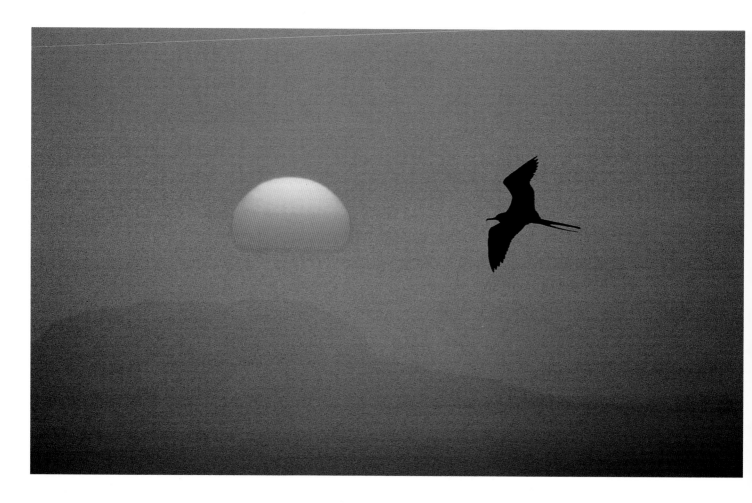

USING A 1/250-SECOND SHUTTER SPEED I froze the flight of a frigate bird in Belize against a setting sun. Using the blur-pan technique with a 400mm lens and 1/15-second shutter speed gave this impressionistic rendition of birds in flight in the U.S. Virgin Islands. Camera, Leica R5; lens, Leica 400mm; film, Kodachrome 64.

Photography is a human act and therefore subjective, a selective act and therefore interpretive. This makes it possible for photography to be an art, for photographers to achieve a personal style—and for the camera to lie.
Arthur Goldsmith

INTERPRETIVE RENDITION: THE CREATIVE CHOICE

We tend to think of all photography as being realistic and truthful. From its beginnings, photography was a tool for documenting our surroundings. People. Places. Events. The camera, being a mechanical device, was thought of as impeccable and incapable of lying. The photograph came to represent, in our minds, a slice of reality. Therefore we never gave much credit to photographers as being interpreters, only recorders.

But if you think about it for a moment, photographers are truly interpreters, for in framing a scene or subject and choosing the elements to include (or exclude), the photographer forces the viewer to see only what was chosen and intended. In other words, when I create a photograph, I'm basically saying to the viewer, "Here is what I want you to see. This is my vision of something beautiful or significant and I want you to share my vision." Therefore, I become an interpreter, a translator. I can create a photo-

graph of a beautiful scene, but I don't show you the pile of beer cans at my feet because I've chosen to show you only the beauty. (I suppose, in this instance, that also makes me a liar as well as interpreter.)

More importantly, suppose I make a picture of a lovely alpine meadow full of wildflowers. And I do it in such a way as to make it as "realistic" as possible—everything sharp from foreground to background. The photograph may document the place very well, but it doesn't necessarily tell you how *I* felt about being there. It is a neutral portrayal because we expect all flower-filled alpine meadows to be beautiful. This is not judgmental, by the way. I'm not saying that this is a boring way to photograph an alpine meadow. In fact, without departing from a realistic rendition, there are an infinite number of ways of portraying that scene—making it challenging from a creative standpoint.

TWO DIFFERENT CREATIVE INTERPRETATIONS OF AN ALPINE MEADOW
in Wyoming's Snowy Range. The first (left), a realistic approach using a
15mm ultra-wide-angle lens at a low angle, stopped down to f/22 for maxi-
mum depth of field. Everything from here to forever is sharp (except for a
flower or two blurred by wind movement). The second rendition (above) is
impressionistic; using a 180mm telephoto with extension tube, shot at maxi-
mum aperture of f/2.8 and at ground level, I focused on the edge of one or
two flowers. Also, I positioned myself so that some other flowers were
nearly touching the front of the lens. The shallow depth of field created
these impressionistic washes of color. Camera, Nikon FM-2; lens 180mm
Nikkor; film, Kodachrome 64.

Double and Multiple Exposures

Making two or more exposures on the same frame can be a way of creating visually exciting and interpretive or impressionistic photographs.

Many cameras have a small lever that allows you to make multiple exposures. If you're not sure, check your camera's manual. It's possible to accomplish the same thing by using the film rewind button, but it is a little trickier. You'll need to turn the rewind knob first to take up any film slack, then hold in the rewind button while making exposures. For either method, a motor drive is very useful in making several exposures.

Obviously, some adjustment must be made for the exposure when you start adding one or more images on the same piece of film. Generally, if the subjects being layered on top of one another are of the same tonal value, the exposure should be divided evenly between the individual exposures so as not to overexpose. In other words, when making sixteen exposures on a single frame, each picture should receive one-sixteenth of the correct exposure for one picture— the equivalent of four f-stops.

The easiest way of adjusting exposure is to multiply the ISO film speed by the number of exposures you wish to make and set this on your film speed dial. For example, when you're using ISO 64 film and want to make a double exposure, set the film speed dial to 125 and use the meter in the normal way (and don't forget to reset to normal speed when you're through). Or you can use this chart:

Film Speed Setting for ISO

Number of Exposures	25	64	100
2	50	125	200
4	100	250	400
8	200	500	800
16	400	1000	1600
32	800	2000	3200

Having satisfied my first impulse to document the scene, I can also turn to a more impressionistic rendition. What is there about this place? How does it make me feel? Happy? Reminiscent? Sad? What are the elements that give this place such emotional impact? Color? Sunlight? Wind?

We tend to think of painting as the medium for creating abstractions and impressionistic interpretations, while photographs are thought of as strict interpretations of the real world. But there's no legislation requiring all photographs to be strict documentary records of the world.

Let's go back to that alpine meadow. One of the primary things I respond to is color. To convey the joy of lying in this sunwashed field of flowers, I chose, for one interpretation, a medium telephoto lens with an extension tube—a 180mm f/2.8 lens, to be exact. With the extension tube I can focus closely and by shooting at maximum aperture, f/2.8, I have a very shallow depth of field. Therefore, things very close to the lens and things beyond my point of focus—in this case, a yellow flower—are very much out of focus and become merely washes of color. This is exactly what I want—subtle washes of color. I can actually line up my shot in such a way as to have other flowers or grasses almost touching the front of the lens and their presence creates those wonderful, subdued, diffused, dreamy colors.

Also, for this particular picture, I chose to focus on the yellow flowers in that meadow of mixed colors. Why? The bright yellow has a warmth to it that conveys more readily the feeling of a sunwashed field. The blue flowers are more somber. It's subtle, but it does have an overall effect on the impact of the final picture.

Impressionistic photographs are interpretive renditions of senses or emotions. Have you ever tried to photograph the wind? Or sounds? Or fear? Or joy? You can, but it's not easy. You have to switch gears mentally, from a realistic way of thinking and seeing to an interpretive one.

Let's go back to that region of the alpine meadow and try photographing the wind. Not far from my field of flowers I found a broad, grassy swale where the wind created ripples of waves through the grass. Obviously, you can't photograph the wind itself. So you need to look for the effect that wind has on things—motion and, in this case, creation of patterns.

Illustrated here are three interpretive renditions of my wind-blown grasses. In the first, I used the pattern of bent grasses, with the curved lines of the blades of grass, to convey a sense of movement. Shutter speed was 1/125 of a second to "freeze" the movement and render each blade sharply.

The second rendition utilizes a slow shutter speed—in this case, 1/4 of a second—to allow some blurring of the motion of the grasses. Note that, while some of the grasses are blurred and convey a sense of movement, others are relatively stationary and sharp. The combined effect says "wind." Incidentally, when trying something similar, using slow shutter speeds, you should make several pictures because you can never tell with any predictability what the final result will look like.

The third rendition utilizes multiple exposures, in this case thirty-two exposures on a single frame. Since I was handholding the camera, there was slight offset of each image as it was recorded on the frame, giving a "wave" of images of the grasses, one on top of the other. The net result is a picture that conveys the feeling of waves of wind flowing through the field of grass. Again, in using multiple exposures, the overall effect of the final image is difficult to predict—so try a number of pictures, varying the angle and the amount of camera movement you allow between exposures. (To make proper exposures with multiple exposure

EVER TRY TO PHOTOGRAPH THE WIND? *You can, you know. Not the wind itself, but the effect of wind—as on these grasses. In the first, the wind had bent the blades of grass into curves that give a feeling of wind; this was shot at 1/125 of a second to stop movement. The second was shot at 1/4 of a second, allowing some of the grasses to blur as the wind moved them. The third was made by shooting thirty-two exposures on a single frame, creating an impression of waves of wind blowing through the grass. Camera, Nikon F3; lens, 180mm Nikkor; film, Kodachrome 64.*

ABOVE RIGHT: THIS DREAMLIKE HALO *effect is created by a double exposure. The first shot was made with a 500mm lens focused sharply on the blossoms and branch of a fruit tree. A second exposure was made on top of the first, but this time the lens was not focused on the branch, but set at some point closer, creating an out-of-focus image on top of the first. Experiment with different subjects and different lenses—it can exercise your imagination. Camera, Nikon F3; lens, 500mm Nikkor; film, Kodachrome 64.*

RIGHT: ANOTHER IMPRESSIONISTIC *rendering—this one in a vehicle speeding along a dusty road in Tsavo National Park in Kenya. It was a van, with no hood in front, so I used my 20mm ultra-wide-angle lens and shot at a 1/4-second shutter speed. Note that the center of the picture is sharp because the relative movement there is minimal. But at the edges, you get this "swishing" effect, blurring because of the slow shutter speed and movement of the vehicle. It gives this incredible feeling of speeding into a scene. You can do this on a motorcycle or bicycle; I've even done it from airplanes and gliders landing or taking off. Camera, Nikon FM-2; lens, 20mm Nikkor; film, Kodachrome 64.*

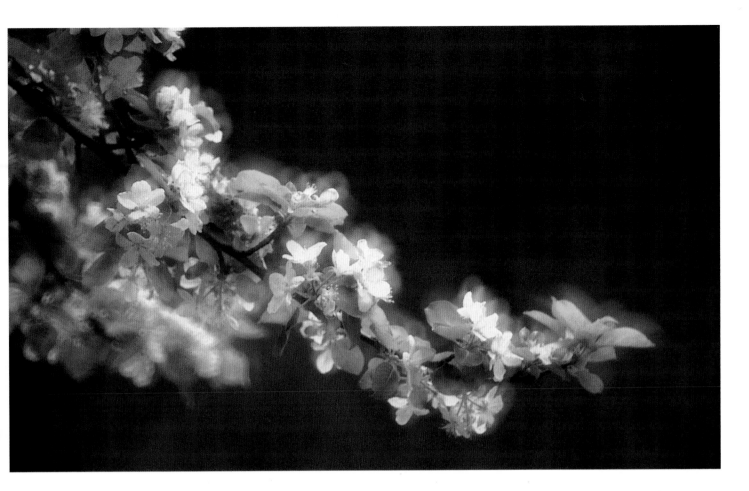

OPPOSITE: ABSTRACTIONS ARE EVERY-where, you just need to look. They can range from a closeup study of weathered wood in Idaho to reflected colors on the surface of water in Norway—or your own back yard. Camera, Leica R5 and R6; lenses, 70–210mm and 35–70mm.

USING A 400MM TELEPHOTO AND A 1/8-SECOND SHUTTER SPEED, I CREATED THIS impressionistic rendering of a gull landing in Alaska. Camera, Leica R4sp; lens, Leica 400mm; film, Kodachrome 64.

techniques, see the accompanying table.)

Instead of multiple exposures, a simple double exposure can also be effective in interpretive renditions. In the shot of the branch of apple blossoms, I made a simple double exposure using a 500mm lens to isolate on just that branch. For the first exposure, I was focused sharply on the branch and blossoms. After re-cocking the shutter (without advancing the film), I made the second exposure with the lens focus shifted to a closer focusing distance. This created an out-of-focus image superimposed on top of the first. It's an interesting technique and I've used it for numerous subjects, including nude studies. The effect created is one of a dreamy feeling about the subject, with a soft, out-of-focus halo.

There are other ways of creating impressionistic photographs. Certain filters, for example. Diffusion filters can soften an image, creating a dreamy look to the scene or subject. Other filters create multiple images or far-out color renderings.

It's fun to experiment with these, though at times they can become a little gimmicky. One of my favorite tools is a 15mm ultra-wide-angle lens I own. It's an early model made for the Nikon and has a built-in set of filters for black and white photography—a deep red, orange, and yellow filter. This combination—ultra-wide-angle and intense color—can sometimes make a really startling photograph.

Another realm of interpretive photography is abstractions. In this case, abstractions are often created by extreme closeups of common things. Obviously, you'll need a macro lens or closeup adaptor lenses allowing close focusing. The emphasis here, as in abstract painting, is on the boldness and power of pure lines or forms or shapes or patterns or texture without the encumbrance of relating these things to real objects.

For abstract photography, the choices of subject matter are nearly limitless. But this is the realm where you have to learn to see carefully. Within your own house-hold there are wonderful abstract subjects—fabrics, surfaces, objects ranging from silverware to tools, reflections, bright and bold colors, subtle colors. If you're a cook, as I am, there are wonderful things on the stove. Just one example: the color and texture of simmering spaghetti sauce (don't let it splatter the front of your lens and don't get so caught up in photographing it that you let it burn!).

Try your hand at abstract or impressionistic photography. The experience, the problem solving, and the thought processes that go into it will benefit your other photography as well.

CONSIDER THE LIGHTING CONTRAST OF *a scene or subject when shooting with slide film. Slide film's narrow latitude won't handle mixed lighting, that is, scenes that include bright sunlight together with deep shadow. As illustrated in the first example, if you expose for the sunlit area, the shadows are almost black, with no detail. If you expose for some shadow detail (center), the sunlit areas wash out badly. What to do? Wait for lower contrast—overcast or even a single cloud that momentarily covers the sun. Camera, Nikon FM-2; lens, 105mm Nikkor; film, Kodachrome 64.*

FILMS AND FILTERS

The camera is my tool. Through it I give reason to everything around me.
Andre Kertesz

Film, that is color film, is the palette with which we paint with light. This is the area in which there's the closest analogy to painting, for in oils, acrylics, and watercolors there's a whole spectrum of pigments and paints available, each different in its rendition. So, too, with film. There is no such thing as a perfect color film. All are approximations of reality.

As any artist will tell you, complete technical mastery of the medium is the key to successful accomplishment. I think it's vital to have knowledge of color film characteristics, even if later on you never use more than one or two emulsions.

To gain this knowledge, I urge you to do some testing of color films. It's really the only way you can learn how each film records colors of the real world. At the same time you can also learn something important about characteristics other than color rendition: contrast and latitude, grain, acuity, sharpness, plus how certain films react to certain lighting situations, e.g., open shade and overcast skies. I think this is especially important nowadays, with so many films available and with so many differences. In recent years there has been a trend toward making films that record greatly exaggerated colors. Some of this relates to the demand of advertising photography for extremely saturated color to attract attention. But for outdoor and nature photographers, these films can appear garish in their rendition of many, if not most, subjects. Do some testing, and decide for yourself whether these emulsions are suitable for your needs.

Before detailing film test procedures, let me make an important point here: I'm discussing *slide* films, rather than print films. Why? Because most serious amateur photographers and nearly all professional photographers use slide or transparency film. Slide film is the film of choice for publication; almost all magazine and book publishers use slides to make color separations for the four-color lithographic printing we see on the pages of magazines and books. And, of course, many of us use slides for projection to share our work with audiences and friends.

The testing procedures outlined here really aren't useful for print, or color negative, films. The reason is, there are too many variables in dealing with print films. Development or processing of the print film is just the first step (for slide film it's the only step). Prints have to be made from the color negatives and, depending upon where you get your prints

73

done, there can be great variation in color balance and color rendition. Print films processed and printed by your local One-Hour Jiffy Photo will look a lot different from those done by a top-notch custom color lab. These variations will make meaningful comparisons of different brands and kinds of print films difficult at best, and impossible at worst.

Even with slide films, there can be variations due to processing. My advice is: If you don't have access to a good, professional processing lab, use the film manufacturers' processing mailers if available. You can also process E-6 film (which accounts for most of the slide film available) yourself. It's not difficult and, with practice, you can achieve good, consistent results.

In order to make your film testing meaningful, you need to take a scientific approach to it. Don't shoot a roll of Kodachrome today, some Fujichrome tomorrow, and Ektachrome the next day, and expect to have any meaningful comparisons. Variations in lighting conditions, time of day, and other factors will make the comparisons of dubious value, perhaps useless. Set aside a block of time on a given day to do these tests uninterrupted. Depending on how many films you test, it make take from one hour to two or more. Here's a suggested procedure:

1. Do two sets of tests—one in bright sunlight, the other in overcast conditions. You'll want to learn how different films respond in these extremes of lighting. For example, some will show more vibrant color rendition in cloudy weather.

2. Use fresh film. It's not a fair test to use old, outdated or nearly outdated emulsions that you've been saving for something unimportant. Also, if you ever have occasion to use any higher speed films—ISO 200, 400, 800—be sure to include them in the tests. As I'll discuss later, these films can have characteristics that are rather tricky to handle and it's helpful to know about this.

3. Make sure the lighting stays constant for the duration of the tests. For the sunlight tests, pick a clear, cloudless day. (For Seattle and Juneau residents, the sun is that big, bright thing that appears in the sky once or twice a year.) And don't do the tests too early or late in the day when intensity and quality of the light changes rapidly. For overcast conditions (yea, Seattle and Juneau), pick a day when it's not likely to clear off, but, rather, remain more or less uniform gray overcast.

4. Use a tripod. If you're going to be evaluating sharpness of films, you don't need blurred images from hand-holding the camera.

5. Use the same camera body and the same lens for all the tests. Slight variations in shutter speeds between camera bodies might lead to some incorrect conclusions about film speed. It's a royal pain in the whatchamacallit to do it this way, and you may waste a number of frames on a given roll, but it does help eliminate some variables and inconsistencies.

6. Pick meaningful test subjects. In the past, I've done film testing using color charts, like the kind made by Kodak, and they leave something to be desired. In the real world I don't go around photographing color charts. So, if your photographic interest is primarily nature, choose a place with a mix of natural objects, e.g., a flower garden with a variety of colors—greens, reds, yellows, browns. If it's winter, a trip to the local florist can get a bouquet with a variety of colors. Or a fruit bowl stocked from the local supermarket with yellow bananas, red apples, green lettuce, etc. If you do a lot of people photography, you might prevail on a patient friend to endure the tests. Also, be sure to include something of neutral color—a swatch of white, for example.

7. Determine your exposures carefully. I recommend taking a meter reading off a gray card placed temporarily in front of the test subjects. Do that for each film batch you test.

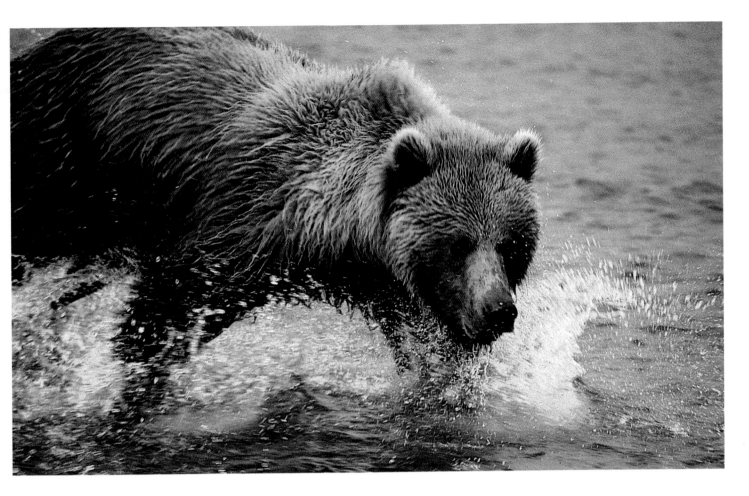

PICK YOUR FILM ACCORDING TO THE KIND OF SHOOTING YOU PLAN *to do. For wildlife, with long telephotos, you probably need something relatively fast, like Kodachrome 200, to stop the action of, say, an Alaskan brown bear chasing a salmon. Other times the extra speed is necessary because of lighting, as in this shot of a black rhino and calf, shot on a cloudy morning in Ngorongoro Crater in Tanzania. Bear: camera, Nikon 8008s; lens, Sigma APO 500mm. Rhino: camera, Leica R5; lens, Leica 560mm. Film (for both), Kodachrome 200.*

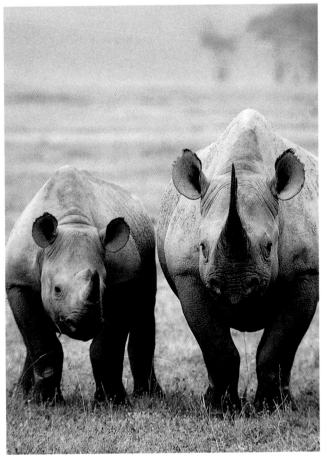

CHOOSE DIFFERENT FILMS FOR DIFFERENT PURPOSES OR SUBJECTS. *When I was photographing the amazingly lush forests of the Bikin River Basin in far eastern Siberia, I wanted to portray this greenery in the best possible way. So I chose Fujichrome Velvia for its superb rendition of greens. Camera, Leica R6; lens, Leica 35–70mm zoom.*

VELVIA IS ALSO A GOOD CHOICE FOR THE BRIGHT COLORS OF *flowers, as in this shot in Zabaikalsky National Park on the shore of Siberia's Lake Baikal. Camera, Nikon 8008s; lens, 35–135mm zoom.*

Slide Film — RMS Grain Size

Slide Film	RMS Grain Size
Kodachrome 25	9
Fujichrome Velvia	9
Ektachrome Duplicating Film	9
Kodachrome 64	10
Agfachrome 50RS	10
Agfachrome 100RS	10
Agfachrome CT100	10
Fujichrome 50	11
Ektachrome 50HC	11
Ektachrome 64X	11
Fujichrome 100	11
Ektachrome 100 Plus Professional	11
Ektachrome 64 Professional	12
Agfachrome 200RS	12
Agfachrome CT200	12
Ektachrome 160T (Tungsten)	13
Ektachrome 200	13
Kodachrome 200	16
Fujichrome 400	16
Ektachrome 400X	19
Ektachrome P800/1600	17/36
Agfachrome 1000RS	26

Print Film — RMS Grain Size

Print Film	RMS Grain Size
Kodak Ektar 25	4
Fujicolor Reala	4
Fujicolor Super HG100	4
Fujicolor Super HG200	5
Fujicolor Super HG400	5
Kodak Ektar 125	5
Kodacolor Gold 100	6
Kodacolor Gold 200	6
Kodak Vericolor III	6
Kodak Vericolor 400	6
Agfacolor XRS100	6
Agfacolor XRS200	6
Agfacolor XRC100	6
Agfacolor XRC200	6
Kodacolor Gold 400	7
Agfacolor XRS1000	8
Fujicolor Super HG1600	10
Kodak Ektar 1000	11

Note: There is no direct comparison of RMS values between slide and print films.

8. This may sound silly, but to avoid confusion later, include a little note in each picture with the name of the film being tested. When the slides come back from processing, it's not always possible to tell which film is which.

9. No matter which film, keep the chosen shutter speeds shorter than 1/15 of a second to avoid any reciprocity failure (more on this later).

10. Make bracketed exposures. The procedure should be like this: Make the basic exposure based on the meter reading. Then underexpose, in one-half f-stop increments, down to two f-stops. Do the same with overexposure, in one-half f-stop increments to two f-stops of overexposure. Put a slip of paper or a Post-It® note in each frame indicating the change, e.g., "correct," "-1/2," "-1," etc. This also helps later on in correlating information about different films. The purpose of this part of the test is to gain knowledge about the latitude of the film, that is, how forgiving or unforgiving it is toward over- and underexposures.

11. Finally, if you're really feeling ambitious about this film testing, you might try one more set of tests—some scenic or landscape shots to give you an overall "feel" of how each film handles sky color, earth tones, etc.

Okay, the tests are done and the film is processed. Now what? First, remember that we're doing these primarily for comparisons. You can't make meaningful comparisons by projecting slides because we have very poor color memory. You can't recall what the red looked like two or three slides ago when you're looking at a new one on the screen. Use a lightbox. Lay the slides out so you can look at different films side-by-side. Use a good quality loupe or magnifier of at least 4X magnification, preferable 6X or 8X.

What do you look for? Here are several factors that I consider when comparing films:

Rendition of color as it relates to personal taste and final use of pictures. Note that I didn't say anything about *realistic* color. As I said above, there's no such thing as a perfect color film. Because of the nature of color dyes in modern films, they end up being, at best, approximations of reality. If there were a color film that could faithfully capture reality, we might not like it. A lot of our preferences may be based on the fact that, over the years, we've come to like slight exaggeration of colors. And recently, some films exaggerate more than slightly.

So, what you need to decide is whether you like it or not. How is the rendition of primary colors—reds, yellows, blues? And how does it handle greens, as in foliage and leaves? In the case of people, how does the film render skin tones? Is there any color bias, that is, does it seem to be warm (slightly reddish or yellow) in rendition, as if shot with a warming filter, or cool (slightly bluish) in rendition? The latter often shows up most in open shaded areas or in overcast conditions. You can best detect such bias by looking at neutral colors in your slides—white areas, in particular.

Sharpness and grain size relating to reproduction or projection. This is an area where there's a lot of confusion and, sometimes, misinformation. In general we've always accepted the idea that the finer the grain, the sharper the film. That's generally true. But there's more to it than that. Grain size alone does not always relate directly to *apparent* sharpness. A low contrast, fine-grained film may not *seem* as sharp as a higher contrast, moderate-grained film. And then there's something called acuity or edge sharpness that relates to how a film renders the edges of objects in a picture. A larger-grained, high acuity film can actually give sharper-looking images than a finer-grained, low acuity film, as we'll see below.

Let's look at grain size first. Technically, the measure for a film's grain size, or granularity, is given as a Root Mean Square (RMS) value. In black and white

films, grain is made up of microscopic crystals of metallic silver. In color film the grains are clusters of dye particles. Because grains, either dye or silver, can vary in size for a particular film, the RMS value is a way of stating a typical or statistical average size for the grain of a film. Don't be frightened off by this technical information. The thing of importance to remember is, *the lower the RMS value, the finer the grain of the film*. The table here gives the RMS for a number of currently available slide films and print films. (A note of caution: You can't directly compare the RMS values of slide and print films; comparison can be made only within each category, i.e., relative values of RMS for slide films relate only to slide films and RMS values for print films relate only to print films.)

Looking at the table of RMS values, we can see that films such as Kodachrome 25 and Fujichrome Velvia and Ekta-chrome Duplicating film have the lowest numbers—RMS 9. As you would expect, these are the finest-grained and the sharpest films. But there are some surprises. Among the higher-speed films, Ektachrome 200 has an RMS grain value of 13, while Kodachrome 200 has an RMS of 16. Therefore, you would expect that Ektachrome 200 is a sharper film, right? Wrong. Though the grain in Kodachrome 200 is slightly larger than Ektachrome 200, the Kodachrome 200 has much better acuity and thus slides made on this film really appear significantly sharper.

As you evaluate your film tests, think also of how you plan to use your pictures. If you plan to use them primarily for projection, even the grain in faster films will not be quite so apparent. But for publication, particularly large-page blowups, or for making large prints from your slides, the grain of faster films will be noticeable.

Contrast and latitude. These two items are related. Latitude refers to the ability of films to handle over- or underexposure. Narrow latitude means high contrast. All color slide films have narrower latitude than color negative or print films. From a practical standpoint, we need to be aware of a film's latitude and contrast because when we encounter extremes of lighting, as I discussed in the chapter on light, the film will not be capable of handling it. Some films are better than others at handling contrast. And the higher-speed films have extremely narrow latitude, so much so, in fact, that many of them shouldn't be used in bright sunlight because highlights will wash out and shadows will become totally black.

When you examine your film tests, take special note of the latitude of the various films. Slide films, in general, are not that forgiving of exposure errors. For critical work, the low- to medium-speed

HOW DO DIFFERENT FILMS RENDER CER-
tain colors? Here's a striking example, a comparison of Kodachrome 64 (far left) and Fujichrome Velvia (left). The scene is on a high bluff overlooking the rugged shore of Lake Baikal in Siberia. Bear in mind that reproduction on a page is not always faithful to the actual slide. Nonetheless, the Velvia rendition of Baikal's waters is an exaggeration of the actual blue color, while the Kodachrome rendition is not quite as vivid as the real color. Recognize that no color film recreates colors with absolute fidelity; the true color of this scene probably lies somewhere between these extremes. Camera, Leica R5; lens, 70–210mm zoom.

films (ISO 25 to 100) have a latitude or exposure tolerance of one-half f-stop overexposure and one f-stop underexposure. For some of the high-speed films, ISO 400 and higher, the latitude is one-third f-stop overexposure, one-half f-stop underexposure. In other words, if you use higher-speed films, be extra careful in determining correct exposure. And it doesn't hurt to bracket exposures to be sure that you hit one right on.

The overall effect of your film testing will be a "feel" for what certain films can and cannot do; most importantly, this can aid you in choosing films for general use and for specific uses, such as low light conditions. You'll also learn that there are certain tradeoffs to be made. Sharper, finer-grained films mean low or medium speeds that may or may not be useful or possible in very low light conditions. For example, I find that Kodachrome 25 is just too slow for much wildlife photography, because long telephoto lenses generally don't have sufficiently large apertures to allow fast enough shutter speeds to overcome possible camera/lens vibration or subject movement. However, Kodachrome 64 is still a very sharp film, though not quite as fine-grained as K25. If I need still more speed, I use 100 speed Ektachrome Plus Professional or Kodachrome 200.

Finally, I should mention a new high-speed film released by Kodak, Ektachrome 400X, a vast improvement over the earlier version of this film. I've always considered films of 400 speed and higher to be for emergency use only, to be used when it's that or no picture at all. However, this new 400X has excellent sharpness and color rendition and I wouldn't hesitate to use it.

An overview of slide films and their characteristics (also called "Norton's Objective and Not-So-Objective Assessment of Films"). For those who choose not to do any film testing, I'll summarize here some of my own observations about most of the currently available slide films. This as-

sessment covers *daylight*-type slide films. I'll discuss briefly some *tungsten*-balanced color films at the end.

The Kodachrome family. Kodachrome was invented in the mid-1930s, first as a motion picture film, then still film. For years, and after a few changes and significant improvements, it was the standard against which all other films were compared. Now there are three daylight-type Kodachromes available: 25, 64, and 200. The Kodachromes are unique—no other slide films are constructed like them. They are non-chromagenic, meaning that, unlike other slide films, no color-forming couplers are incorporated in the different emulsion layers. Instead, color is added by separate development of dye layers, a very elaborate process requiring expensive machinery. This is the reason why Kodachromes can be developed only at certain labs. By *not* incorporating color couplers in the emulsion, these layers can be made ultra-thin. And this, in turn, makes for great sharpness.

Of the three Kodachromes available today, K25, K64, K200, the first two share similar characteristics in color rendition, particularly for reds and yellows. In my opinion, rendition of greens is somewhat better in K25. In K64, greens tend to be muted, almost gray-green. There's also a slight difference in contrast between the two, with K64 exhibiting higher contrast than K25, but not by a lot. Exposure latitude for both films (for critical work) is one-half f-stop overexposure, one f-stop underexposure.

Kodachrome 200 is significantly different from the other two members of the family in that it has a warmer rendition, it is discernibly grainier, and has greater contrast. The warmth of this film is quite noticeable, especially when shot side by side with Kodachrome 64. It's almost like shooting K64 with a warming filter like an 81A or a CC05R. Though grainier than K25 and K64, Kodachrome 200 has excellent acuity or edge sharpness, making it, in my opinion, superior to any

other film of that speed. I've used a lot of Kodachrome 200 for wildlife work and, in particular, it was vital in allowing me to photograph mountain gorillas of Rwanda and Zaire for my book, *The Mountain Gorilla*. Incidentally, there's special processing service available for this film allowing you to use it at a speed of 500. On several occasions in my gorilla photography the lighting was so bad that I had to use the 500 speed. The results were very good, with grain staying nearly the same, though there was a decided shift in color balance toward red. In general, be careful using Kodachrome 200 in bright light conditions—it's very contrasty. Latitude is one-half f-stop overexposure and one-half f-stop underexposure.

The Ektachrome Family. There are so many Ektachromes available that it's confusing to choose among them. And by the time you finish reading this, there may be even more. It used to be that a common family trait of the Ektachromes was a strong bias toward blue. I can remember shooting certain winter scenes in which the shadows came out very blue. One of the reasons for so many emulsions nowadays is the fact that Kodak has compensated for the blue bias and produced films that are warmer-toned. Undoubtedly, some were also developed to compete with the vivid color rendition of the Fujichromes. Depending on your preference, warm tones, cool tones, vivid color, more natural color, there seems to be an Ektachrome to satisfy you.

To try to sort out the Ektachrome family, I've divided it up into three parts: low speed (ISO 50 and 64), medium speed (ISO 100) and high speed (ISO 200, 400, 800/1600).

In the low speed group is Ektachrome 50HC, ranked as the finest-grained of the family with grain nearly equal to that of Kodachrome 64. This is a neutral rendition film, with neither a blue nor yellow-red bias, though I find that it may need a warming filter for high elevation shoot-

ing (high ultraviolet component in the light).

Ektachrome 64 is closest to the old Ektachromes in that it tends to have a slight blue bias, in my opinion. A warming filter is often necessary for open shade and high elevations.

Ektachrome 64X is definitely a warmer film, not requiring a warming filter, and has nice rendition of skin tones.

In the medium speed—ISO 100—there are four Ektachromes. Ektachrome 100HC and Ektachrome 100 Plus have neutral renditions. Ektachrome 100X is a warmer rendition film while Ektachrome 100 is a cool rendition film with a blue bias. I use a lot of Ektachrome 100 Plus (EPP) because it has good color saturation and, in my opinion, is slightly sharper than Fujichrome 100.

In the high speed range—ISO 200 and greater—there are four films available. Ektachrome 200 has an indicated grain size smaller than that of Kodachrome 200, RMS 13 versus RMS 16. However, Kodachrome 200 is still a sharper film because it has much better acuity or edge sharpness—and it has much better color saturation. Ektachrome 200 is a pale film by comparison, in my opinion.

Ektachrome 400HC and Ektachrome 400X replace the older version of Ektachrome 400, which was not a very good film. Ektachrome 400X in particular has a moderate grain size and has excellent color saturation—something the older Ektachrome 400 lacked.

Ektachrome P800/1600 is a film that requires you to choose the speed—either 800 or 1600 (or 3200, if necessary). At a speed of 800 it's not bad, but it certainly is what I call an "emergency only" film; in other words, it's either that or no picture at all. Grain is very noticeable, color saturation good. But the biggest problem is the very narrow latitude at 800 or 1600 ratings—about plus or minus one-third of an f-stop for critical work. If you're more than half an f-stop off in exposure, the

I ONCE CONSIDERED 400 SPEED AND higher films to be for emergency use only because color and grain just weren't that good. But I must admit that Kodak's Ektachrome 400X is a vast improvement, incorporating the T-grain technology for smoother grain structure. With this speed it's possible to push the envelope a little when lighting gets bad, as in my shot of the cheetah and cub or the leopard at dawn, both on a dark, cloudy day in Kenya's Masai Mara Game Reserve. Camera, Leica R6; lens, Leica 400mm.

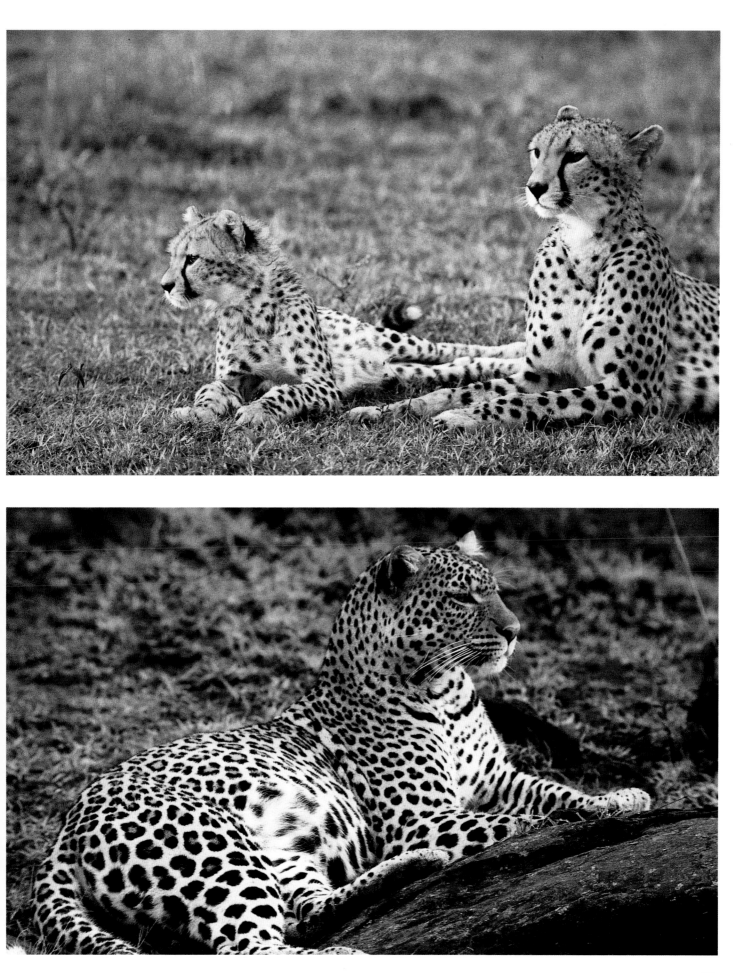

NEED A FILM IN THE ISO 100 SPEED range? I usually use Ektachrome Plus Professional (EPP). It has excellent color rendition and fine grain; in side-by-side comparison, I see little difference in color between EPP (top) and Fujichrome 100, though I find EPP to be slightly sharper, with better acuity. When compared to, say, Kodachrome 64 (center), EPP is definitely a warmer film, as seen in these comparative shots made of Alaska tundra near Kamishak Bay. Camera, Nikon 8008s; lens, 55mm Micro-Nikkor.

DON'T PUSH SLOW SPEED FILMS TO higher speeds—there are higher speed films available that handle the situation at least as well. Very contrasty films such as Fujichrome Velvia gain even more contrast when pushed; if you do push Velvia, use it in low contrast lighting, as here in a forest scene shot in overcast lighting. Camera, Leica R5; lens, 35-135mm zoom.

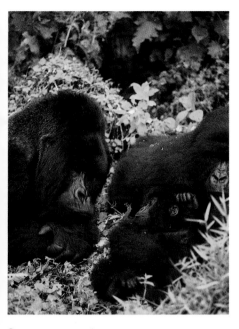

SOMETIMES IT'S NECESSARY TO PUSH *film beyond its normal speed (and have the lab process accordingly). When I was working on my book, The Mountain Gorilla, I had to spend much time in the high altitude rain forests of the Virunga Volcanoes of Rwanda and Zaire. Overcast skies and heavy forest canopy made for some difficult lighting conditions; to make matters worse, it was difficult to use a tripod in the heavy undergrowth. This shot of silverback Rugabo and family was made with Kodachrome 200 pushed to 500, processed by Kodalux for that speed. The grain and color held up amazingly well. Camera, Leica R4sp; lens, Leica 70–210mm zoom.*

picture may be unusable for publication purposes.

The Fujichrome Family. One important characteristic—bright, bold colors, especially of greens found in nature—has made Fujichromes a popular choice for many nature subjects.

Fujichrome Velvia, with an ISO rating of 50, is remarkable, having an RMS grain value of 9, the same as Kodachrome 25, which had been the fine-grain champ for years. It also has greatly exaggerated color, a feature that may or may not be beneficial at times. I like it for forest and scenic shots on overcast days because it has an added punch in color. However, if I'm trying to emphasize a quiet, subtle mood in a picture, I'll use Kodachrome 64, which has a more realistic rendition.

Fujichrome 50 is not quite as fine-grained a film as Velvia and is close to Kodachrome 64 in grain and sharpness. It also has less vivid color rendition than Velvia has, but it's still a pretty rich and saturated film—especially for greens.

Fujichrome 100 has similar color rendition to Fujichrome 50: bright and bold. It's not quite as sharp, however. In fact, when I compared Fujichrome 100 to Ektachrome 100 Plus, I found the Ektachrome to be a little sharper.

Fujichrome 400 has rich color saturation, but it is not as sharp a film as Ektachrome 400X. And since Ektachrome 400X has excellent color saturation, it's the film of choice.

Fujichrome P1600 is very grainy, a strictly "for emergency use only" film. It's very contrasty with narrow latitude for exposure error.

OTHER FILM ATTRIBUTES

Thus far I've discussed only daylight-balanced films. There are films available for shooting under tungsten light, as in studios or for stage shows. Of these, I've used Ektachrome 160T pushed one stop, that is, rated at 320, and the results have been excellent—certainly of publishable quality.

One important factor about choosing any color films is whether to use professional or amateur emulsions. What's the difference? Without getting into great technical detail, the answer is: little or none when it comes to basic characteristics such as color saturation and grain size. The major difference is that professional films are released for sale when they have been tested to exhibit optimum color balance and peak sensitivity (accurate ISO speed rating). Color films age with time, that is, when stored at room temperature there's a gradual shift in color balance. Amateur films are assumed to be stored for a certain time at room temperature on a dealer's shelf and their aim-point for optimum color balance takes this into account. In other words, amateur films reach their best color balance and sensitivity a few months after release. Professional films are right-on the moment you buy them and, in fact, should be refrigerated or frozen if not used right away.

For all practical purposes you may not see much difference between amateur and professional versions of the same film (except the price!).

One other important characteristic of films is reciprocity failure. Don't let it scare you. In everyday shooting we can choose among a wide range of shutter speed and f-stop combinations. At very short or very long exposures films lose sensitivity. For practical purposes we needn't worry about the short end. But for long exposures—one second or longer—there may be concern, depending on the film. If you don't make corrections for reciprocity effects, your shots may come out severely underexposed.

In addition to loss of sensitivity, long exposures may cause a color shift, and to give a correct rendition of the subject, you may need to use a color correcting filter. The chart gives exposure corrections and filter recommendations for a number of the films mentioned above.

Reciprocity Failure in Color Films

This subject sounds a little ominous and intimidating, but it isn't. And it is something you should know about.

In everyday shooting, we can choose among a wide range of f-stop and shutter speed combinations. If the meter indicates a correct exposure of 1/60 second at f/8, we can use 1/8 at f/22, 1/15 at f/16, 1/30 at f/11, 1/125 at f/5.6, 1/250 at f/4, and 1/500 at f/2.8. All will give the proper exposure. However, films lose sensitivity at very short or very long exposures. For practical purposes, we needn't worry about the short end. But long exposures, around one second or longer, may be of concern. If you *don't* make corrections for reciprocity effects, your shots may come out severely underexposed.

In addition to loss of sensitivity, long exposures may cause a color shift—and to give a correct rendition of the subject, you may need to use a color correcting filter. The following chart gives exposure corrections and filter recommendations for a number of commonly used color films.

WHEN SHOOTING DANCERS UNDER *stage lights, such as these on the Indonesian island of Bali, you can use a high speed film such as Fujichrome 1600, but it's very contrasty and grainy (above). Also, since this is a daylight-balanced emulsion (5500 degrees Kelvin), the lower color temperature of the stage lights (about 3200 degrees Kelvin) made the dancers a bit on the yellow-orange side. An improved film choice is Ektachrome 160T (opposite), where T stands for tungsten color balance of 3200 degrees Kelvin. Skin tones now appear normal. I pushed the film one stop, rating it at 320 with excellent results. Now there is an Ektachrome 320T, which can be pushed to 640 (one stop) with good results. Camera, Nikon FM2; lens, 180mm Nikkor.*

Film	Exposure Time (Seconds)		
	1	4	10
Kodacolor Gold 100	add 1 stop CC 20Y		NR
Kodacolor Gold 400	add 1/3 stop No filter		add 1 stop No filter
Ektapress Gold 100	add 1 stop CC 20Y		NR
Ektapress Gold 400	add 1/3 stop No filter		add 1 stop No filter
Ektapress Gold 1600	None No filter		add 1 stop No filter
Ektar 25	None No filter		None No filter
Kodachrome 25	add 1/2 stop No filter		NR
Kodachrome 64	add 1 stop CC 10R		NR
Kodachrome 200	NR		NR
Ektachrome 64	add 1/2 stop CC 10M		add 1 1/2 stop CC 15M
Ektachrome 100	NR		NR
Ektachrome 100 Plus	add 1/2 stop CC 05R		NR
Ektachrome 200	add 1/2 stop No filter		NR
Ektachrome P800/1600	NR		NR
Fujichrome 50	None No filter	add 1/3 stop CC 05M	add 1/2 stop CC 08M
Fujichrome 100	None No filter	add 1/3 stop CC 05M	add 1/2 stop CC 08M
Fujichrome 400	None No filter	add 1/3 stop CC 02Y	add 1/2 stop CC 02Y
Fujichrome Velvia	None No filter	add 1/3 stop CC 05M	add 1/2 stop CC 08M

Note: CC indicates color correcting filter, and the numbers refer to the density of the filter: Y is yellow, R is red, M is magenta. NR means not recommended.

FILTERS

I have my own personal rule about filters: Use them for a purpose, then take them off the lens. I don't like the idea of making a filter, no matter what kind, a permanent part of a lens. I especially don't buy the idea that filters "protect" lenses. They don't. But they do add two more surfaces which can contribute to lens flare. Furthermore, glass and optical plastic filters degrade lens sharpness. This is particularly true when filters are used on medium or short focal length lenses because light rays coming in at an angle are refracted by the filter, causing de-focusing, most notably at the edges and corners of the picture. Gelatin filters are far less of a problem because they are thinner and cause less refraction of light rays.

Probably the most useful filter for color photography is the polarizer. It helps to eliminate glare from surfaces and to increase contrast of sky-and-cloud pictures. The darkening of blue skies can be dramatic, but bear in mind that the effect is most pronounced when shooting at 90 degrees to the azimuth of the sun. In other words, if you stand facing the sun, the area of maximum polarization will be to your immediate right or left. The effect is minimal in the direction of the sun and at 180 degrees away from the sun.

There are other uses for polarizers. As I mentioned, they help to eliminate glare from surfaces such as water. If you wish to portray the clarity of water or some objects beneath the water's surface, a polarizer will reduce, if not do away with entirely, surface glare. Rotating the filter while it's on the lens and while you're viewing through the viewfinder will show you the point of maximum effect.

Glare occurs on other surfaces, but sometimes it's not apparent at first. Foliage, for example, reflects sunlight in the form of glare—especially from broad-leafed plants. Using a polarizer will eliminate that glare and cause the color of the foliage to be more intense.

A little-known quality of polarizing filters is their ability to minimize haze—far better than any so-called haze filters. Again it has to do with glare from surfaces, but in this case the surfaces are millions of tiny water particles that constitute haze. At certain times of day, and at the proper angle to the sun as described above, a properly rotated polarizer will reduce that haze-glare and improve the contrast and color of scenes. Try it. I find it easiest to just hold the filter in front of my eye and rotate it to see what effect it'll have, before putting it on the camera.

Second to the polarizer in importance is the split-field neutral density filter. Don't let the name frighten you. It's merely a filter, half of which is a neutral density filter, i.e. one that holds back a certain amount of light without affecting color, while the other half is clear. This is useful for those scenes with greatly differing lighting. In my illustration on page 89, the colorful cliffs are illuminated by sunlight, while foreground detail is in shadow. The split-field neutral density filter helps to even out the exposure by holding back light from the upper, brighter part of the picture, while allowing exposure for the lower half to bring out details. The particular filter used here is one in which the neutral density part holds back two f-stops of light. You can also purchase one that has a one f-stop effect, but I find this to be less useful. These are square Cokin filters, by the way, and when used with the Cokin holder the filter can be slid up and down and rotated to place the demarcation line exactly where you want.

Occasionally, I find some other filters useful—especially if I want to create a dramatic effect. I carry deep blue and deep red Cokin filters with which I may drastically alter the reality of a scene or subject. Even more useful, I find, are some Kodak gelatin color correcting filters— CC05R, CC10R, CC05B, and CC10B. The "CC" refers to Color Correcting, the

numerals to density, the last letter to color—R for red, B for blue. An 05 density is a very pale color, a 10 density a little more intense, but still rather pale. The red filters are sometimes useful in adding a little color oomph to sunrises and sunsets, a little warmth to overcast or open shade scenes when some films tend to go a little blue. The blue filters I find to be useful from time to time to create a certain mood to pictures. They can impart a touch of coolness to foggy, morning scenes. Or they can be used to make mountain streams appear cool or cold.

Gelatin filters need to be handled carefully because they are, indeed, coated with gelatin and must be kept away from water and sticky fingers. There are other warming filters such as the 81A and skylight filters, available in glass or optical plastic Cokin sizes. The 81A is a light

amber, useful to counteract blue bias in some films. Skylight filters seem to vary in intensity, depending on the manufacturer. Some, like the Nikon Skylight, are close to a CC05R gelatin filter—a pale red, in other words. Again, such filters are most useful for correcting blue bias.

As with so many other aspects of creative photography, you're limited only by your own imagination when it comes to using filters. Experiment.

POLARIZING FILTERS CAN MAKE A DRAMATIC *difference in some landscape photos by darkening skies and eliminating reflections from water, as in this shot of Augustine Volcano and Chenik Cove in Kamishak Bay, Alaska. Polarizers also help eliminate haze in certain scenes; note that in the second picture the polarizing filter has eliminated some of the distant haze obscuring detail at the volcano's base. Camera, Leica R4sp; lens, Leica 70–210mm zoom; film, Kodachrome 64.*

THE ABILITY OF POLARIZERS TO ELIMI-
nate surface glare also makes it possible to
intensify colors. *The first shot (above) shows
how the polarizer intensifies color by elimi-
nating glare. In the second shot (above right),
without the polarizing filter, this scene of red
tiled roofs in Charlotte Amalie in Saint Tho-
mas lacks the intensity of color because of
glare. Camera, Nikon FM-2; lens, Nikkor
35–135mm zoom; film, Fujichrome 100.*

OCCASIONALLY THE GLARE ON THE SUR-
face of water interferes with photographing
*what's in the water (center). By using a
polarizer (right), I was able to eliminate the
glare and show these masses of salmon in
Chenik Creek in Alaska. Camera, Leica R5;
lens, Leica 70–210mm zoom; film, Koda-
chrome 64.*

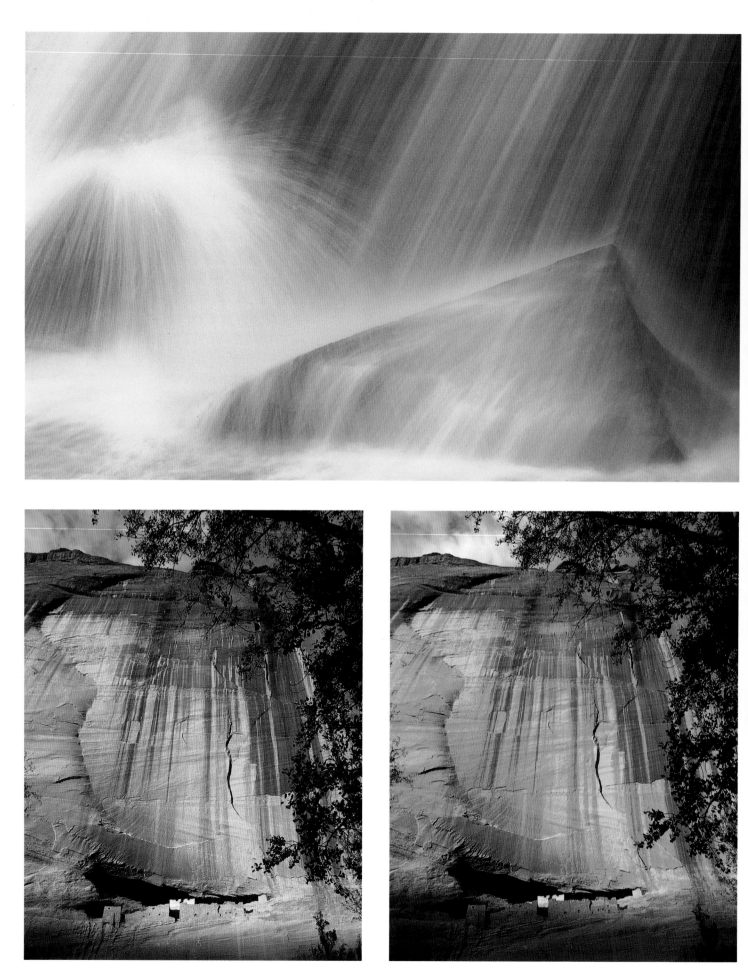

OPPOSITE: SOMETIMES I USE COLOR *compensating (CC) gelatin filters to add warmth or coolness to certain scenes. They give a subtle feeling of coolness to this waterfall in the Great Smoky Mountains (top). I used a very pale CC05B (blue) filter. In Canyon de Chelly National Park in Arizona, I used a CC10R (red) filter to simulate late afternoon color on these canyon walls at White House Ruin (below right). Camera, Leica R5; lens, 70–210mm (Great Smokies) and 21mm (Canyon de Chelly); film, Koda-chrome 64.*

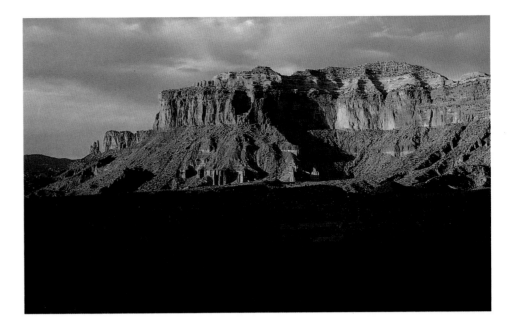

A SPLIT FIELD NEUTRAL DENSITY FILTER *is clear on one half, and has a light-absorbing neutral density in its other half. I use the Cokin #121, which has a neutral density equivalent to two f-stops of light. Here's a situation where such a filter is very useful: a scene in western Colorado, part in sunlight, part in shadow. In the first picture (top), the exposure for the sandstone cliffs is correct, but the foreground in shadow is too dark. In the second picture (center), I exposed for the shadow area, but the cliffs are greatly over-exposed. In the third picture (bottom), I used the split field neutral density filter to even out the exposure—the upper half held back some of the light that would have overexposed, allowing the lower clear half to render the shadow area properly. Camera, Nikon FM-2; lens, Nikkor 35–135mm zoom; film, Kodachrome 64.*

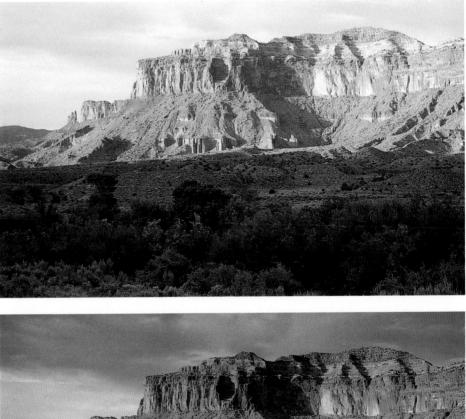

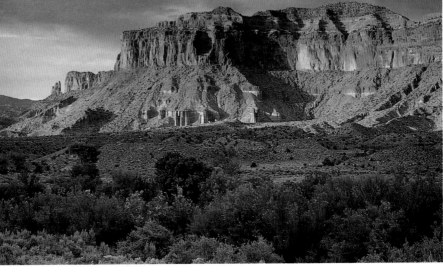

WILDLIFE

. . . nature has ceased to be what it always had been—what people needed protection from. Now nature—tamed, endangered, mortal—needs to be protected from people. When we are afraid, we shoot. But when we are nostalgic, we take pictures.

Susan Sontag

I KNOW PEOPLE WHO HAVE LIVED IN *Alaska for thirty years and have never seen a wolverine. So I was pretty excited when a wolverine actually approached me in the McNeil River State Game Sanctuary. I put the camera and lens on a good firm tripod and shot lots of film, bracketing exposures to be sure. Camera, Nikon 8008s; lens, Sigma APO 500mm; film, Kodachrome 200.*

GOOD BIRD PHOTOGRAPHY CAN TAKE IN-*credible patience and time. Yuri Shibnev is a Russian friend of mine who lives in the Siberian Far East and specializes in bird photography. To get these pictures, he spent hours cramped in a small blind, being careful not to disturb his subjects. These photos were made using an East German–made, 2¼ single lens reflex Pentacon and a flash unit that takes flash bulbs (which means replacing the flash bulb between shots). As I said, great patience!*

This is the rare Grey-faced buzzard eagle on its nest in Kedrovaya Pod Nature Reserve.

Wildlife photography entails so much more than making photographs of animals. It really involves making a strong visual statement about animals in the wild. While good animal portraits can be made in a zoo, good wildlife photographs cannot.

As in so much of photography, wildlife photography involves a whole philosophy, a way of seeing and dealing with the subjects on film. Part of it has to do with environment. Part is related to animal behavior. The blending of those elements, together with an eye for interpretation, creates the strongest wildlife photographs.

Many years ago, on my first trip to Africa (and as everyone does on their first trip there), I got caught up in the excitement of photographing certain animals and didn't realize, at first, that I was missing something important in my photographic renditions. Lions, in particular, are easy to photograph in the game reserves and parks of Kenya and Tanzania. You can drive right up to them in safari vehicles and they ignore not only the vehicles, but also the clatter and whine of cameras and motor drives. After the initial excitement of being in close proximity wore off, I began to think about lions and their environment. What elements in their surroundings contribute to their success as a species? How do they hunt? When? What special adaptation, such as color, aids them? What kind of social behavior is there among lions?

Before I go on any photographic assignment I do a lot of research about the place I'm visiting and the environment I'll be in. Prior to my visit to Africa, I read and read. Therefore, I knew a great deal about lions and their behavior, but at first I didn't relate this knowledge to my photographic efforts. It was only after I began to think about and then immerse myself in lion habitat and behavior that I began to create good photographic studies of lions—good, that is, in the sense of being strong visual statements about lions and their domain.

Another example has to do with my friend Larry Aumiller, the biologist/manager of Alaska's famed McNeil River State Game Sanctuary, the place that has the highest concentration of brown bears in the world (brown bears are the same species as grizzlies). When *Smithsonian* magazine asked me to do an article about Aumiller and his experiences with the bears, I realized that this would entail not only good wildlife photographs, but, if possible, shots of Aumiller and the bears together. Even though Larry has great rapport with these grizzlies (I suspect that he even thinks like a bear), it's not possible to control the behavior of the bears. So I had to bide my time.

At one of McNeil's observation areas we were photographing a number of

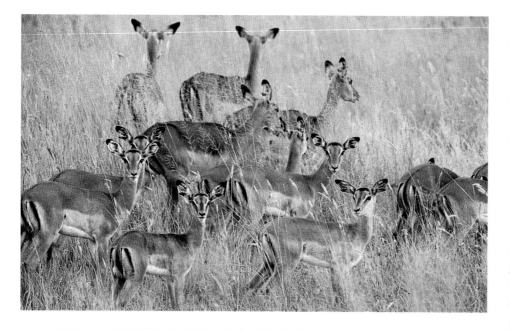

WHEN WORKING WITH GROUPS OF animals it's often difficult to come up with a strong composition. Randomly scattered animals tend to make for a chaotic arrangement in the picture. I look for patterns, which can take a great deal of time and patience. When I made a clicking noise, this herd of female impalas turned to look—at least a few of them did—and I made this shot, with eyes, ears, and faces in a harmonious arrangement.

The Steller's sea lions in Kenai Fjords National Park in Alaska weren't so cooperative; I had to bide my time and wait for a good arrangement. This was made doubly tough by shooting from the deck of a pitching and rolling boat. Using a tripod was impossible on the moving deck; I hand-held, timing my shots with lulls in the boat's movement. Impalas: Camera, Leica R4sp; lens, leica 400mm; film, Kodachrome 64. Sea lions: Camera, Nikon F3; lens, 180mm Nikkor; film, Kodachrome 64.

WHETHER YOU SHOOT WILDLIFE IN YOUR *own locale or in the wilds of Africa, think! Think habitat. Think environment. Think behavior. Lions are predators of the African savannah. Their domain is grassland, their color nearly that of grass. This shot typifies behavior and environment and habitat. These lions in Masai Mara Game Reserve in Kenya were lying in wait for a herd of zebras some distance away and moving toward them. To me this photograph portrays well the drama of life and death that goes on in this environment. The zebras spotted the lions in time. But another time . . . Camera, Leica R4sp; lens, Leica 400mm; film, Kodachrome 64.*

SOMETIMES THE ANIMALS ARE TOO CO-*operative. Rock hyraxes at Seronera Lodge in Serengeti National Park in Tanzania are so used to people, they approach very closely at times. Instead of photographing the animal, I chose to capture a student on one of my photo workshops trying to photograph an overly friendly hyrax. Nostril closeups, anyone? Camera, Leica R5; lens, Leica 70–210mm zoom; film, Kodachrome 64.*

ON AN ASSIGNMENT FOR AUDUBON *magazine several years ago, I arranged to have some herpetologists take me to one of the few remaining, active hibernating dens of timber rattlesnakes in upstate New York. We saw many, but the most memorable was this one hiding under some leaves—I almost stepped on it. He, or she, never rattled, never even moved or flicked a tongue, apparently feeling secure in the leaf cover. So I set up a tripod, sat down (after checking carefully for any relatives), and made several photos of this endangered reptile. I moved away to photograph some others. When I came back to this spot, the snake was gone; it had quietly slipped away. Camera, Nikon F3; lens, 105mm Nikkor; film, Kodachrome 64.*

BEHAVIOR AND ACTION SHOTS OF WILD-
life are the ones that take the most patience
and timing. In planning a wildlife photogra-
phy trip, allow enough time in a given place
to really be able to capture action and behav-
ior. In East Africa, for example, there are
sometimes hours of hanging around a pride
of lions in order to get just a few moments'
worth of action, like the humor of a lioness
being bugged by flies.

Spending several days in one particular
area of Denali National Park in Alaska al-
lowed me to be on hand when this red fox
came trotting by with a mouthful of ground
squirrels—bringing home the groceries. And
while working on my book, The African
Elephant: Last Days of Eden, I spent
countless hours in the company of elephants,
waiting for brief opportunities such as this
one of two siblings greeting each other affec-
tionately.

Many different trips to McNeil River
and environs in Alaska gave me the chance
to photograph this mother bear catching a
salmon for her hungry kids.

Hippos are normally placid, lying
around in rivers feeding or sleeping, but oc-
casionally a territorial dispute breaks out and
you need to be ready to capture the action.

The hyenas had just taken down a ze-
bra, hunting as a pack, when I arrived on
the scene—not a pretty one, but it's the way
life goes on in the wild. During their feeding
frenzy, the hyenas would look up occasion-
ally to check for lions that might move in on
their kill, and I used this opportunity to cap-
ture these blood-smeared hyenas as they
looked around nervously.

SOMETIMES THE SMALLEST ANIMALS ARE *the most difficult to photograph. The pica, denizen of the alpine tundra in the Rockies, is very restive. I had to lie around on the warm, sunny tundra for a whole morning (somebody has to do it!) while this little guy ran nervously back forth between den and feeding area. Camera, Leica R5; lens, Leica 400mm; film, Kodachrome 200.*

ANOTHER ENDANGERED SPECIES IS THE *Komodo "dragon." This member of the monitor lizard family grows to almost eleven feet and lives on the remote islands of Komodo and Flores in the Indonesian archipelago. Even getting there is a real adventure. Once there, park rangers guide a handful of visitors to a feeding area where the dragons congregate. A real long telephoto isn't necessary here because the lizards approach rather closely— sometimes too closely (they are carnivorous and have, on occasion, eaten people). Camera, Leica R5; lens Leica 70–210mm zoom; film, Kodachrome 64.*

AFRICA IS LOADED WITH COLORFUL BIRD *life, but capturing it on film isn't that easy. This saddle-billed stork allowed us to approach slowly in a vehicle, but it still took a long tele to capture it well on film. Camera, Leica R4sp; lens, Leica 560mm; film, Kodachrome 200.*

bears catching salmon from a stream. I had the 560mm telephoto and Leica on a tripod. But I also had another camera body with a 70–210mm zoom lens lying on the ground next to me. I had it loaded with Kodachrome 200 film so that I could hand-hold with a reasonable shutter speed to prevent any blurring due to camera movement.

From previous visits, I knew that the bears often wandered quite close to these strange, camera-toting bipeds in their midst—more out of curiosity than aggression. For the safety of visitors, Aumiller discourages them from approaching too closely. He does this by standing at the periphery of a group and confronting the bear—sometimes talking to it or giving a wave of the hand. It wasn't long before Maryanne, a six-year-old 450-pound female, grew tired of fishing and decided to check us out. As she ambled our way, I grabbed the camera with the zoom lens and positioned myself so that Aumiller was in the foreground and Maryanne was in the background. A wide-angle lens would have made the bear appear too small, so I used the zoom at a medium telephoto setting—about 150mm, as I recall—in order to create a perspective where the bear appeared quite close. (As it turns out, she came within about fifteen feet of us!) Out of the numerous pictures I shot, the one that best told the story of Aumiller and his relationship with these bears shows him standing casually, hands in pockets, as the bear looms close to him. (She simply turned away after Larry spoke to her in a soft voice.)

Technique. I use these examples to illustrate two important points about wildlife photography technique: preparedness and attentiveness. Being prepared involves more than having the right equipment. It also entails the research you do before leaving home. Having knowledge of wildlife behavior and habitat is vital to creating strong, meaningful wildlife pictures. Attentiveness is your state of alertness when you're in the field. By pay-

ing careful attention to the behavior of certain animals, you can often put yourself in a situation for the best photographs. For example, the red foxes that I often photograph at Chenik Head in Alaska have regular, daily hunting routines. By observing those regular routes and times of day, I'm able to position myself to get the best possible photographs of them.

I consider all good wildlife photographs to be the result of a controlled accident. Wildlife—being wild—is generally out of our range of control or influence. (Unless you work with tame or captive animals, a practice I don't think much of.) We can't ask that grizzly bear to hold that pose or to move into a better position. So it's really accidental, out of our control, when an animal is in an ideal situation—good lighting, clean uncluttered backgrounds, good pose, etc. What we can control is our position, to take advantage of the serendipity. And also within our control is the right choice of equipment to capture effectively that decisive moment. Our very presence often influences animals in such a way as to make it very difficult to get good photographs. They run—or fly away—and won't return until we leave. Under these conditions, the choices involve using a blind or hiding place or, through great patience, possibly habituating the animal to our presence.

Blinds—or hides—can be as simple or elaborate as you choose. Simplest is a lightweight nylon poncho or tarp that can be draped over branches or even a tripod. More elaborate commercial blinds consist of lightweight aluminum frames with a nylon shell that fits over them like a tent. In fact, small tents can also be used effectively, but these are designed more for sleeping than sitting up. Of course, the blind works only in a situation where birds or animals congregate at a particular place with regularity and frequency—at a nest, for example, or a favorite watering hole or den. Some ani-

IN HERDS, LOOK FOR INTERACTIONS *between and among two or more animals. These zebra in Kenya's Masai Mara Game Reserve cooperated nicely. Camera, Leica R5; lens, Leica 400mm; film, Kodachrome 64.*

EARLY MORNING IN LAKE NAKURU *National Park in Kenya found these yellow-billed storks squabbling in a tree with a convenient moon behind them. Camera, Leica R5; lens, Leica 400mm; film, Kodachrome 200.*

THIS IS THE LONGEST HORN I'VE EVER *seen on a rhino, and the rhino is the most belligerent I've met. This one came busting out of the brush in central Kenya, hell-bent on doing serious damage to our vehicle. There was time for only a few quick shots before he charged back into the brush. Camera, Leica R5; lens, Leica 400mm; film, Kodachrome 64.*

mals may return to a particular place to browse or graze, or perhaps there's a natural salt content in the soil that attracts. Some birds may favor a certain tree branch as a perch. It's always a good idea to keep field notes on such behavior as this. The relative frequency of return to places by animals can be determined from your notes, and this information may increase your chances of successfully photographing the animal there.

The composition of wildlife photographs needs careful consideration. While it's often tempting to use the longest lens possible and fill the picture area with the animal, keep in mind the importance of relating the animal to environment. Check the viewfinder carefully for details. Don't get so caught up in the excitement that you overlook the distracting branch or cluttered background. Also, by waiting a moment or so, a slight change in the animal's position will give those nice highlights in the eyes. And speaking of eyes, on a tight, frame-filling shot you should focus on them. Even if other parts of the animal are out of focus, the eyes need to be sharp.

Depending upon the species of wildlife, you need to think about static pose versus dynamic action in your photographs. The easier is the nicely posed subject, looking at the camera, alert and poised, with the lighting just right and the catchlights in the eyes. This kind of photograph should make a strong statement about the beauty and elegance of the animal, whether it be a mule deer in Montana or an impala in Tanzania. It should be clean and direct, with few distracting elements—not easy to accomplish, considering the lack of control we have over such subjects. But that's one of the reasons I suggest that if you don't have a large amount of patience, wildlife photography isn't for you.

There's also another consideration that involves the time you have for getting the shot. Sometimes it's a fleeting moment and it's necessary to shoot

quickly. But often animals will "freeze" as a reaction to the presence of people, and by exercising a little patience a far better shot can be made. This is particularly important because the very act of taking a picture—the sound caused by camera and/or motor drive—will frighten the animal. In fact, in many situations I turn off my camera's motor drive and advance film slowly and quietly by hand when I sense that the animal is very nervous.

Dynamic action photography is even more difficult. Trying to follow action with a long telephoto lens mounted on a tripod can often be an exercise in frustration. I've had some good success using a video fluid pan head in place of the usual tripod head. Be sure to get one that's sturdy enough—many of them are made for lightweight home video cameras, not heavy telephotos. Another option is a gunstock or shoulder stock, a brace that fits against your shoulder like a rifle, with camera and lens mounted on it. This works reasonably well in following action, provided the lens is not too heavy and cumbersome. If you plan to try this with a 600mm f/4 lens, you'd better do some weightlifting exercises first.

A motor drive is essential for good action photography. However, I rarely use the motor drive in a continuous run mode like a machine gun. There may be a few instances of fast action where that may be necessary, but I generally use the motor drive in single frame mode and time my shots accordingly. It gives me a better sense of timing and a somewhat better sense of the decisive moment to capture on film. I feel I have more control over the final picture.

And then there's animal behavior photography. Almost all editors I deal with have told me that, although they love the nicely done, posed wildlife studies, they yearn for good animal behavior photographs. Mating behavior, hunting and stalking prey, defense against rivals or predators, raising young, play, social

behavior and dominance in a group, almost any kind of interaction with members of the same or different species—these are all important things that make for great photographic studies. To do it well you need to immerse yourself in the study of the behavior of a particular species. Then you need to spend countless hours in the field waiting for those moments of behavior to capture on film. It's not the kind of wildlife photography that one enters into casually. But the rewards for a job well done can be a lot of published work simply because so few people have the dedication it requires.

Equipment. By its very nature, most wildlife photography entails the use of telephoto lenses. Today we have a great variety of top quality lenses to choose from. Some are moderate in aperture and price, others have large maximum apertures and equally large prices. What focal length to choose? And what maximum aperture is needed? What about extenders? Or mirror lenses?

Let's examine first something about telephoto lens design. True telephotos have one or more positive lens elements in front and negative lens elements at the rear to create an effective focal length that is shorter than the actual physical length of the lens. (Long focus lenses, such as the Leitz 560mm and 400mm Telyt lenses, have no negative rear elements and they are as long as their focal lengths, measured from the film plane.) In other words, a 400mm telephoto lens is considerably shorter in length than 400mm. While the negative rear lens elements make for more compact design, they also present problems in correcting for chromatic aberrations when attempts are made to increase the maximum aperture of the lens. For many years the maximum aperture feasible on, say, a 400mm telephoto was f/5.6 or, perhaps, f/4.5. Optical quality diminished greatly at larger aperture designs. And even using the lens wide open at those modest apertures didn't yield the highest resolution images. However, that's been changed with the introduction of very low dispersion glass. There are many high resolution telephotos available today using low dispersion glass, often denoted by the terms "ED" or "LD" to indicate "Extra-low Dispersion" or "Low Dispersion" glass. With these low dispersion glasses, apochromatic lens designs are possible. An apochromatic (APO) lens corrects for three points of the color spectrum (red, blue, and an intermediate wavelength in the yellow-green wavelength), rather than two points (the red end and blue end of the spectrum). Thus today's high resolution telephotos can have very large maximum apertures—600mm f/4 or 400mm f/2.8—plus apochromatic correction.

Do you need them? The answer will be determined not only by your pocketbook, but by the kind of wildlife photography you do. A lot of good wildlife photo opportunities come at times of day when lighting is not ideal. (In fact, I might argue that very little, if any, wildlife work should be done in harsh, direct overhead sunlight.) Using a high resolution film such as Kodachrome 64 in dim light requires a fairly large aperture or else a slow shutter speed. Since telephoto lenses magnify every little movement, slow shutter speeds will result in unsharp pictures from image blur due to camera movement. Even if a tripod is used to eliminate camera movement, the subject may move and cause an unsharp image. In order to use faster shutter speeds you'll need to switch to a faster film. But faster films are grainier and won't give the crisp, sharp pictures that slower emulsions will.

A large aperture telephoto would seem to be the answer. But before investing in one, be aware of a couple of drawbacks. First, size and weight. A typical 400mm f/3.5 telephoto weighs about six pounds. An f/2.8 is about two pounds more. Adding that to your regular camera outfit results in significant weight to carry around. If all your trips are by car,

KNOWING THE BEHAVIOR AND HABITS OF YOUR SUBJECT CAN HELP *greatly in getting the best shots. I had been observing this red fox for several days at the Chenik Wilderness Camp in Alaska. Every afternoon she would leave her den, where she had some young, to go off hunting. But when the weather was nice she would detour from her usual route to walk along the beach and take a few moments to loll in the warm sun. One sunny afternoon I beat her to her favorite spot on the beach and waited. My presence didn't bother her at all (I suspect because she had become used to seeing this strange biped with cameras wandering around her territory). She stretched out on the beach and posed as though she were on my payroll. Camera, Nikon FM-2; lens, 105mm Nikon; film, Fujichrome 50.*

ALTHOUGH IT'S NOT ALWAYS IN OUR CONTROL, IDEAL WILDLIFE *photographs, like other photographs, should aim to be clean and simple in design and composition. I had to spend an hour or more working myself into a position where I could capture these mountain goats with the blue sky as a background. The locale is, quite literally, my own backyard—14,214-foot Mount Evans, a half hour drive from my home in Evergreen, Colorado. No polarizer was used for this shot; that's the natural color of the sky at this elevation. Camera, Leica R5; lens, Leica 400mm; film, Kodachrome 200.*

it's probably not a problem. But I guarantee that you won't do much hiking or backpacking with a 400mm f/2.8 lens. And one of those monstrous 600mm f/4 lenses, weighing in at fourteen pounds, requires a pack mule for wilderness trips. Cost is another drawback. All that big glass is not cheap; you can spend several thousand dollars for a large aperture, low dispersion glass telephoto made by the main camera manufacturers like Nikon and Canon. Some independent brands like Sigma are a better bargain, offering outstanding resolution, large apertures, and relatively lower cost.

A more modestly sized (and priced) 400mm f/5.6 lens (also using low dispersion glass for excellent resolution) weighs only about two and a half pounds. Is the smaller aperture a big disadvantage? Not since the advent of Kodachrome 200 film. As discussed in the chapter on film, this emulsion is incredibly sharp for its speed. Using Kodachrome 200, you've effectively turned your f/5.6 lens into an f/2.8 without sacrificing film sharpness—and you've retained the lightness and portability of the f/5.6 lens.

For a lot of my work I prefer to carry smaller aperture, lighter weight lenses. I use the Leitz 400mm f/6.8 Telyt and the 560mm f/6.8 Telyt lenses for the Leica. (Those apertures are about one-half f-stop slower than f/5.6—but still not a problem when I use Kodachrome 200.) The total weight of both lenses together is less than a 400mm f/2.8. Furthermore, they break apart in the middle for compact carrying. And as a final bonus, I've tested these lenses carefully and they are, without doubt, the sharpest I've ever used. Incidentally, both lenses can be adapted to other cameras by a professional camera repair house. If weight isn't a consideration (when traveling by vehicle in Africa, for example), I'll use a Sigma APO 500mm f/4.5. It's shorter than the Nikon 500mm f/4, making it easier to pack in my carry-on baggage on airlines. And the quality is excellent.

Mirror or catadioptric lenses are very small in size and light in weight. Most are 500mm—a good focal length for much wildlife work. The maximum aperture of most is a rather small f/8. (This is a fixed aperture, by the way, meaning that you can't stop down for more depth of field.) In the past this small aperture almost always necessitated use of those higher speed, grainier films. With Kodachrome 200 it's no longer a problem—you have usable speed and a sharp film. Drawbacks to mirror lenses? At f/8 the image in the viewfinder does tend to be a bit dim. And not being able to stop down for more depth of field is a handicap at times. To me, the most distracting feature of mirror lenses is the out of focus "doughnuts" caused by any specular highlights in the background—highlights such as those you'd get from the surface of water. Finally, in terms of quality it's best to stick with your camera manufacturer's brand. I've tested some made by independent lens manufacturers and they aren't very good in resolution.

Lens extenders. These optical devices fit between lens and camera body and extend the focal length of the lens. A 2X extender doubles the focal length; a 1.4 extender multiplies the focal length by that amount. In other words, a 400 mm lens with a 1.4 extender becomes a 560mm.

Using a lens extender causes a loss in light reaching the film. For a 2X extender the loss is two f-stops; for a 1.4 it's one f-stop. So a 400mm f/5.6 lens with a 2X extender becomes an 800mm f/11 lens. With a 1.4 extender the same lens becomes a 560mm f/8 lens.

Quality? My testing indicates that most 2X extenders result in considerable loss of resolution when used at maximum aperture of the lens. Basically, the resultant pictures aren't sharp enough for publication use. Stopping the lens down one or more f-stops improves the quality considerably, but it also makes for a very

I WAS WORKING ON AN ASSIGNMENT FOR Smithsonian *magazine, an article about Larry Aumiller, the biologist/manager of the McNeil River State Game Sanctuary. In his many years of work here, Aumiller has gained a keen understanding of bear behavior that has led to an unusual, benign relationship between the bears and the people who come to visit. I needed a photograph that showed the friendly relationship between Larry and the bears. Maryanne, a 450-pound female, approached us out of curiosity. To create the perspective that heightens the sense of the bear's closeness (she was only about fifteen feet from us), I used a 70–210mm zoom set at about 150mm. Larry, with hands casually in his pockets, simply spoke a few words to keep Maryanne from coming any closer. Camera, Leica R5; lens, Leica 70–210mm; film, Kodachrome 200.*

small aperture. The 400mm f/5.6 lens with a 2X is an 800mm f/11 wide open; stopping down one f-stop yields f/16. Such a small aperture dictates use of a moderately fast film to maintain reasonable shutter speed. Of the 2X extenders I've tried, only the Leica gives pictures at maximum lens aperture that are publishable, but this device is considerably more expensive than any other brands.

The results using 1.4 extenders are much better than with the 2X. Even at maximum lens aperture, publishable quality pictures are possible with the brands I've tested. However, my advice is that you purchase the camera manufacturer's brand of extender. They cost more, but the quality is much better.

Autofocus lenses would seem to be a great aid in wildlife photography, but I'm not convinced that they are that helpful. In fact, in my experiences in using autofocus, in a few instances these devices actually slowed me down in getting the pictures I wanted. Why? First, I found that if I missed the focus mark the first time, it took almost a second for the autofocus mechanism to recycle and hit the focus correctly. Second, the autofocus indicator is right smack in the center of the camera viewfinder. Rarely do I want my subject centered in the picture. So, to re-compose with the subject in another part of the picture involves the following sequence: Center the subject so the autofocus will focus; push or hold in the focus lock button; re-compose the picture with the subject where you want; shoot. Doing it with manual focus, however, I can focus and compose simultaneously and get the picture quicker. This is extremely important when shooting moving subjects.

In my opinion, autofocusing has little value in serious wildlife photography. As I noted in the chapter on lenses, autofocusing can also interfere with control over depth of field. Given the choice, I'll stick with manual focusing lenses for more complete control.

A tripod is essential for using long telephoto lenses. It's always tempting to buy one of those flimsy jobs to save weight—but don't do it. There are some reasonably sturdy tripods of modest weight that will give solid support to your telephoto. Don't sacrifice image quality with a shaky tripod.

Incidentally—and this is a personal preference—the type of tripod with locking levers is faster and more convenient to use than those with screw collar rings. The latter seem more prone to jamming from water, dirt, mud, and cold weather.

A very convenient tripod accessory is a ball head. It gives excellent mobility and practically infinite degrees of freedom in moving the camera and lens into various positions. It's especially useful when you're using a macro lens and trying to position the tripod and camera to get a closeup. But I'd urge caution in using a ball head with a long and heavy lens. While it would appear that you can gain more mobility in following action with the telephoto, I haven't found a ball head that will hold long lenses steady enough to prevent image blur.

When working from a vehicle you might try a trick I use on African safaris—a beanbag. I'd recommend one at least twelve inches long by eight inches wide and about four inches thick when filled with beans. It's a very stable platform on which to rest a long lens and, so long as there's no movement in the vehicle, I've been able to get sharp results at surprisingly slow shutter speeds with long lenses. In addition, you have a great amount of freedom to move the lens in following a moving subject.

For trekking around in the field, I find a regular camera bag too inconvenient to carry. Instead, I prefer a rucksack in combination with a photo vest. The vest, and its endless supply of pockets, keeps things handy that I use often. The rucksack carries items I need less often—the longer telephoto lenses, for example. I also have a small belt pouch that contains a supply of film.

Use whatever works best for you. Don't get bogged down with too many gimmicks and gadgets. Remember, the final photograph is the thing that's of greatest importance.

LOOK FOR TELLING DETAILS IN YOUR TRAVEL PICTURES. ON THE *island of Lamu off Kenya's Indian Ocean coast, there's a feeling that you've stepped back in time two hundred years or more. But there are subtle reminders on this island where no motor vehicles are allowed—the T-shirt worn by the donkey rider. All else is old, very old, in this seat of Islamic culture. Cameras, Leica R5; lens, Leica 70–210mm; film, Kodachrome 64.*

IN THE TOWN OF ALESUND ON NORWAY'S WESTERN COAST, I WAS *struck by the distinctive architecture and the waterways—the town is built on a series of small islands. Early morning the water was calm, giving me this reflective study of the town. Camera, Leica R6; lens, Leica 70–210mm; film, Fujichrome Velvia.*

TRAVEL PHOTOGRAPHY

When I think of travel photography, I think of early explorers who set sail on long journeys and returned with exciting stories of fabulous adventures, told and re-told in courts and taverns or wherever people would listen in rapt fascination. Travel photography is storytelling photography, and today we bring home tales of our adventures in film cannisters rather than a ship's diary. But the similarity with ancient yarn-spinners is very real, for like all good storytellers we need to think in terms of drama, detail, and humor. Most of all there must be continuity. As in all good stories, there should be a beginning, a middle, and an end (and please, don't make the visual ending a sunset).

If this begins to sound a little like Cinematography 101, you're right. Some of the traditional methods in film making apply here, and our photo essays should embody some of those principles. For example, film sequences often open with an establishing shot—something that gives a sense of place—followed by a medium shot that brings us into a particular locale and begins to give us more detail about the place or people. And then there are detail or close shots that give us glimpses of action or people or events of importance to the story. The remainder of a particular film sequence is often a mix of medium and close shots with a pacing that gives visual rhythm and also gives us a good sense of the story.

Whenever I critique travel photo essays in my workshops, I find that many people never get beyond the establishing shot. Too many of the pictures are scenic or landscape shots, with little if any detail about people or events or culture or *things* that make a place unique or unusual. Some of this has to do with timidity—being reluctant to get too close to people. Some of it has to do with circumstance. For example, traveling with a tour group generally doesn't allow time to become intimate with people, events, or things. (In fact, group travel is often frustrating for serious photographers, because non-photographers just don't understand the need to spend a lot of time in certain places.) Let's look, in detail, at all the elements that go into good travel photography.

Planning. This should go well beyond the quiet evenings dreaming over travel agency brochures. Before I start on any magazine or book assignment, I spend a lot of time at a library doing research. Much of this has to do with the practical aspects of travel photography—climate and weather conditions to prepare for, potential transportation difficulties, accom-

modations, possible restrictions on travel and photography (many museums, both domestic and foreign, have strict rules on photography and some don't allow it at all).

Maps are vital in planning. I love maps and on more than one occasion those evenings spent poring over maps have helped me in getting a sense of place, the kinds of terrain, angles of the sun for good lighting, and planning for sunrise or sunset photographs. In one instance my obsession with maps allowed me to get some unique photographs. When planning one of my trips to Siberia to work on my book on Lake Baikal, I discovered on a detailed contour map a valley that seemed to have some spectacular features similar to those of Jackson Hole and the Grand Tetons of Wyoming. After arriving at Baikal, I arranged a helicopter trip, and later a drive by vehicle, into the Barguzin Valley and made the first photographs ever by an American—and perhaps by any non-Russian—of what can be called Siberia's equivalent of Jackson Hole.

In addition to visiting the library, a trip to some good bookstores is vital. A number of good guidebooks are available nowadays, covering almost any region or country on the globe. *Insight Guides*, and *Spectrum Guides*, in particular, are chockfull of great information dealing with culture, history, parks and scenic areas, climate, accommodations, travel, and much more, including useful maps. I generally don't carry these books with me (too much weight), but I do carry certain photocopied pages that I feel will be of use.

Be thorough enough in your research to avoid or minimize surprises. This is particularly important for climatic conditions. Some of the better travel guides list temperature and precipitation data month by month—important information to guide you in selecting clothing and rain or cold weather gear to bring. Also, in certain locales transportation can be a problem. To avoid time-wasting hag-

gling on the scene, you may find it advantageous to book in advance with a local guide service or arrange car rental before you arrive.

Obviously you need to check on any visa requirements for the countries you'll be traveling in. It's also wise to check on any shots or other health precautions required. Call the embassies involved for information.

While it's not necessary to become fluent in the languages of the countries you plan to visit, I find it enormously helpful to learn a few phrases of greeting and expressions of thanks. In most countries I've found that people are very appreciative and flattered by the fact that I've made some attempt to learn their native tongue. Many times this has elicited a great deal of help from people who might otherwise be shy or reluctant to help foreigners. Though I'm reasonably conversant in Russian and Swahili, I can also order a beer, find the men's room, say thanks, and ask a few questions in about six other languages. And it helps in certain photographic situations as well. On the remote Indonesian island of Komodo (home of the famed "Komodo Dragons"), I was photographing the people who live in the island's only village. One little boy and his mother, who were very shy and not at all used to being photographed, frowned at me in puzzlement until I said *terima kasi* (thank you), whereupon both broke into broad smiles and began talking to me. I didn't understand them, but I kept nodding and photographing them in a more relaxed, unposed manner.

Preparing photographically is different from the practical planning. It's nice to have some idea of the kinds of photographic possibilities and the only way to do that is to look at pictures of the place—pictures made by someone else. But there's a pitfall here: Like it or not, we end up with some preconceptions— photographic preconceptions. And if we're not careful, we can lose the capa-

THE IBAN PEOPLE OF SARAWAK, BORNEO *(Malaysia), are former headhunters, but really nice headhunters. These were cooperative enough to do some traditional dances for us. Most of us tend to be shy when it comes to asking people permission to photograph them, but more often than not a smile and polite request will elicit a positive response. You don't even have to speak the language—a smile and a friendly demeanor break down a lot of barriers. Camera, Leica R5; lens, Leica 70–210mm; film, Kodachrome 200.*

OPPOSITE: LOOK FOR WHAT I CALL SLICE- *of-life photos, something that captures the essence of a place or culture. In rural Russia, for example, and particularly Siberia, things are pretty simple and fundamental. These are snippets of life from Siberia: The motorcycle with sidecar is a common means of transportation; this family came to visit a camp on Lake Baikal. The kids and bikes are in the village of Tutai on Lake Baikal.*

In Alaska, a slice-of-life photo is of some very common footwear—hipboots, also called "Alaska sneakers." Look for details of this kind for your own pictures; it's easy to let them go unnoticed if you're not observant. Camera, Leica R5; lenses, various; film (kids on bikes) Fujichrome Velvia, and (others) Kodachrome 64.

bility of being innovative, and end up making photographs that are imitations of others. The Snake River Overlook in Grand Teton National Park is worn with footprints of photographers taking shots of the scene à la Ansel Adams.

So when I'm looking at the photographs of others in books and magazines, I ask myself not how can I imitate that picture, but how can I improve on it. For that particular place, how can I, using my own style, make a photograph that is better? Time of day? Angle of view? Lens choice?

Working under editorial constraints is different from having the freedom to shoot as you like. In some ways that's good, because editorial needs force me to be creative and to search out every photographic possibility. But in other ways it brings a lot of pressure: I *have* to produce something good and usable, regardless of weather, regardless of restrictions and problems, regardless of equipment malfunctions. It's what being a pro is all about. Which makes all the planning necessary. But even for an amateur, this planning can greatly help in accomplishing some great photography.

Equipment Choices. This is tough. Ideally, you'd like to bring every piece of photo gear you own, and some you don't, to cover all possible opportunities. The practical side says, NO WAY! A lot of what you *can* bring is obviously dictated by the kind of trip. Domestic travel by vehicle allows a lot more choices than foreign travel in remote regions. But even a tour of western national parks by car can present problems if you bring too much equipment. You still have to get out and carry that stuff. And leaving some of it behind in the vehicle is asking for theft.

My own general rule is to try to pack just enough equipment to give me the versatility I need, but no more than I can carry—on my back in a rucksack, or over my shoulder in a camera bag.

For lens choices, I often use zooms rather than fixed focal lengths. I can get a wide range of focal lengths out of a couple of zoom lenses, such as a 35–70mm and a 70–210mm. And I bring something shorter and longer—a 20mm, or, on occasion, a 15mm, and maybe a 400mm. The choice of long telephotos is dictated by the kind of photographic possibilities there are in a given place. If there's good bird and wildlife potential, I'll bring a long tele. Incidentally, one of the things I like about Leica teles—the 400mm and the 560mm—is that they break apart in the middle, allowing easy transport. And, in addition to superb sharpness, they're pretty light in weight, because they have relatively small maximum apertures—f/6.3. (That could be a drawback in low light, but not with Kodachrome 200 available nowadays.)

A macro lens is also vital, since many zoom lenses don't focus close enough, and those that have so-called macro focusing don't give as sharp an image as a good macro lens. And I bring an extension tube set for really close work.

For foreign travel, I have another rule of thumb: *Everything goes in my carry-on bags.* And I mean everything—cameras, lenses, film supply, the whole works. The only things I might put in check-through bags are spares—spare batteries, spare camera bodies, maybe a lens or two that I can really live without if they're lost. In all my jaunts around the world I've been lucky and had relatively few lost or delayed bags. But all it takes is once.

Also, your destination will dictate how much spare stuff you need to bring. In Europe, Japan, and many other countries there's no problem picking up batteries (unless it's an oddball variety) and certain kinds of film (though I still prefer to bring enough of my own to last the duration of my trip). But in Africa, Central and South America, Indonesia, Russia, or a lot of other places, you'd better pack what you think you'll need. There are no camera stores in Irkutsk, Komodo Island, Samburu, or Tikal. And even if there were, I'm not sure I'd trust

MY FRIEND ED BORG IS A WELL-traveled travel photographer and I like the way he seeks out color or the somber sense of a culture, as in this shot of fishing boats in Malta. Camera for both, Minolta 7000xi. (Photo copyright by Ed Borg)

LOOK, SEE, ISOLATE. THE CULTURE OF certain places is so different from our own that, at first, it seems easy to capture the essence of it. But sometimes it's so overwhelmingly different that you still lose sight of details. I found that true in Bali on my first trip. It is a place where aesthetics are interwoven throughout the whole culture; from a hibiscus flower placed on a statue, to incredible dances involving dragons of folklore. Camera, Leica R5; lenses, Leica 35–70mm and 70–210mm zooms; film, (hibiscus) Kodachrome 64 and (dragon) Ektachrome 100 Plus.

the batteries or film found there.

My camera bags are pretty scruffy, and that's deliberate. Part of my philosophy to protect gear from being ripped off is to maintain a low profile. Aluminum camera cases are asking for trouble, because all over the world they've come to be associated with expensive camera equipment. My two carry-on bags look like they've been through the Civil War. In fact, one of the bags is just a plain, black canvas over-the-shoulder tote bag. I'd also avoid these lovely, new designer-signature bags that smack of $$$. (Sorry, Galen, it's great equipment, but it attracts too much attention.)

Cameras, too, attract attention when slung around the neck or over the shoulders. To minimize that, I cover the name plates with black tape, transforming my expensive Leicas and Nikons into generic unknowns. Also, avoid those colorful camera straps with brand names all over them. I usually carry two cameras, one slung over each shoulder with the lens facing *inward*. This tends to shield the camera from the view of anyone approaching (and also keeps the lenses from whacking against narrow doorways). Carrying two or more cameras around your neck, in plain view, can be asking for trouble in some big cities. The idea is to maintain a low profile, particularly in those parts of the world where crime is rampant.

Additional items that might prove helpful are plastic bags, in a variety of sizes, to keep things dry in rain or from spray on boats, electrician's tape for quick repairs, and a set of jeweler's screwdrivers for tightening things that loosen up.

I recommend that, traveling overseas, you don't keep passport or money in your camera bag. If the bag should be ripped off, you could face a lot of hassle without a passport and money.

As mentioned above, I have all my film with me in my carry-on bags. DON'T put any film in check-through baggage, because X-ray machines used on checked bags are much more powerful than at the security gates. I don't mean to suggest that all checked baggage is X-rayed at every airport, but I've been told that it happens often enough to not take chances on ruining film. What about security-gate X-rays? In the United States, airport security people must honor requests to hand-inspect camera equipment and film. Fine. But if your film supply is still in the opaque Kodak cannisters, at some airports security personnel will open every single one to look inside. If you've got two to three hundred rolls of film, you might miss your flight. To avoid this hassle, I save—and have my film lab save—empty, transparent Fuji film cannisters and I reload my Kodak films into these. For overseas travel, I often take the film out of the cannisters completely and put the cassettes into heavy duty Zip-Loc bags. This not only allows easy visual inspection, but it saves bulk as well. I put the cannisters in separate plastic bags in my check-though luggage, then reload the film into the cannisters when I arrive at my destination. (The cannisters do provide a good degree of protection against dust and moisture.)

In most foreign airports, security people *do not* have to honor requests for hand inspection. So your task is to get them to do so. Having film out of cannisters in plastic bags, described above, will help to show them how effortless it will be to hand-inspect. A smile and polite demeanor also help. But if all fails, I usually carry some lead-lined film-shield bags folded up in one of my camera bags. Frankly, I'm not sure how effective these really are, because security people are still able to see the film inside the bag when it goes through the machine.

In all honesty, I must tell you that I've become far less concerned about X-rays than in the past. My philosophy nowadays is, if you can avoid X-rays, do so. If not, well, I'm not too concerned—at least, in certain places where I've been traveling frequently in recent years. I've

LOOK AROUND FOR DISTINCTIVE ARCHitectural details, like windows or doors; in Siberia there are these traditional shuttered windows, sometimes ornate, often colorful. In the city of Khabarovsk in the Siberian Far East, I found this colorful window of a fish market. Who says Russia is drab? Also in Khabarovsk I found this Russian version of hopscotch some kids had chalked on the sidewalk. Keep your eyes open for these details as you wander new towns and cities. Cameras, Leica R5 and R4sp.

111

had film zapped—sometimes more than twice—in Helsinki (where security people seem to have the personality of Nazi storm troopers), Zurich, Frankfurt, Madrid, Nairobi, Moscow, in places in the Far East and other areas of Africa, and frankly, I haven't seen any problem. Once, several years ago on a trip across the then–Soviet Union, my film got zapped at least five times—including some 800 speed emulsions—and I didn't detect any damage. At least, not that I could ascertain, and I'm pretty critical when I look at my transparencies.

One last item concerning overseas air travel: Many foreign airlines restrict carry-on bags to one per person. With all my gear and film, I need two. So a few weeks before an overseas trip, I call the executive office of the airline, asking for someone in authority over such things, and obtain a letter permitting me to have two carry-ons. Most times flight attendants don't enforce the rule, but it helps to have back-up just in case.

Tripod? Flash? These depend on my destination and kind of shooting. On safari in East Africa a tripod isn't really needed most of the time because you're confined to a vehicle in the game parks and a beanbag resting on the roof hatch gives good solid support. In the rain forests of Borneo or Central and South America, a tripod is essential. If you're going to be photographing primarily people and cultural things, a tripod can get in the way of photographic fluency and, sometimes, the need to work quickly to capture a fleeting expression or action. If tripods could be filled with helium and didn't weigh anything, I'd probably bring one all the time. But when I'm working as a photojournalist, it's a hindrance. I mean, if you're walking down a street in Bali with two or three cameras slung over your shoulder and around your neck, carrying a tripod in your hand, what do you do with it when you see some fleeting photo opportunity and you need both hands free to shoot? Drop it on the ground

with a thud? (And attract attention?) For situations like this, keep yourself free and unencumbered. Leave the tripod home, or at least in the hotel.

Flash, too, is problematical. It's great for interiors and those dim light situations outside. But, it also attracts attention and often makes people shy away. I usually carry at least one small on-camera flash unit, and occasionally my big "potato masher," a higher-powered flash. However, I also try my damndest *not* to use them because of the intrusion.

For example, I photographed a Russian Orthodox church service in the Siberian city of Irkutsk at a time when people were still nervous about government repercussions over active religious expression. Understandably, these people wanted privacy. With a nod, a smile, and a point to my camera to ask quiet approval, virtually everyone nodded assent to allow me to take pictures. But I did so quietly and as unobtrusively as possible, using Kodachrome 200 pushed to 500 and with a relatively fast f/2.8 zoom. (Some of the portraits of children holding candles were illuminated almost entirely by the candlelight, using 1/15 of a second shutter speeds, hand-held—carefully.) Had I used a flash, I think people would have been very upset.

Film choices? Another tough one. It really depends on where you're going and the kinds of shooting you do. By having that Kodachrome 200 with me, I was able to photograph in the church in Irkutsk. I usually carry a mixture of different films and the ratio varies as to locale. On safari in Africa I'll bring a lot of Kodachrome 64, some Fujichrome Velvia (for really wild color), some Ektachrome 100 Plus Professional (EPP) when I need a little more speed, and a bunch of Kodachrome 200—probably equal in amount to the Kodachrome 64 and EPP. Also, I bring a couple of dozen rolls of Ektachrome 400X, and maybe half a dozen rolls of Ektachrome 800/1600 (EES). If I'm going to a rain forest envi-

ronment or places of constant gloomy weather, I'll skew that ratio in favor of more Kodachrome 200 and Ektachrome 400X.

If my destination offers opportunity for lots of interior photography or adequately lit stage presentations, I'll bring several rolls of Ektachrome 160, a tungsten-balanced film. Pushing it one stop, rating it at 320, gives great results. (Remember that because "pushing" the film requires special processing, it is important to notify your lab accordingly.)

Amount of film? Another tough one. As a rule of thumb, I usually recommend ten rolls per shooting day (as opposed to traveling day). But obviously this should be tailored to your own shooting style. If you bracket a lot, ten rolls per day could be about right. If you don't, you can get by with less. My philosophy is, *it's far better to bring back with you unused film than to run out when the photography is great.* There have been times on safari in Africa when the action was so incredible that I've shot over forty rolls in a day. The same is true of certain times in Alaska at McNeil River photographing bears—on one memorable day I shot fifty or more rolls. Makes you feel like you need a water-cooled motor drive!

The Travel Photo Essay. When I arrive at a destination, be it domestic or foreign, I try to open up my senses to everything around me. During the first several hours I may take few, if any pictures, and concentrate instead on *seeing* and scouting out the good photo possibilities. What time of day for this place, what time for that? Where are the details? What's distinctive about dress and architecture and flora and fauna and culture? Above all, I really do think *story.* I look for the establishing shots that set the scene, then the detail pictures to show the distinctiveness of the place. I look for variety. I look for *soul.*

One *Life* magazine photographer I knew back in the 1960s had an interesting philosophy about assignments. He said that he concentrated intensely on making the *one single* photograph that captured *everything* about the essence of the place or subject of his photo essay; one photograph that said everything, visually, that needed to be said. I asked him if he ever accomplished that, and he said no, he didn't feel that he had. (And this was the photographer who sat next to Castro on his triumphant drive into Havana in 1959.) But by adopting that mindset, it made him concentrate that much more on the story and made all his pictures better.

Most travel photography involves people. And people photography isn't easy. The problem is, people react to a camera, sometimes adversely, sometimes in a shy or self-conscious way. Either way, it's difficult to get natural, unposed photographs. We all have to work out our own methods of dealing with this. You can be sneaky and keep your distance, using a long telephoto lens, but sooner or later you're discovered and, more often than not, people get angry at such sneakiness. There are many places in the world where people just do not want to be photographed—and it has nothing to do with "stealing their spirit." Sometimes, as in Africa, they want compensation because, in their minds, they've come to believe that most photographers make money selling their photos and these people would like a share of it. In other places it's a feeling of intruding on the privacy of individuals—and I can't say I blame them, after seeing how rude some photographers can be.

For my own personal style of photographing people, I don't like being sneaky. I try to communicate with my subjects. I've learned how to ask, politely and with a smile, permission to photograph someone in Russian, Swahili, Indonesian, Spanish, Zairoise, Yupik Eskimo, and Navajo. And undoubtedly I'll learn it in many more languages before I hang up the cameras. More often than not, the request is granted.

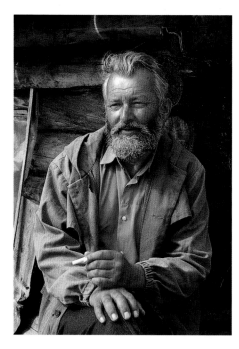 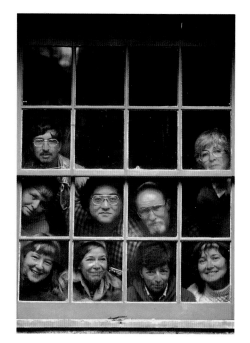

The first thing that happens, of course, is that your subjects begin to pose rather stiffly. That's okay, let them. Usually the reason I want to photograph them is that they are engaged in some activity—carving wooden artifacts, or weaving, for example. After I've made a few pictures in the posing phase, I try to discuss with them—in their language, if I know it, or through an interpreter—the activity they are engaged in, asking interested questions about how they accomplish their task. Most people are proud of their accomplishments and soon lose themselves in talking about—and demonstrating—their skill. By then they've forgotten about your camera, even though I usually keep mine to my eye while asking questions. Very often this technique can generate some wonderful rapport with people—sometimes lasting well beyond the time needed for pictures. More than once I've not only gotten good pictures, but been invited in for vodka, pombe, tuak, or tea.

In photographing people, don't forget details—like the hands of a wood carver, farmer, or fisherman. Or distinctive headware. Or footwear. In Alaska, out in the remote bush, many people run around in turned-down hip boots, because they're getting in and out of boats or float planes. These are called "Alaska sneakers," and they are definitely a distinctive feature of the state.

Costumes and distinctive clothing are important elements in a good travel story. However, in many places people dress just the way we do most of the time and traditional, ethnic clothing and costumes are worn only during certain festivals and holidays. Therefore, it's important to check dates of such holidays and festivals when doing pre-trip research.

Signs add a distinctive flavor to a travel photo essay. I'm always on the lookout for unusual or humorous signs and on a number of occasions travel publications have used such pictures. In certain foreign cities the modern architecture makes them look like any other city. Including signs in the pictures helps to identify locale. (I'm not necessarily suggesting here signs that have the name of the city, but signs in the language of the country—anything that gives a strong visual clue that it isn't Cleveland.)

Architectural distinctiveness is another feature to look for. Some is obvious—the onion-domed spires of Saint Basil's Cathedral in Moscow, the white-washed buildings of the Greek islands, the temples of Thailand. Some is subtle. In rural Sweden, the rolling farmlands and farmhouses are reminiscent of rural Pennsylvania or New England. Only when you look closely do you discover certain design features that are distinctive—like window and door trim or elevated barns.

When all of this is blended together—distinctiveness, detail, people, mood, action—you should have a visual story that flows like a good movie script.

114

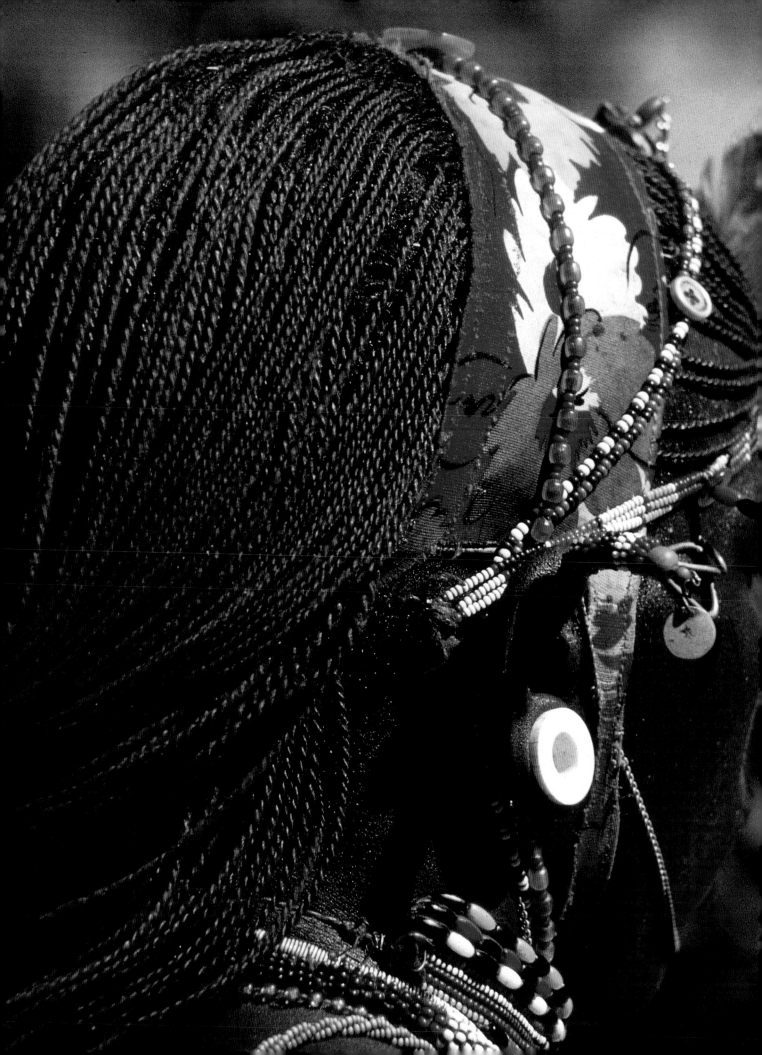

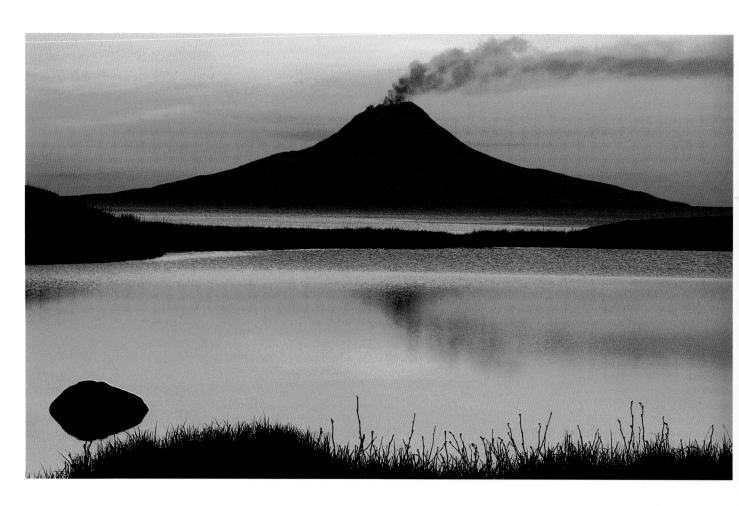

LANDSCAPE AND SCENIC PHOTOGRAPHY

GOOD LANDSCAPE PHOTOGRAPHY *embodies mood and drama in such a combination as to capture the feeling of a place. Timing is often crucial. I was up before dawn to get this shot of Alaska's steaming Augustine Volcano from Chenik Head, taken three months after a major eruption. Camera, Leica R5; lens, Leica 70–210mm zoom; film, Kodachrome 64.*

TIMING WAS ALSO CRUCIAL IN THIS *dawn shot of the mountains above the Brown Bear Coast of Lake Baikal in Siberia. The color and the clouds changed quickly. Camera, Leica R5; lens, Leica 70–210mm zoom; film, Kodachrome 64.*

When photography was young, many of its first practitioners were landscape photographers. Part of the reason for this was purely practical: The first available emulsions were so very insensitive to light as to require bright, sunlit scenes in order to form an adequate image. Thus, much early photography was done outdoors.

However, certain kinds of landscape photography also came about by virtue of a strong movement in the world of art toward romanticism in the portrayal of nature. In both Europe and America, artists painted landscapes of pristine forests and mountains and lakes, done in such a way as to evoke a romantic, Garden-of-Eden feeling toward nature. The wilderness, heretofore considered a fearsome enemy of humanity that had to be conquered and subdued, was suddenly glorified as a place of scenic grandeur, inspiring and uplifting to the human spirit.

In America the development of practical photographic processes and equipment coincided also with the great westward expansion of our nation. By the 1870s, when the use of wet-plate emulsions made field photography a feasible, if somewhat cumbersome, art form, large parts of the eastern and southern United States had been settled and tamed. What wilderness remained was in the West, and thus there emerged several hardy pioneering landscape photographers who roamed the untracked regions of desert and canyon country of the Southwest and the rugged Rockies and Sierra Nevadas.

The tradition began with one of the best-known of early landscape photographers—William Henry Jackson. He was born in 1843, during the time in which daguerreotypes were the most common form of photography. His first job, at age eighteen, was that of a photographer's assistant and artist (retouching prints). There he learned the necessary skills of dealing with the cumbersome wet-plate process, part art, part chemistry, part physics.

After the Civil War he traveled west, eventually ending up broke in Omaha. In order to earn money, he took another job as a photographer's assistant and, in

117

a short time, found himself able to buy out his employer with a small down payment. Jackson's love of the outdoors, and the West in particular, led him to pursue contracts with the westward-expanding railroads to photograph scenery along their routes. Soon he established a reputation as one of the finest of landscape photographers, leading Dr. Ferdinand V. Hayden to contact him in 1870. Hayden, one of the directors of the Geological and Geographical Surveys of the Territories, established by Congress, was leading a series of yearly expeditions to map and survey parts of the little-explored regions of the Rocky Mountains. He asked Jackson to serve as official photographer, and the young man accepted eagerly.

Thus, in the summer of 1871 and at the age of twenty-eight, Jackson found himself with the Hayden Survey in the mystical region called Yellowstone. It was still largely *terra incognita*, even though early fur trappers had explored parts of it as early as 1807. Even when such people as the legendary Jim Bridger described smoking hills and boiling geysers, few believed them. Thus Jackson portrayed to the world, for the first time, these and other wonders of Yellowstone.

The following winter his photographs were to assume an important role in the history of conservation. Jackson's prints, together with the paintings of artist Thomas Moran, who also accompanied the expedition, helped to convince a rather indifferent Congress to establish Yellowstone as the world's first national park.

Jackson continued his work with the Geological Survey for many more summers, visiting and photographing such places as Yosemite, the Grand Tetons, Mesa Verde (he was one of the discoverers of the Anasazi cliff dwellings there), Chaco Canyon, and the region of what is now Rocky Mountain National Park. Directly and indirectly his photographs helped in establishing those and other places as national parks. He continued

his landscape photography for many more decades, eventually traveling around the world. At the age of ninety-six, on another trip to his beloved West, Jackson tried out a wondrous new film— Kodachrome! ("Oh, I wish I could do it all over again in color," he remarked.) He died at age ninety-nine, one of the most remarkable landscape photographers ever.

It's difficult to comprehend the work required of Jackson and other early landscape photographers to make a photograph. Today we zip into Yellowstone by car, carry two or three electronic cameras with a wide variety of lenses, shoot hundreds of color pictures, zip home again to get film processed, then project our glorious color images for friends to see. For Jackson and others, it was a major expedition, first by horse-drawn wagon for weeks, then by pack mule in the wilderness where horses and wagons couldn't go. The total weight of his equipment was over three hundred pounds. Jackson's basic camera was an 8x10 format. On occasion he used 11x14 (some photographers, such as Timothy O'Sullivan, used cameras as large as 20x24 inch format!). When Jackson found a scene he liked, it meant unloading all the gear from the mules and setting up the dark-tent. Then he disappeared into the confines of the tent to begin sensitizing a plate. Actually, the tent was not completely dark, being lined with a yellow muslin to allow a dim yellow-orange light to filter through, acting like a safelight. The emulsions were orthochromatic, sensitive primarily to the blue end of the spectrum and thus not affected by the dim light.

To prepare a plate, Jackson would first extract a clean piece of glass from specially padded and slotted leather cases. The glass had to be cleaned carefully before the next step, the coating of one side with a layer of collodion—cellulose nitrate dissolved in ether—in which potassium iodide had been dissolved. The thin collodion film served as a medium to hold the light-sensitive emulsion in much the

THIS ONE DIDN'T ENTAIL WORKING *quickly, but rather waiting for the right light. These marabou storks had perched in the acacia tree in Kenya's Masai Mara Game Reserve, but the lighting was dull, flat. A nothing picture; about fifteen minutes later, it became something much more dramatic as the setting sun dipped below the cloud cover. Camera, Leica R4sp; lens, Leica 560mm; film, Kodachrome 200.*

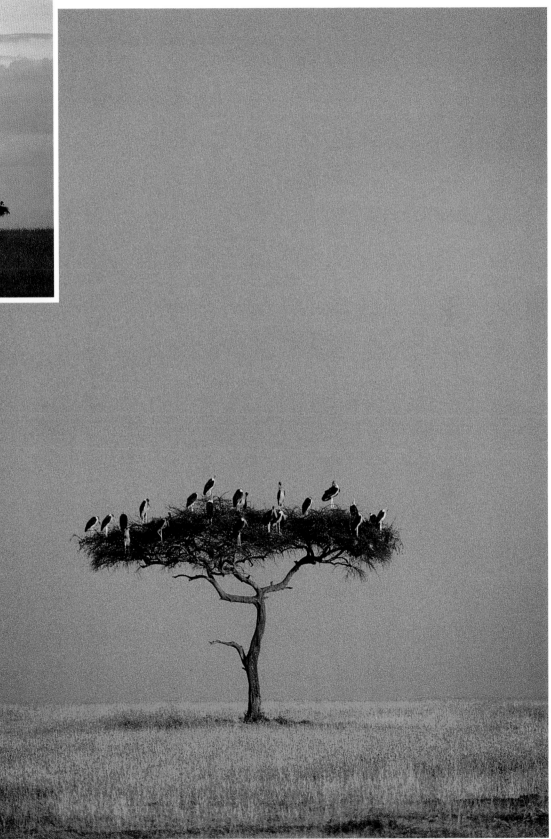

WEATHER SO OFTEN DICTATES THE FEEL-
*ing of a place and the beauty of a scene. I
mean, clear blue skies are okay, but for me
I'll take the drama of weather. Near the In-
donesian island of Komodo I photographed
these gathering storm clouds in early morn-
ing light. Camera, Leica R5; lens, Leica
70–210mm zoom; film, Kodachrome 64.*

IN KENYA'S MASAI MARA GAME
*Reserve, I photographed these storm clouds
in late afternoon light. Note how placing the
horizon line low in the picture creates a sense
of the vastness and openness of this country.
Camera, Leica R4sp; lens, 70–210mm
zoom; film, Kodachrome 64.*

IN THE ARRIGETCH PEAKS OF ALASKA'S
*Brooks Range I photographed these rugged
pinnacles under gloomy skies, with a slim shaft
of light coming through. The somber mood
of overcast conveyed the coldness of the land-
scape. Camera, Nikon F3; lens, 105mm
Nikkor; film, Kodachrome 64.*

same way that gelatin does in modern film. Next, the plate was dipped into a solution of silver nitrate and left for several minutes while a light-sensitive precipitate of silver iodide formed on the surface of the collodion. The plate was then loaded into a light-tight holder and was ready for exposure in the camera. There was one catch, however: The exposure and subsequent development of the image had to be carried out before the plate dried. (Otherwise, the emulsion lost much of its sensitivity and was rendered useless for making photographs.) After exposure, the film was developed, fixed, and dried.

Jackson and others of his era had to be skilled in the combined art and science of photography, chemistry, and sensitometry, and only after long experience did a photographer acquire the necessary "feel" for the working medium. There were many problems to cope with, such as available water supply, which might range from the mineral-laden waters of Yellowstone to pure mountain streams.

Then there was exposure. Compared to modern films, the wet plates of Jackson's era were incredibly insensitive to light, corresponding roughly to a film speed of 0.1. By comparison, Kodachrome 25, considered a rather slow film today, is 250 times faster than Jackson's wet plates.

Despite the seeming crudeness of equipment and emulsions, and despite the difficulties and problems, Jackson and others were able to create photographs of exquisite beauty.

So I don't want to hear any complaints about equipment or film.

TECHNIQUES AND EQUIPMENT

I became a landscape photographer in the early 1960s when I began my career as a nuclear physicist at the National Reactor Testing Station in Idaho. We used to ride a bus from Idaho Falls fifty miles out into the vast desert where the

project was located. To many people, this desert, part of the Snake River Plain and a northern extension of the Great Basin Desert, appears to be a bleak and barren place. I found it incredibly beautiful. There were frigid January mornings, with the temperature well below zero, when the land was blanketed with snow, blue and cold, and the dawn sun painted the snow-covered peaks of the Lost River and Lemhi ranges a brilliant orange. It was like a depiction of the end of planet Earth, the sun a dying white dwarf and the world frozen and lifeless. In summertime dark thunderstorms, with sweeping curtains of rain, moved ominously across the desert on jagged legs of lightning. In spring, cactus blossoms, Indian paintbrush, evening primrose, bitterroot, globemallow, and scores of other kinds of wildflowers splashed vivid color amid the gray-green sagebrush. And at any time of year there were fiery sunsets when the sky blazed with red, yellow, orange, magenta.

As I said, I became a landscape photographer in those days. Unfortunately, security regulations wouldn't allow me to carry a camera to the project. So I had to satisfy myself with taking *mental* photographs of those glorious scenes.

One key to good landscape/scenic photography is *timing*. Anyone can barrel up to the rim of the Grand Canyon in the middle of a hot summer day, take a snapshot, and roar off in a cloud of dust. But a good landscape photograph of the Grand Canyon takes time to find the right place and the right time of day in which to capture the color and drama of this magnificent place. Sometimes it's a combination of serendipity and sweat. Galen Rowell tells of running for a mile (at 11,000 feet!) across the steppes of Tibet, chasing a storm, to make his famous photograph of the rainbow over the Lhasa Monastery. Sometimes it's crucial timing. Ansel Adams had only moments in which to set up the camera, before the twilight faded, to make his famous "Moonrise over Hernandez, New Mexico"

photograph.

Timing relates to being there at the right time. To me the essence of good landscape/scenic photography is capturing some of the many moods of a place. And also capturing some element of drama. Most often, good landscape photographs are made by taking advantage of unusual lighting or changing weather—storms, clouds, fog, mist. Unfortunately, the weather and lighting don't always cooperate. In her excellent book, *Capturing the Landscape with Your Camera*, my friend Pat Caulfield sums it up well: "You can't force the sun to shine, the rain to fall, or a plant to bloom."

To someone who has never tried it in a serious way, it would appear that landscape photography is very easy: You just point your camera and shoot. Only after viewing many disappointing pictures do you realize how much work can and must go into a good landscape photograph.

Whether it's near home or on a distant journey, start your landscape photography expedition by allowing enough time. Since many of us do our landscape photography on vacations, it's important to plan those trips well. As in the case of travel photography, a certain amount of time can be saved by doing some research on a particular place. Because weather often dictates mood and creates the kind of dramatic lighting for good photographs, do some research on the weather and climate of a place you plan to visit.

For example, in many places in the Colorado Rocky Mountains, afternoon thunderstorms are common in the months of May, June, and sometimes parts of July. As these storms begin to form, clouds build up over the peaks, first as puffy white cumulus, then dark, forbidding cumulonimbus. Soon, lightning crackles among the peaks and the sky is dark and forbidding. All of this makes for dramatic photography. The rain is often brief, but pounding. Veils of rain sweep downward from blue-black clouds. Later,

as the storm passes, clouds begin to clear. Shafts of sunlight poke through ragged holes in the clouds, creating spectacular lighting. Hillsides of trees are illuminated brightly by rays of sunlight, while other areas are dark and somber. The contrast between the light and dark, the bright colors and somber colors, makes for dramatic scenics. Finally, as most of the clouds clear away, the land is bathed in sunshine again, but this time everything gleams wetly, bright and shiny. More great photography. Sometimes the warming sun evaporates the water left by the rain, creating mist and rising vapors. More moody effects. And, since storm clearing is often in late afternoon, the remaining clouds are painted brilliant colors as the sun begins its descent below the horizon. The whole show could well have been staged by Eastman Kodak to sell film. On such days you can shoot a great many great pictures.

However—and this is where the timing and planning are so important—if you visit the Colorado Rockies in August and September, you may miss such dramatic scenes. The weather patterns at that time of year most often consist of day after day of boring blue sky, with few if any clouds or storms. So pre-trip research becomes important if you hope to be there for the drama.

Don't try to take in too much on a given trip. Again, whether your photography expedition is near home or a longer vacation trip, you have to allow a reasonable amount of time. As I discussed in chapter one, to capture the essence of a place on film, it's necessary to absorb it, feel its moods and qualities. You can't do that if you spend one day in Grand Teton, another day in Yellowstone, and yet another in Glacier National Park. You would be better off concentrating your available time in only one place, and visiting another the next year. I find that so much of my own successful photography of a place hinges on how long a time I spend there. It has to do with the feeling

SIBERIA'S LAKE BAIKAL, SISTER LAKE TO *Lake Superior, is the oldest and deepest on earth. It also has some of the purest water in the world, and to capture the clarity of it I made this shot with a 21mm ultra-wide from a boat as we pulled into shore on Ushkanyi Island. The perspective was such that the lens gave a downward view, into the water, as well as outward. Camera, Leica R5; lens, Leica 21mm; film, Fujichrome Velvia.*

REFLECTIONS CREATE A SENSE OF *peacefulness. The water is unrippled, undisturbed. To reinforce that peaceful feeling I composed this picture of Lake Marie in Wyoming's Snowy Range with the image divided nearly in half—a symmetrical composition, in other words. Aren't we always taught that is a compositional no-no? But why not, if it works? Camera, Leica R5; lens, Leica 35–70mm zoom. Film, Kodachrome 64.*

USING REFLECTIONS IN ANOTHER WAY, I *chose to show the Chigmit Mountains in Alaska's Lake Clark National Park as a reflection on a calm morning. The rocks and shoreline at Turquoise Lake give a sense of place. Camera, Nikon F3; lens, 55mm Micro-Nikkor; film, Kodachrome 64.*

I develop for a place and experiencing many changing days and nights. This is an intangible element, but an important one in good landscape photography: The more you get to *know* a place, the better your photography of it.

The ease with which we can transport ourselves from one place to another, coupled with plenty of film and motor driven cameras, tends to make us try to cram too much in a given time. Because we can make photographs quickly and fluently doesn't mean we *have* to shoot quickly and move on.

Having decided to concentrate on a particular region or place, you need to consider the equipment to use for landscape photography: camera(s), *format* of cameras, lenses, film, tripod, etc. Traditionally, landscape photography seems to be most often associated with large format view cameras. Certainly many of the great, more contemporary landscape photographers used large format—Ansel Adams, Eliot Porter, Edward Weston, Phil Hyde, and others. But it's not absolutely essential to use large format.

You need to ask yourself how you intend to use your landscape photographs. Slide shows for your own personal pleasure and to share with friends? Small prints (up to 11x14), again for your own personal pleasure and perhaps home or office decor? Or do you have the ambition to exhibit and possibly sell prints, especially larger-sized ones (over 11x14 size)? If the last is your choice, then you might consider a medium or large format camera. For the others, there's nothing wrong with the quality available from 35mm format. Available films and lenses make it possible to get excellent results, and even some fairly large-sized prints that are sharp. But for best results, you might want to assume a large-format mind set in your 35mm work. This means spending extra time analyzing the image in the viewfinder.

I remember once discussing with Phil Hyde, a dedicated large format photographer, the pros and cons of 35mm versus large format cameras. I joked with him about having to lug all that heavy stuff around, and he laughed, agreeing. But then he got philosophical for a moment. "You know," he said, "the nice thing about a large format camera is that when you get everything set up and stick your head under that focusing cloth, the whole rest of the world goes away and you're left with that big, beautiful image to concentrate on."

He's right. Large format cameras do force you to be more deliberate. Besides, with the cost of each picture being up to ten times the cost of a 35mm shot, you soon learn not to waste pictures. If you ever have an opportunity to do some large format work, it will help to instill discipline in your photography.

If you do your landscape photography with 35mm format, you should pay careful attention to that viewfinder. Often, landscape photographs are made up of many elements. It's necessary to concentrate carefully on the image in the viewfinder to be sure that you have a harmonious composition, with all those elements working together. So stop, think, analyze before taking the picture.

Lens choices. As I mentioned in the chapter on creative use of lenses, there's a mistaken belief that most good landscape photography is done with wide-angle lenses—because they give a more panoramic view. In fact, wide-angle lenses can be disappointing unless they're used carefully, which usually means including some strong foreground elements to give a sense of space and perspective. For mountain landscapes, more often than not, a medium telephoto lens can give a much stronger sense of the grandeur of mountain scenes. That's because telephotos can magnify or amplify the height and size of mountains in relation to foreground elements. In 35mm format, my own favorite focal length for many landscapes is a 100mm to 135mm lens. This range of focal lengths comes closest to being the ideal perspective for many scenic photographs.

If you use a large format view camera, or sometimes a medium format, you have to use a tripod. No way can you hand-hold a 4x5 view camera. With 35mm, however, it's possible to hand-hold—and sometimes get acceptable results. But I would advise making a tripod a part of your routine with 35mm landscape photography. First, it gives a stable enough platform to use slower shutter speeds that can't be used hand-held. And the reason that you might use these slower shutter speeds is because you need to use a smaller lens aperture for great depth of field. The one hallmark of good landscape photographs is supreme sharpness, giving great clarity to the land and sky and other elements of the picture. It is, in the tradition of landscape photographs, a way of giving the viewer a feeling of standing there and sensing how this land *feels*.

Another reason for using a tripod is to make you work more deliberately and carefully. Merely putting the camera on a tripod makes me think more carefully and analyze just what it is that I hope to accomplish in this picture. I begin to adopt a large format attitude about my picture taking.

THIS REFLECTION, IN A NORMALLY DRY WATERHOLE IN MONU-
ment Valley straddling Utah and Arizona, struck me as being surre-
alistic. To enhance that surrealism, I used a 15mm ultra-wide-angle
lens, composing with perfect symmetry. Camera, Nikon FM-2; lens,
15mm Nikkor; film, Kodachrome 64.

WILLIAM HENRY JACKSON, PIONEER LANDSCAPE PHOTOGRA-
pher in the American West, went where no photographer had been
before, and today his pictures still rank among the best. Photo at
Glacier Point, Yosemite Valley—before there was a Yosemite Na-
tional Park. Camera, probably an 8x10 view camera, possibly 11x14;
lens, unknown; film, wet plate, equivalent ISO speed about 0.1.

CLOSEUPS

CLOSEUPS RANGE FROM MEDIUM *distance subjects to extreme closeups of tiny objects. In the medium range, I often look for patterns of nature, as in these aspen leaves and spruce cone. Shooting straight down at a medium distance allows enough depth of field to keep subjects sharp; it's still necessary, however, to use a tripod for best results, particularly because soft overcast lighting—the best kind for this sort of work—dictates using shutter speeds too slow to hand-hold. Camera for both, Nikon FM2; lens, 105mm Micro-Nikkor; film, Kodachrome 64.*

AT ABOUT EIGHTEEN INCHES AWAY FROM *the subject it's possible to stop the lens aperture down for enough depth of field to maintain the sharpness of this tundra lady slipper orchid and its surrounding vegetation (far left); however, moving to within inches with a macro lens or extension tubes causes depth of field to shrink, even when the lens is stopped down to small or medium aperture. So when the depth of field is only a fraction of an inch, what parts should be sharp and what parts unsharp? Here I kept the front edge and surface of the orchid in the depth of field zone for sharpness and let the rest of the flower and background be unsharp (left). That softness actually enhances the delicacy of the flower. Camera, Leica R5; lens, 100mm Leica macro; film, Fujichrome 100.*

One of the qualitites of closeup photography that makes it so fascinating is that it allows us to see in great detail a part of our world we normally overlook and often trample underfoot. I remember as a kid spending a lot of my time lying on the ground, on my stomach, looking at tiny things—ants, blades of grass, foliage of ground cover, decaying leaves, spider webs, a world of infinite variety and fascination. It's all still there, and more. Closeup photography gives you a chance to become a bold explorer in a strange new world. To enter this new realm, you need a few items of special equipment and you will need to understand certain techniques to deal with problems you will encounter.

Closeup choices. Most regular lenses have a minimum point of focus that's too far away for good closeup work. There are three basic ways you can focus closely: 1) supplementary closeup (diopter) lenses that fit over the front of a regular lens; 2) extension tubes used in conjunction with regular lenses; and 3) a macro focusing lens specially designed for closeup work. (Actually there is a fourth method using a bellows extension, which is basically the same as extension tubes, but allows continuous magnification changes over a wide range.) There are advantages and disadvantages to each method.

Supplementary closeup, or diopter, lenses are like filters that screw onto the front of your lens. They are light, easy to use, require no exposure correction. Most common are +1, +2, +3 diopters. A diopter is, by definition, the reciprocal of the focal length, but all you really need to know here is that the larger the diopter number, the closer the focusing. In addition, different diopter lenses can be stacked, or used together; a +2 used with a +3 becomes a +5 diopter. A +5 diopter, used on a 50mm lens, allows focusing as close as six inches from the front of the lens (with the main lens set at its closest focusing distance, usually about two feet), covering an area about three inches by four and a half inches. Using a +1 diopter on the same lens, again with lens set at minimum focusing distance, allows you to focus on a subject about fifteen inches from the front of the lens, covering an area about six and a half inches by ten inches. Disadvantages? To varying degrees, supplementary lenses degrade the image sharpness. The greater the diopter, the worse it gets. For smaller diopters it can be acceptable, but beyond +4 diopter the images may not be acceptably sharp—especially for large blowups as prints or for publication.

Extension tubes, which fit between a regular lens and the camera body, allow close focusing by moving the lens farther from the film plane. You can buy extension tube sets, comprised of three or more tubes of different thicknesses. They can be used singly or in combination with each other. Nearly all couple to auto-

diaphragm mechanism and some retain auto-focusing. Using extension tubes offers a sharpness advantage over supplementary closeup lenses. However, regular, non-macro lenses are really not optically corrected very well for closeup work—especially those with large maximum apertures, f/1.8, f/1.4. So if you use them for extreme closeup work—1:1 or greater—the image quality may suffer. (The notation 1:1 means that the image is the same size as the object being photographed.)

If you plan to do much closeup photography, a macro lens is a good investment. Very often this macro lens can be used for other photography as well. For example, a common macro lens focal length is 55mm or 60mm. Since this is close to the so-called normal lenses for 35mm cameras, the macro can be used for distant work, doubling for the regular 50mm lens. Many camera manufacturers also make macro lenses around 100mm in focal length and this is my recommendation. This moderate telephoto, coupled with close focusing capabilities, allows you to get a tight closeup at a moderate distance from your subject. Use of the shorter focal length macro for the same image magnification would require you to move in closer and possibly frighten off the subject.

As you would suspect, macro lenses are designed for extreme closeup work and the image quality is excellent. Most allow focusing down to 1:2, that is, the image is half the size of the object. And, by adding an extension tube designed specifically for that lens, you can achieve a magnification of 1:1 or better.

One problem created by use of extension tubes or bellows is light loss. It's the inverse square law (you remember that from Physics 101, don't you?): The light reaching the film diminishes inversely with the square of the distance of the lens from the film plane. At a 1:1 magnification, that amounts to a loss of two f-stops of light. Back in the olden

days, before built-in metering systems measured light coming through the lens, we used to have to make calculations or consult tables to make exposure compensation. That's unnecessary today with through-the-lens (TTL) metering systems that measure the actual light and compensate for exposure. However, you should realize that at high magnifications, light loss will translate into slower shutter speeds—often too slow to hand-hold or to stop movement of a subject. So, for extreme closeup work, 1:1 or better, you need to consider your film choice carefully. Or consider using flash.

Depth of field considerations. There's something else to deal with in closeup photography: The depth of field shrinks dramatically. The greater the magnification, the shallower the depth of field. At a 1:1 magnification with a 50mm lens and an aperture of f/16, the depth of field is about 1/8 of an inch. That means that you have to do some careful planning and composing in order to keep most things in the picture sharp. It's not easy. Most things, from flowers to insects, are very irregular in shape and thus a large part of the subject may be outside the depth of field zone. The thing to remember is, if you're using a high degree of magnification, chances are you're looking at only a small part of a flower anyway, so why not make that part, the stamen or pistils, for example, the center of interest. Let the rest of the flower blend out of the depth of field zone into soft washes of color.

Sometimes it's possible to position the camera in such a way as to shoot at a more level part of a subject, keeping elements in the picture within the depth of field zone. Certain flowers like fleabane asters have petals that lie within a fairly flat plane, allowing you to position the camera and lens so that the film plane is parallel to the relatively flat plane of the flower. At moderate distances, the flower can be kept within the depth of field zone.

SOME ZOOM LENSES HAVE SO-CALLED *macro-focusing features. These vary from lens to lens, but in general these "macro" focusing capabilities don't allow very close or true macro work. In addition, quality of the closeup images also varies and, since zoom lenses aren't well corrected for closeup work, they can't quite match a good macro lens. However, for medium range work, macro-focusing zooms can do a decent job. This wooly louse-wort (what a name for such a pretty flower) on the tundra at Chenik Head in Alaska was shot with a Nikon 35–135mm zoom in macro-focusing mode. Camera, Nikon 8008s; film, Fujichrome Velvia.*

IN THE REALM OF ULTRA-CLOSEUPS, *near 1:1 image to object ratio or better, a whole new world of seeing begins to open up. We normally don't see things on this scale, such as these water drops on pine needles. I used a 55mm macro lens with extension tube to move in close. Round, out-of-focus highlights in a picture of this sort will take the shape of the lens diaphragm; if you stop the lens down, these become hexagons. I wanted them to remain circles, so I shot at maximum aperture to keep them that way. Camera, Nikon FM-2; lens, 55mm Micro-Nikkor, extension tube; film, Kodachrome 64.*

FOR CERTAIN SUBJECTS, A LONGER *focal length macro lens is better. I like the 105mm macro for many things. Insects are usually frightened off if you approach too close with a 55mm macro. And for my friend here, a prairie rattler found in Idaho's Salmon River country, it's definitely better not to approach closely. Camera, Nikon FM-2; lens, 105mm Micro-Nikkor; film, Fujichrome 100.*

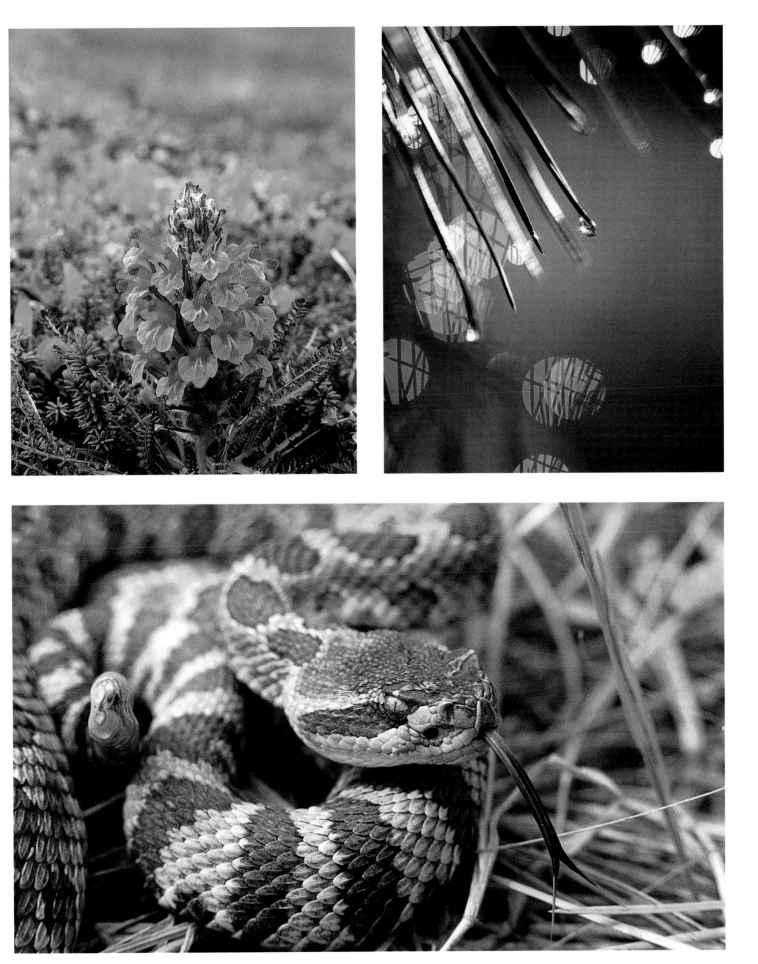

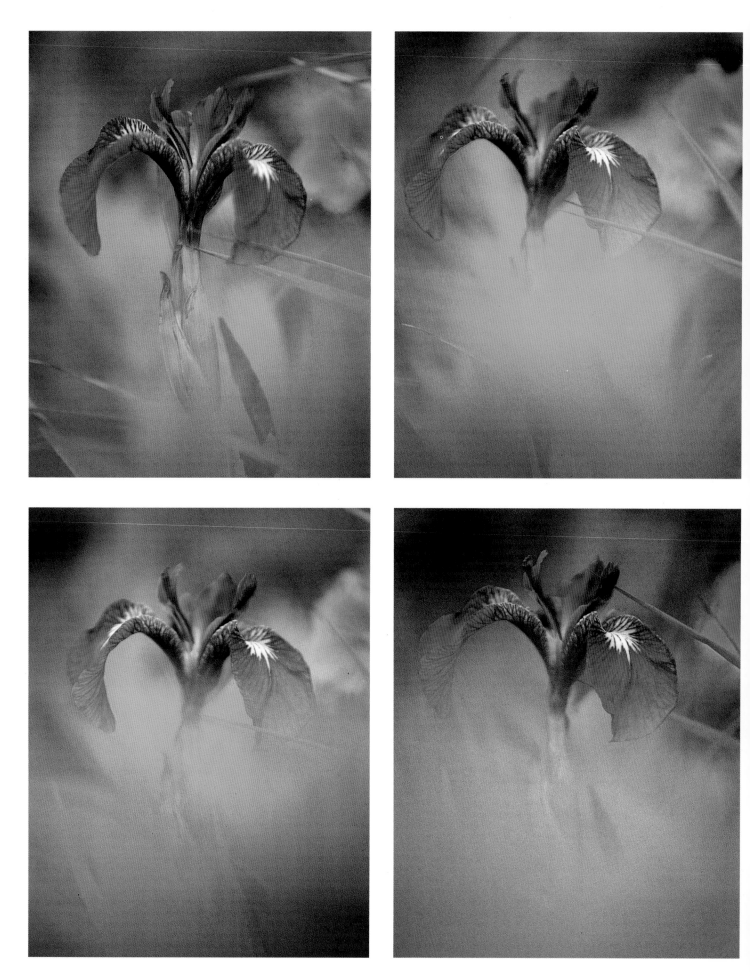

ONE OF MY FAVORITE TECHNIQUES FOR *photographing flowers is to use a 180mm f/2.8 telephoto with an extension tube to allow close focusing. Moreover, I shoot at maximum aperture so the depth of field is very shallow. If you do this, have patience; you have to compose very carefully because of that limited depth of field. But the results can be beautiful.*

This wild iris growing on the tundra at Chenik Head in Alaska is a good example of the technique. Lying on my stomach at ground level (wet-belly photography), I was shooting through some other vegetation. The shallow depth of field turned this into soft washes of color, some green (grasses), some purple (other flowers). This sequence shows the variations, all made by moving my position slightly. Incidentally, there are two advantages to this technique: You don't need to use a tripod (at f/2.8 in reasonable lighting you'll be using relatively fast shutter speeds), and because you're shooting at maximum aperture, what you see in the viewfinder is what you get; no need to check depth of field with the preview button. Camera, Nikon FM-2; lens, Nikkor 180mm f/2.8; film, Fujichrome 100.

The same is true of certain other subjects, such as leaves. You can often align yourself so that the film plane is parallel to the plane of a leaf and thus keep the surface in sharp focus within the depth of field zone.

Determining the depth of field zone is difficult in closeup work because normal depth of field scales on lenses don't apply at such close distances. You have to rely on using the depth of field preview button. And, of course, you know that if you use the DOF preview things get very dark in the viewfinder—particularly if you've chosen a very small aperture to maximize the depth of field. As I suggested in the chapter on lenses, try shading your eye and viewfinder to eliminate stray light. For most cameras you can buy an accessory rubber eyecup to fit on the viewfinder. (This helps, though it interfers with opening the camera back and has to be removed. And mine have eventually been knocked off and lost, so I just use my hand.) Leave your eye at the viewfinder long enough to let it adjust to the dimness. In this way you should be able to determine whether certain elements in the picture are acceptably sharp and make necessary adjustments if they're not.

One technique that I like for close-up work uses a medium telephoto lens of large aperture—a 180mm f/2.8 lens is my favorite. Though these lenses are not designed for close focusing (five feet is usually the minimum focusing distance) you can add an extension tube so that they will focus closely. In the case of my 180mm, I use an extension tube designed for use with a 55mm macro; on the 180mm it allows me to focus to about sixteen inches.

By shooting with this lens at f/2.8, I have minimal depth of field. As described in chapter six, that's great for creating impressionistic close-ups of, say, flowers. I can actually shoot through grasses or flowers very close to the front of the lens and, with the shallow depth of field, these elements appear as out-of-focus washes of color. Backgrounds, too, are strongly out of focus. The tricky part of this technique is keeping something of significance on the flower in focus, but often by moving around and composing carefully, that can be done. Incidentally, another nice thing about this technique is that you can hand-hold, giving you freedom and mobility to make small changes quickly. You can hand-hold because at f/2.8, with a medium speed film in moderate lighting conditions, you'll be using a fairly fast shutter speed—often 1/250 of a second or faster. I usually lie on the ground and brace camera and lens with my elbows resting on the ground.

Tripods: to use or not to use. If you plan to do much serious closeup work, I think you should resign yourself to using a tripod. Hand-holding, especially for extreme closeups, is a pretty iffy proposition. The shallowness of the depth of field makes focusing very critical, so that any slight movement can mean the difference between something being in that shallow depth of field zone or not—which translates to unsharp pictures. In addition, if you are using medium speed films coupled with small apertures, you're forced to use slow shutter speeds, with possible resultant image blur.

Using a tripod also has the advantage of freeing both hands in case you want to use a reflector or diffuser, or bend an intruding branch or blade of grass out of the way. And be sure to use a cable release to minimize camera shake when you make an exposure. When I'm using slow shutter speeds, I always like to either lock up the mirror or pre-release it (only a few cameras have this feature), otherwise the mirror flipping up just before the shutter opens could introduce some image-blurring vibration. Unfortunately, not all camera bodies have a mirror lock up feature. If you plan to do a lot of closeup photography, you may want to choose another camera body with this feature in mind.

Here's a trick for Nikon FM-2 users: You can pre-release the mirror by using the self-timer. Slide the self-timer lever part way over (instead of getting the full twelve seconds of timer countdown, try for about four or five), then trip the shutter release button. When you do this, the mirror flips up *first* (allowing vibration to dampen out), then the timer counts down and trips the shutter. I wish more camera bodies had this feature, but they don't. In most others, the self-timer counts down, then the mirror flips up just before the shutter goes off in the normal way—with the possibility of mirror vibration.

Reflectors and diffusers. The quality of light is especially important in closeup photography. Bright sunlight is very harsh and should be avoided for delicate subjects like flowers. So if you work in the shade or on overcast days for softer quality of light, you may need a reflector to bounce a little more light onto a subject or to fill in shadow areas. The simplest reflector is a sheet of heavy duty aluminum foil, spread and shaped to reflect light onto your subject. This has the advantage of being very light and easy to carry—I usually fold such sheets up several times into a compact size. If it's not windy, the sheet can often be propped up in grass or foliage to stand alone.

A little more elaborate, and bulkier, is the Springlite reflector sold by Spiratone. Circular in shape, and folding neatly for carrying, it has a metallized cloth surface. The one I use opens out into a three-foot-diameter circle that can bounce a lot of light. Incidentally, oftentimes reflectors can act as good shields against wind, keeping your subject from waving all over.

If you're forced to work in bright sunlight, you may want to consider using a diffuser. The simplest is a single layer of cheesecloth or a very thin piece of white cotton or nylon held over your subject to soften the sunlight. Problem is, if you have to cover a large area, it sometimes takes two or more people to hold it (or else you need to rig up some kind of tent-like affair with stakes and poles). Certain kinds of translucent plastic sheeting, like polyethylene, could work, but I would run some tests because some of them seem to impart a color cast to things.

There are two commercial diffusers worth checking into. One is the Diffusion Tent from Blacklock Photo Equipment, Inc., which uses a special plastic having good neutrality with regard to color balance. The other is the Macro Mate, a collapsible bellows-lens shade that uses translucent material and attaches to the front of your lens via adapters. It has to be used for subjects that are small enough to fit inside the translucent bellows, which has a front opening of about four inches by four inches. Both of these diffusers can be used with flash outside the units to provide more light.

Flash for closeups. In the past I've been a bit dubious about using flash for closeup photography because, like sunlight, it can be a very harsh kind of lighting that overpowers delicate tones and hues of flowers and other subjects. However, I've found that if you're willing to work at it and bring a few extra items into the field, you can soften flash illumination and make it a little more acceptable. I use a Lumiquest reflector for my flash units. This device attaches to the flash head with velcro fasteners. It's also very lightweight and easy to carry around. The flash head is aimed upward and the Lumiquest bounces and diffuses the light, giving very soft and even illumination. There's a loss of about one and one-third f-stops of light as compared to direct flash, but with a powerful enough flash unit and working at close distances there's still plenty of light. Using two flash units with Lumiquest reflectors gives excellent coverage of subjects with very soft and uniform lighting.

Most flash systems today are integrated into the camera electronics, giving through-the-lens (TTL) exposure

THIS SHOT OF INDIAN PAINTBRUSH WAS *made using the technique with the 180mm f/2.8 lens. Camera, Nikon FM-2; film, Fujichrome 100.*

I COULD HAVE FOCUSED CLOSER ON THE *flower in the center, but I chose a medium range closeup for this cluster of flowers known as "podshnezhnik" on the shore of Lake Baikal in Siberia. Nature isn't always perfect; I wanted the flawed scene— the wind-tattered and withered flowers. Of course, you have to keep it from becoming too cluttered, but the large flower is a good center of interest. Camera, Nikon 8008s; lens, 55mm Micro-Nikkor; film, Fujichrome Velvia.*

control—that is, light from the flash is measured after it passes through the lens and the sensor shuts off the flash after determining that the proper exposure has been made. It makes for very accurate and very hassle-free flash photography, as opposed to the days when you had to calculate exposure from guide numbers and distance and set the exposure manually.

Ringlights are a good choice for certain kinds of close-up work. These attach to the front of a macro lens via filter rings and surround the periphery of the lens with flash lighting. With TTL exposure, ringlights are a good choice for photographing insects or other small subjects. The illumination is very even and bright enough to allow small apertures for improved depth of field. This is important for extreme macro work where depth of field is very shallow and you've got little critters that won't hold still.

Film choices. The choice of film for close-ups depends upon whether you use flash or ambient light. With a fairly powerful flash system you can use slower speed films—ISO 25, 50, 64—for greatest sharpness and finest grain. For ambient light, it's often desirable to have a medium speed film, ISO 100, but it depends on lighting and other conditions. For flower photography on an overcast day, you may be able to use a slow speed film, provided the flowers aren't whipping around in a breeze. More often than not a medium speed, and sometimes ISO 200, is necessary for a moderate shutter speed *and* a small aperture for good depth of field.

For flower and foliage close-ups, I like the Fujichromes. Velvia has very intense rendition of color, particularly greens. Fujichrome 100 is also a good choice, though in recent years I've been using more and more Ektachrome 100 Plus because I think it's a bit sharper than Fujichrome 100.

With dimmer lighting, and often when I'm using a flash with a reflector/bounce, I choose Kodachrome 200. In fact, even in moderate lighting on an overcast day, I often shoot with Kodachrome 200. The extra speed gives a bit more chance of using motion-stopping higher shutter speeds when there's a breeze. The color rendition of Kodachrome 200 is quite good, in my opinion; reds and yellows are rich and saturated, though greens are a little subdued.

DOING UNDERWATER PHOTOGRAPHY *while snorkeling/free-diving (diving without a tank) is possible, but it's more difficult and takes more planning for each shot. This underwater scenic of elkhorn coral and purple sea fan was done off Saint John, U.S. Virgin Islands, in only fifteen feet of water—easy enough while free-diving. Camera, Nikonos V; no flash; lens, 35mm Nikkor; film, Ektachrome 100.*

THIS RAY WAS PHOTOGRAPHED OFF THE *barrier reef of Belize while I was snorkeling. Camera, Nikonos V; lens, 35mm Nikkor; no flash; film, Ektachrome Plus Professional.*

THIS PUFFED-UP PORCUPINE PUFFER FISH *was photographed in about forty feet of water off Saint John, U.S. Virgin Islands. The Nikonos closeup attachment, with its wire frame, would have frightened the fish too much; instead, I used the underwater housing with reflex viewing to be less obtrusive. We didn't harass him any more than necessary. After getting this shot, we let him swim off to the safety of a cave in some corals. Camera, Nikon FM-2 in Ikelite housing; Ikelite underwater flash; lens, 55mm Micro-Nikkor; film, Fujichrome 100.*

UNDERWATER PHOTOGRAPHY

Underwater photography may not be for everyone, but if you're looking for new photographic challenges, I definitely recommend it. In my case, I didn't begin serious underwater photography until the early 1980s when my friend Dana Fagan, a diving instructor and cinematographer on Saint Thomas, U.S. Virgin Islands, invited me to do some diving there. I was barely off the plane when he whisked me off in a boat, strapped a tank on me, and pushed me over the side. I was hooked. That first exposure to the incredible color and diversity of coral life made me anxious to capture it on film. And that's when I discovered just how challenging it can be.

The challenge—and the difficulty—of underwater photography makes it a complex subject. What I'll present in this chapter represents a broad overview, designed for photographers who may be just getting started in underwater work, or for those who would like to try it in the future.

Diving versus snorkeling. You have two choices for underwater photography: scuba diving or snorkeling/free-diving (that is, diving without an air tank). The first gives more freedom and flexibility in capturing underwater scenes and sub-

jects; the second is less expensive, requires far less training, but is much more limiting.

For snorkeling, you need a good mask, a set of fins, a snorkel, and a means for taking pictures in water—a waterproof camera housing or an underwater camera like the Nikonos or the Sea & Sea Motor Marine. If you're just starting out and plan to do underwater work only occasionally, I recommend the inexpensive Ewa vinyl camera housing, which allows use of a regular camera. There are several models, including ones for video cameras. Some will allow use of a flash as well. These flexible "bags" are made of tough, heavyweight vinyl, with optical glass ports front and back for the camera lens and viewfinder. There's a fitted glove sealed into the unit making it possible to hold the camera inside and manipulate focusing and camera controls. A major drawback to these is the buoyancy caused by air remaining in the bag when it's sealed up. This buoyancy makes it difficult to free-dive while snorkeling. I recommend buying a large-sized bag, with room for flash and camera, and placing a lead diving weight in the bottom, below the camera body. Though the manufacturer claims the units can be used to

135

depths of one hundred feet, it's far safer to limit use to thirty feet or less. Moreover, at greater depth the increasing water pressure squeezes the bag, making it a bit more difficult to manipulate camera controls. It takes practice and patience to use one of these.

The obvious limitations to snorkeling/free-diving are the depth to which you can photograph and the time you can spend below the surface. If you choose the right locale, there are many corals that grow just beneath the water's surface, making it possible to shoot certain kinds of closeups without free-diving to any depth. Many places in the Caribbean and along the barrier reefs of Belize and Australia offer sites like this. Often you can position yourself over the corals and shoot straight down on them from a moderately close distance. There's plenty of light at these shallow depths; however, you often have ripple shadows caused by surface ripples. In addition, these shallow corals are most often found just offshore where wave action can toss you around and make for difficult positioning.

Free-diving eliminates some of these problems of surface photography. With practice you can hold your breath and make a sub-surface dive to give you access to different and more diverse corals and fish. You may find it necessary, as I do, to use a diver's weight belt to neutralize buoyancy and allow a longer time at depth. If you're constantly fighting buoyancy, it's much more fatiguing and makes it more difficult to set up for a shot. Your depth and time-at-depth depends on your ability and practice. My friend Dana and my son Scott, who is also a scuba diving instructor, can free-dive consistently to depths of eighty feet or more and stay for what seems an impossibly long time. I find that my free-diving photography is limited to about fifteen feet or so, giving me a reasonable amount of time to set up and shoot.

Obviously free-diving photography requires that you pre-plan carefully. Snorkel over the area you plan to free-dive and check out the photographic possibilities. Sometimes I'll make a preliminary dive or two to check more closely the possible subjects and take a light-meter reading. On the surface, I make sure everything is set—f-stop and shutter speed. And then make the dive. You'll discover that it's often necessary to make several dives, shooting each time, because it's difficult to position yourself and hold still for very long.

Incidentally, I've noted that there is a tendency for free-divers and snorkelers to do more coral damage than scuba divers. When fighting buoyancy at depth, it's tempting to reach out and hold onto a coral to stabilize yourself. DON'T DO IT! Many species of coral are delicate and brittle and will break off very easily. And watch your fins. When turning or kicking to return to the surface, it's easy to inadvertently kick and break a projecting piece of coral. Also, in shallow waters, sand kicked up by snorkelers can smother and kill corals. At Trunk Bay in Virgin Islands National Park on the island of Saint John, heavy snorkeling activity, which kicks up clouds of sand and increases water turbidity, has caused the demise of a great many corals. So use great care to minimize your impact on these delicate underwater communities.

If you do much snorkeling/free-diving photography, you'll eventually reach the point where you'll yearn to stay down there for much longer times. And then it's time for scuba diving lessons. Most people find it convenient and inexpensive to take preliminary scuba diving lessons near home, in the safety and comfort of a swimming pool. Later, you can take your final lessons and open water dives at a good diving destination in the Caribbean or elsewhere. When you've become certified, you can arrange your own diving photo trip at hundreds of possible sites where you can rent tanks and equipment and a diving guide. Or you

THIS LIVELY LITTLE CRITTER, A SPOTTED *fairy shrimp, would not have tolerated a wire frame closeup attachment. So I used my Ikelite underwater housing, with a Nikon FM-2 camera and 55mm Micro-Nikkor lens, Ikelite flash, Kodachrome 64. I had to approach very, very slowly.*

THE COLORS IN CORAL COMMUNITIES *are really incredible, but you need flash to bring them out. This scene, in about forty feet of water off Saint Thomas, U.S. Virgin Islands, would appear very blue without flash, and the color intensity would be lost because water absorbs much of the red end of the spectrum—the deeper you go, the bluer it gets. These are sponges on star coral, with a yellowtail damselfish. Camera, Nikonos V; lens, 35mm Nikkor; flash, Nikonos SB102; film, Fujichrome 100.*

THE WIRE FRAME CLOSEUP ATTACHMENT *works well for stationary subjects like these coral polyps and blue sponge, growing on the roof of a cave in forty feet of water off Saint Thomas, U.S. Virgin Islands. I had to turn on my back to make this shot, being careful that my air bubbles didn't get in the way. Camera, Nikonos V; lens, 35mm Nikkor with Nikonos closeup attachment; film, Fujichrome 100; flash, Nikonos SB102.*

ANOTHER CASE WHERE THE WIRE FRAME *closeup attachment works well—the flamingo tongue cowry, an underwater snail, grazing on a purple sea fan (actually a soft coral, or gorgonian). Camera, Nikonos V; lens, 35mm Nikkor with Nikonos closeup attachment; flash, Nikonos SB103; film, Kodachrome 64.*

may find it more convenient to make trips with groups organized through dive shops or clubs. Either way, you now have to get more serious about your underwater photo equipment.

Equipment choices: underwater camera versus waterproof housing. I use *both* an underwater camera and waterproof housing for my regular cameras because there are advantages and disadvantages to each. With a good quality housing like the Ikelite, you can use your existing terrestrial camera. Ikelite housings are rigid plexiglass with sealed, interchangeable ports for various lenses, including a dome port for ultra-wide-angle lenses. There are sealed controls for manipulating focus (or you can rely on autofocusing), f-stops and shutter speeds. There are also sealed plugs for attaching underwater flash units. You have to select a particular housing for your brand and model of camera; for example, Ikelite makes separate models for the Nikon 8008, the F4, and for specific, older model Nikons.

Underwater housings are rather bulky and slow to use. It takes some practice to manipulate quickly the external camera controls. Often it's better to leave the camera in, say, aperture priority mode and manipulate just the aperture setting for exposure control, letting the camera automatically set the correct shutter speed. Also, I find that focusing can be a little tricky at times, particularly at greater depths where light is dimmer. Ikelite makes a device called "Super Eye" that screws onto the camera viewfinder and provides a magnified image at the viewing port. I highly recommend it because it definitely makes for easier focusing.

After each dive and shooting session, the underwater housing has to be unsealed and the camera removed to change film and/or lenses, then reassembled. It's a bit slower than changing film or lenses on a Nikonos. In addition, when resealing you need to take great care that the O-rings are seated properly at the mating edges to insure watertightness.

The main advantage of underwater housings is that reflex viewing and focusing eliminates the guesswork of estimating distance setting (as with the non-reflex underwater cameras). Also, certain kinds of close-up photography under water can't be accomplished very easily with non-reflex cameras—moving or timid subjects, for example.

As I mentioned earlier, I use both an Ikelite underwater housing and a Nikonos V (the non-reflex camera). Whether it be the Nikonos V, the Sea & Sea Motor Marine, or the Nikonos RS underwater single lens reflex, a dedicated underwater camera gives much more fluency and ease of use compared with an underwater housing. These underwater cameras have exposure automation and flash systems that take all the mental drudgery out of underwater work. Controls are easy to use.

Because the Nikonos V is a non-reflex camera, it is necessary to estimate camera-to-subject distance and set the lens focusing scale accordingly. This can be tricky and takes some practice. And to allow enough depth of field to cover some errors in focusing, you need to use a small aperture—which may dictate a fast film and/or use of flash.

The Nikonos V has a nice close-up system using a supplementary close-up lens with a wire frame outlining the actual picture area at the proper distance from the lens. You simply place the frame against your subject and shoot. This works well for certain subjects, such as coral formations and sponges, and gives good, detailed close-up photographs. However, many other subjects, such as fish, are frightened away by the wire frame.

The Nikonos V also features interchangeable lenses (of course, they can't be changed under water). Available are a 15mm f/2.8, a 20mm f/2.8, a 28mm f/3.5, all of which are designed to be used *only* under water. Incidentally, these three lenses do not utilize a flat port but, rather, have curved front elements/ports that re-

tain their true focal lengths. There's also a 35mm f/2.5 and an 80mm f/4 which can be used for *both* underwater and above-water photography. These are flat port lenses and, thus, the 35mm becomes nearly a 50mm focal length under water and the 80mm approximately a 100mm.

The ultimate in underwater photography is represented by the Nikonos RS system. This is a single lens reflex designed for underwater use, with complete exposure automation, autofocusing capabilities, and interchangeable lenses. It's a very high quality system—at a very high price.

If you specialize in underwater photography, the Nikonos RS can make life easier for you and may be a good investment. Otherwise, it's a very expensive system to use only occasionally.

Film choice for under water. The speed of film for underwater use becomes more critical than for terrestrial photography. If most of your underwater work entails use of flash, especially for close-ups, you can use a slow to medium speed film of ISO 25 to 64. However, I prefer something faster to allow me to stop down to smaller apertures and help correct for slight focusing errors. A film speed of ISO 100 is a good compromise between fine grain and ample speed. Ektachrome 100 Plus and Ektachrome 100X have excellent color rendition without the problem of exaggerating blue in older Ektachromes.

For general underwater work using ambient light and even with flash, I find Kodachrome 200 excellent. That extra speed allows for smaller apertures and greater depth of field. In addition, the higher contrast of Kodachrome 200 adds a little more punch to ambient light shots where things seem a little flat and pale with other films.

Fujichrome? I've been a little disappointed in these films under water, mainly because the tendency of Fujichromes to exaggerate greens—which is often desirable for terrestrial photography—makes the background waters seem too green, rather than blue-green. For close-ups with flash, the Fujichromes work well, giving good, rich color. But any shots that have an expanse of water in the background seem excessively green—and the deeper you go, the worse it seems.

Flash. Though I don't use flash very often in my general nature photography work, under water I find it to be vital. As mentioned earlier, water absorbs longer wavelengths of light, the red-orange-yellow end of the spectrum, skewing things visually toward the blue end. The greater the depth, the more blue everything looks. However, many corals, sponges, and fish are very colorful, with brilliant reds, oranges, yellows, greens. To bring out this natural color you need to use flash. If you rely on ambient light, those colorful subjects appear drab and pale in the blue light.

There are excellent flash systems available for dedicated underwater cameras (Nikonos, Sea & Sea) and for underwater housings. These offer automated exposure control and, depending on the system, some have through-the-lens (TTL) exposure automation for great accuracy. For my Nikonos, I've used both the SB-102 and the SB-103 flash units. The SB-102 has greater flash output and has a built-in modeling or target light that illuminates your subject to give a preview of the flash illumination. It's a helpful feature, eliminating problems with shadows—especially when using the close-up system with the wire frames. However, the SB-102 is quite large and heavy (admittedly, it's very light under water, but packing and carrying it to your destination is an important consideration) and costs twice as much as the SB-103, which I use most often nowadays. The SB-103 is smaller and lighter, has the TTL capabilities of the larger unit, but lacks the target light feature.

For the underwater housing, I use the Ikelite flash units—two of them mounted on a bracket on either side of the hous-

ing. These offer automated flash, though it's not TTL exposure control.

Before making any major diving trip, I recommend testing and calibrating underwater flash units. Obviously, this needs to be done under water. If your diving destination has services to process slide film (E-6 film), and many of them do, you might do your check-out on your first dive there. Otherwise, make arrangements to use a pool at a dive center/scuba instruction center. Use the deepest end of the pool. For a test target, an aluminum plate about a foot square will serve well. On it, paint a mosaic of colors with enamel or spray paints; include a patch of white and a patch of grey that approximates an 18 percent gray card. For TTL flash units like the Nikonos, start with the ISO film speed setting on the camera at the correct speed for the film being used. Then, in sequence, change this setting in increments on the ISO film speed dial and make further test shots. Example: for ISO 100 film, start with 100 set on the film speed dial of the camera. Make another shot with speed set at 80, still another set at 125, another at 160. In checking these later, you may find it better to use a higher or lower setting for proper exposure.

For non-TTL flash systems, you will make these settings and changes on the flash unit itself.

Perhaps the greatest problem in underwater photography with flash is backscatter from particulate matter in the water. Often these particles are so fine as to be nearly invisible, but if they are located in front of the lens and illuminated by flash, they show up as disturbing bright spots of light in the picture. Often, these can be eliminated or minimized by positioning the flash off to the side of the camera. I usually use the SB-103 mounted on a bracket to the side and slightly above the camera, angled down at the subject. Depending upon the subject distance, you'll need to continually check and re-adjust the angle of the flash.

Another way of minimizing backscatter is to do your photographic work away from other divers. Anyone swimming nearby can kick up a certain amount of debris from corals or sandy bottoms. Also, watch your own actions. Without realizing it, you may kick up particles in positioning yourself; move slowly and be sure your buoyancy control is optimal (more on this later). Your choice of dive site can determine the amount of particulate matter in the water. Deeper off-shore sites are usually better than shallower, close-in sites where wave action and current surge keep things stirred up.

Properties of light under water. The index of refraction of water is greater than that of air. The physical effect of this is to make objects under water appear to be about one-fourth closer than they really are when viewed through the flat port of a mask (or a lens behind a flat port). This creates an *apparent* distance for subjects, as opposed to the real distance. In using a non-reflex underwater camera like the Nikonos or the Sea & Sea Motor Marine, the focusing scale on the lens should be set by estimating the apparent distance to the subject. If you should actually measure the camera to subject distance, *this figure must be multiplied by three-fourths and the resultant number set on the focusing scale.* For example, if you measure a subject to be four feet from the camera, then three feet should be set on the focusing scale of the lens.

If you use a single lens reflex camera in a waterproof housing or the Nikonos RS (a single lens reflex underwater camera), you merely focus as usual through the viewfinder. What you see is what you get.

Because of refraction effects, the angle of view for lenses behind a flat port under water becomes narrower, that is, the lenses appear to be of a longer focal length under water. For example, a 20mm lens under water has the angle of view of a 28mm; a 35mm lens becomes nearly equivalent to a 50mm.

GROWING AMID CORALS ARE NUMEROUS
*tubeworms of various sizes, ranging from
inch-long "Christmas tree" tubeworms to
larger "feather dusters." These animals use
their plumes to capture plankton. However,
they are very sensitive to touch and pressure
in water caused by rapid movement. They
retract in the blink of an eye into a hollow
tube. So photographing them is a bit of a chal-
lenge—especially if you use, as I did here, a
wire frame closeup attachment. It's neces-
sary to move very, very slowly, holding your
position with breath control and being care-
ful not to bump the coral with the frame.
Camera, Nikonos V; lens, 35mm Nikkor
with closeup attachment; flash, Nikonos
SB103; film, Kodachrome 64.*

THIS IS UNDERWATER PHOTOGRAPHY OF
*a little different nature (and temperature)
than that of the Caribbean. I was diving (with
a dry suit) off the shore of Chenik Lagoon in
Kamishak Bay, Alaska, hoping to get shots
of migrating salmon as they began their run
up Chenik Creek to spawn. Actually, as I
got into the mouth of the stream, the water
was very shallow and I could use a snorkel,
rather than regulator and tank. Focusing was
the most difficult part—I had to guess the
distance of the fish swimming by. Fortu-
nately, there was enough light so that I could
stop down for lots of depth of field. Camera,
Nikonos V; lens, 35mm Nikkor; no flash;
film, Kodachrome 200. Water temperature,
about 38 degrees!*

I DIDN'T BRING DIVING GEAR ON MY TRIPS
*to Komodo Island in Indonesia, but I did
have my mask, snorkel, and Nikonos V. Just
snorkeling offshore in shallow water gave an
opportunity to capture a little of the coral life
here. Since it was so shallow, there was plenty
of light and things weren't as blue as they
would be at greater depths. Camera, Nikonos
V; lens, 35mm Nikkor; no flash; film,
Kodachrome 200.*

In addition to refraction, the absorption of light affects underwater photography. Even in the clearest waters of the Caribbean, with a visibility of one hundred feet on a bright sunny day, at a depth of ten feet, there's a loss of two f-stops compared to above-water lighting. At thirty feet the loss is almost three f-stops. Obviously this will affect your choices of film and, in many cases, necessitate the use of flash.

Finally, the *color* of light changes with depth, becoming more blue. The wavelengths from the red and yellow end of the spectrum are absorbed more readily. Below about ten feet everything appears blue or blue-green. Thus, the best way to capture brilliant color is to use underwater flash. More on this later.

General techniques and tips. Probably the most important single piece of advice for good underwater photography is to control your buoyancy. Buoyancy is controlled by adding or subtracting lead weights from your weight belt and by adding or venting air from the buoyancy control (BC) vest. The ideal is neutral buoyancy at any particular depth—neither sinking nor rising. Too many divers tend to use too much weight, thus making it necessary to swim or kick to maintain position. For good photography you need to maintain a static position with as little movement as possible. If fact, I find it possible to fine tune my position just by breath control. With good neutral buoyancy, if you inhale and hold your breath you will begin to rise slowly. Conversely, exhaling will make you sink slowly. If you're constantly kicking and thrashing to maintain position, you'll scare away many subjects, kick up sediment, and very often do damage to corals.

Since you can't change film or lenses under water, it's important to pre-plan before each dive. If you're unfamiliar with a particular dive site, use the services of a local guide and find out what opportunities there are. Or do some advance snorkeling over the site to check out possibilities.

For maximum flexibility, I like to be prepared for both general underwater shots and close-ups. With the Nikonos V, I carry along the close-up system, which can be attached and removed easily under water (I usually use it with the 35mm lens). And I have the SB-103 flash unit attached on a bracket, ready to use. Incidentally, when using the Nikonos under water, I remove the neckstrap from the camera and carry it by the bracket arm of the flash. Leaving the neckstrap on can create problems—like having it float in front of the lens at the last moment before taking a shot.

The underwater housing system requires even more pre-planning. If I'm going to do close-up work, I'll put the 55mm macro lens on the camera. If I plan to use the Nikonos for close-ups with the 35mm lens, it's nice to have opportunity to shoot with a wide-angle; thus I'll put the 20mm lens on the camera and use the dome port on the housing, giving me a true 20mm under water. Toting around both systems under water is a problem; when I need to use one, I have to set the other one down (carefully, so as not to damage any corals). But after a while you work out your own system of doing things efficiently.

If you decide to give underwater photography a try, be patient. The first few times may be frustrating. More than any other kind of photography it takes practice and from this practice you will gain the experience necessary to become proficient. You will find it to be some of the most exciting and rewarding photography. To me it's a little like being an astronaut—you can drift effortlessly and weightless through a wondrous world and capture its magic and beauty on film.

I have travelled widely in Concord.
Henry David Thoreau

YOUR OWN WORLD

NO MATTER WHERE WE LIVE, WE ALL *share one thing: weather. If you don't have spectacular scenery nearby, you can always create skyscapes. Over the years I've done studies of skies and clouds around my home here in the Front Range of Colorado. Camera, Leica R5; lens, Leica 70–210mm zoom; film, Kodachrome 64.*

The comment by Thoreau was in response to a question about his travels, particularly world travels. He had to admit that his journeys were not very worldly, but he went on to point out that there was so much beauty in his domain, and he knew it all intimately.

I guess we can all take a lesson from Thoreau. In particular, now that photography has opened our eyes to the beauty around us, we can find much to photograph right in our own backyards. And I don't mean birthdays and holidays. So often we take for granted our own environment—I know I do—and ignore things that can make for photographs as great as those taken in Kenya or Bangkok or Rio. It all has to do with the kind of photographic seeing I discussed in the first chapter. Perhaps most significant, involvement in photography near home is easy and inexpensive and it hones your skills so that on trips to more exotic places your photographs will be so much better by virtue of the practice.

Self-assignments. I hate to brag, but I'm probably the world's greatest procrastinator. I put things off until the very last deadline crash. But I have to say that having a deadline imposed by editors does force me to complete the project, albeit

sometimes in panic fashion. And maybe that ain't bad—a little adrenaline keeps the creative juices flowing.

Even though you won't have an editor screaming at you via phone or FAX, the discipline of self-assignments can be very beneficial to your photography. You'll have to impose your own deadlines, and whether you meet them is up to you. The main point is to keep photography foremost in your mind whenever you can. Think pictures—even if you don't have your camera with you at the moment. For example, I spend a lot of time (too much, actually) in airports, and airports are great places for people watching. Even though I carry my camera gear with me, I don't take many pictures in airports. But I do look for pictures all the time—people pictures. Fleeting expressions, interesting faces, emotions, all captured in the mind's eye and, occasionally, on film. You can do the same, on the way to work, in the office or on the job, looking for pictures of people, places, things. If it's possible, you might carry a camera with you to work for those times when you can pause a moment and take a great shot.

Assignments should be entered into in a serious way. Make a contract with yourself to complete a shoot covering a

particular theme or subject. Self-assignments can be long-term, even on-going, or they can be short-term projects. The main point is DO IT.

What do you pick for topics? How about, for starters, documenting the town or city you live in. Take a *National Geographic* approach and think long and hard about the environment of your locale. Look, we all live in our own private little world consisting of community, friends, family, jobs. That can be part of your documentation, but think beyond that. Take a good, hard look at familiar places and things around you. What's unique about where you live? Is the lifestyle different from other places? How, in what ways? Any unusual people or events or landmarks in you locale? What about environmental issues? No matter where we live there's always some environmental matter that affects us. (More about this in a moment.) A good documentation of the issues involved could even lead to publication in a local newspaper or a regional magazine. Or maybe social problems, dealt with in the same photojournalistic way.

If you don't want to start with something quite so ambitious, then give yourself some mini-assignments, things that can be accomplished in a day or maybe in a few hours on a weekend. These can be whimsical, serious, experimental, and they can be done on a roll or two of film. They'll also be good learning experiences if you enter into the spirit of it. For example, here's one we do occasionally in our photography workshops: Take a ten-foot piece of string and go stake out a territory with it—anywhere, your backyard, a park, some nearby woodland, even your kitchen! The territory can be a circle with a ten-foot radius, or any shape you care to make it. Then shoot a whole roll of film (thirty-six exposures, please) taken from within that territory. You can even stand within your territory and make photographs of things outside it, but the main point is—use your imagination. For the

things within your little realm, you'll need to begin looking—and seeing—what they're all about. Shapes, forms, lines, patterns, textures, colors—see what you can accomplish photographically.

Here's another one: shadows. They're everywhere (except on cloudy days) yet we never take the time to *see* them. This one can be a lot of fun, a real imagination-stretcher. You could do a photo essay just on the shadows of different kinds of trees. Or familiar objects made abstract. Or how about a photo essay on the shadows of friends and family?

One of my own favorites is signs. In fact, over the years I've sold many of my sign photographs to certain publications. The kinds of signs I look for are those that are a little on the wacky side or maybe something off the wall (no pun intended). It's especially fun, when you travel, to look for signs that that are not only humorous, but reflect a little of the culture of a place. For example, in one national park in Kenya a sign at the entrance announces: NO HOOTING IN THE PARK. Rather than being a terrible persecution of owls, the sign merely asks people not to "hoot" the horn of their car while in the park.

Another favorite theme of mine, also an on-going project, is documenting doors and windows of different cultures around the world. Think about it for a moment—what could be more ordinary than windows and doors? They're so utilitarian that we take them for granted and often never give them a second glance. Yet in many places, including, more than likely, your own region, doors and windows are sometimes very decorative and ornate. They speak volumes, in subtle ways, about certain cultures. In the Caribbean, most doors and windows are painted brilliant colors. In Siberia, windows are framed by ornately carved shutters, also colorfully painted. Right in my own backyard I've found beautifully carved doors and colorfully weathered wood on abandoned buildings in ghost

towns of early mining days.

As I said, these are all creative exercises and that is, after all, what good photography is all about—creativity. You might even use self-assignments for experimentation with new techniques or films (infrared film, for example). If all of your work has been of a strictly realistic nature, you might want to experiment with some impressionistic techniques. I find that such experimentation can really stretch the imagination. And that can be helpful in *any* of your photographic work, because it makes you think about how you approach the challenge of capturing a particular scene or subject. If you've never made a double or multiple exposure, try it. For starters, it will make you think carefully about exposure because you will need to divide the exposure between successive shots on the same frame (outlined in the chapter "Interpretive Rendition").

Okay, you've done some assignments and you plan to do more. Now what? What do you do with them? First of all, if you're pleased with your accomplishments, that's what really matters. I've always pushed the philosophy that you should shoot to please yourself first, not for what you think someone else will like. More often than not, if you like a particular photograph, so will others. Some of your assignments could make for good prints for exhibition. Or some entertaining slide shows. Regardless of how they're used, you will benefit from the learning experience in creating them.

Cameras for a Cause. Photography is a powerful form of communication. Susan Sontag, in her book, *On Photography*, makes an important point: "Nobody ever discovered ugliness through photographs. But many, through photographs, have discovered beauty." She also points out that, because we're so familiar with things around us, it often takes a photograph of some of those things to make us notice them.

I can't think of a better way to

ICICLES RIGHT OUTSIDE MY BACK DOOR. *Exposure is a little tricky on this; actually, I started with the "Sunny 16 Rule": the reciprocal of the film speed as shutter speed at f/16, in this case, 1/60 of a second at f/16 for Kodachrome 64. To play it safe, I bracketed one-half f-stop on either side. Camera, Leica R5; lens, Leica 70–210mm zoom; film, Kodachrome 64.*

AND LIGHTNING. THIS SHOT WAS MADE, *quite literally, in my front yard. An approaching thunderstorm after dark gave a good opportunity for this kind of picture. I set the camera on a tripod, set the shutter for B (for "bulb"), and held the shutter open with a locking cable release. I held a black card over the lens, then removed it when I thought there would be another strike. This way I was able to record two or three. Lens was set at maximum f/3.5 aperture. Camera, Nikon FM2; lens, Nikkor 35–135mm Zoom; film, Kodachrome 64.*

COLORFUL OLD BUILDINGS RIGHT IN MY *own backyard in Colorado. As an example, one of them was shingled with old license plates in the town of Telluride. No matter where you live, I'll bet there are similar subjects that can make great photographic studies. For both: Camera, Nikon F; lens, 105mm; film, Kodachrome 64.*

sharpen your photographic skills than to use photography for environmental causes. And I can't think of anything more helpful to the environment than a small army of proficient photographers in numerous locales who are raising people's awareness of the beauty of certain places and the value to our society of preserving unspoiled lands and wildlife. I'm willing to bet that, no matter where you live, not far from home there's some major environmental issue and probably a score or more smaller ones that could use some good photographic documentation to help make people aware of the need to save these places. I might point out, also, that more than a few professional nature and landscape photographers got their start by being involved in such things. I know I did.

How do you get involved? First of all, research. If you haven't been paying attention, start taking note of environmental issues—or potential issues—that are discussed in local newspaper articles. Or look up local chapters of environmental organizations such as the National Audubon Society, Sierra Club, Nature Conservancy, Wilderness Society, National Wildlife Federation. Find out about issues and visit the places of concern. In fact, you should do more than visit the threatened areas, you should spend a *lot* of time there capturing the beauty, the moods, the seasons, the wildlife and bird life—as much as you possibly can.

Chances are, you already know of a place deserving of protection from bulldozers; if you do much nature photography near home, you probably spend a lot of time in nearby forests or along rivers or seacoasts or swamps or desert, some of which may not have any protected status. You, through your photographs, can become champion of these places.

Obviously, merely photographing wild and beautiful places won't accomplish the task of saving them. You need to *show* those pictures to people and perhaps the best way is through slide pro-

grams. Many local clubs are eager for programs for their members. It's an opportunity to show off your photographic skills and, at the same time, educate people on the value of certain places. (Incidentally, it's not unusual for someone who has this sort of presentation to get requests to buy prints of some pictures.)

You could also think about publication. If the environmental issue is of enough importance (and you can *make* it important) many publications might be interested in a story about it. It's highly likely that a local newspaper, at least, will have interest in the story. For that, of course, you'll need some good black and white photographs, which can be made from good quality slides by any good photo lab. Scout out other publications—regional magazines, for example. In many states there are very fine magazines published by state fish and game or natural resources departments. Most often these are quarterly (sometimes semi-annual) publications, but the quality of color reproduction is quite good. Submit a selection of a dozen or so of your best slides, together with a short essay on the issues and the significance of your embattled turf.

You can, of course, set your sights higher. Some environmental issues transcend the local scene, and there's certainly opportunity to place your photo essay in a national publication such as *Audubon, National Wildlife, Defenders* (the publication of Defenders of Wildlife), Nature Conservancy's annual publication, and *Wilderness* (the publication of the Wilderness Society). And don't overlook such magazines as *Harrowsmith, Country Living, Buzzworm, Mother Earth News, Sierra* (published by the Sierra Club), *Wildlife Conservation*, and perhaps a few others I've overlooked. To find others, get a copy of *Photographer's Market* (Writer's Digest Books), available at most bookstores and libraries.

The rewards of this kind of photography are enormous. You may not make

any money at it. In fact, you will probably invest a great deal of money yourself, and invest a great deal of time. But there's great satisfaction in knowing that your own photographic skills have helped influence people in making the right decisions on environmental issues. And in the process you will have become a *photographer* of great skill in capturing the world of beauty around us.

ABOVE: MY OFFICE IS SEPARATE FROM MY HOUSE, CONNECTED *by a wooden patio/walkway. One winter morning when I came into the house for coffee I was intrigued by my own footprints on the snow-covered wood. I made this photograph just for the fun of it, a study in design and, perhaps, enigma—two different prints, two different directions. Around home you can shoot just for the pure fun and joy of it. Who cares if no one else likes it? Camera, Leica R5; lens, Leica 35–70mm zoom; film, Fujichrome 100.*

ABOVE RIGHT: THIS PHOTO WAS MADE, QUITE LITERALLY, IN *my back yard in Colorado. We were hit by an early snowstorm one September (we have two seasons here: last winter and this winter!) and these aspen were coated with snow. I deliberately underexposed by half a stop or so to convey the gloomy feeling of the weather. Lens, 105mm.*

RIGHT: LATER IN THE WINTER AFTER A HEAVY SNOWSTORM, *the sun came out and wind began to gently shake these blue spruce trees laden with snow. I stood under them, shooting up with a 20mm ultra-wide-angle lens as the snow cascaded down. For a self assignment of your own, find a tree nearby and do a seasonal documentation of it, what it looks like in spring, summer, fall, winter. Or different times of day—or night. Camera for both, Nikon F; film, Kodachrome 64.*

About the Author

Photo copyright © by Susan Kelm

Boyd Norton travels extensively in documenting the world's wild places and environmental issues, a specialty he has pursued as a photographer and writer for more than twenty years. No stranger to hazardous assignments, he has photographed poisonous snakes, crazy bush pilots, snorting Cape buffalo, charging grizzly bears, rhino and elephant poaching, whitewater rapids, Borneo headhunters, prowling leopards, mountain gorillas, and Moscow taxi drivers.

His articles and photo essays have appeared in most major magazines, including such publications as *Time, National Geographic, Smithsonian, Audubon, Conde Nast's Traveler, Stern, Vogue, Geo, Money, Outdoor Photographer, Popular Photography, Reader's Digest, The New York Times, Travel Holiday, The London Observer,* and Time-Life Books. He is the author-photographer of eleven books, the most recent being *Baikal: Sacred Sea of Siberia* and *The African Elephant.* When he's not in the wilds of Borneo or Siberia or Africa, he calls Evergreen, Colorado, home. There he lives with his wife Barbara, two pet snakes, and a piano-playing cat named Lisa.

Index

Throughout *The Art of Outdoor Photography*, you will find helpful self-assignments, listed here, that you can use to practice and teach yourself.

SELF-ASSIGNMENTS

INDEX